JOURNALISM AND MEANING-MAKING

Reading the Newspaper

THE HAMPTON PRESS COMMUNICATION SERIES
Mass Communication and Journalism
Lee B. Becker, supervisory editor

JOURNALISM AND MEANING-MAKING

Reading the Newspaper

edited by

Verica Rupar

Cardiff University

HAMPTON PRESS, INC.
CRESSKILL, NJ 07626

Printed in the United States of America

Library of Congress Cataloging-in-Publication Data

Journalism and meaning-making : reading the newspaper / edited by Verica Rupar.
 p. cm. -- (Hampton Press communication series. Mass communication and journalism)
 Includes bibliographical references and index.
 ISBN 978-1-57273-937-6 (hardbound) -- ISBN 978-1-57273-938-3 (paperbound)
 1. Journalism--Social aspects. 2. Journalism--Objectivity. 3. Visual communication. I. Rupar, Verica.
 PN4749.J67 2010
 070.4--dc22

 2010017453

Hampton Press, Inc.
23 Broadway
Cresskill, NJ 07626

CONTENTS

INTRODUCTION

The man on the other side of the table was the political advisor of Serbian President Slobodan Milosevic. He was a reasonably intelligent constitutional lawyer in his early 30s, and my off-the-record source of information from the Presidential Palace.

We were talking about the latest incidents at the border between Serbia and Croatia. It was June 1991. Yugoslavia still existed as one country, the problems between republics were open, but there was a hope they could be solved peacefully.

"Why is it so quiet here?" I asked.

"This is a presidential palace, not a brothel."

It was a joke, of course. The old building in the center of Belgrade was a masterpiece of early century architecture, with marble floors and Venetian mirrors, home to the noble dances between the two world wars, and political deals in the communist era. Milosevic's predecessor, Ivan Stambolic, turned the palace into a lively place, with a few parties that raised the eyebrows of the puritan apparatchiks from Milosevic's camp. The two politicians fell apart a few years earlier and animosities were so strong that the brothel metaphor served as a code for identifying sides.

We both laughed. The advisor of Slobodan Milosevic and the journalist from the daily Politika could still laugh about politics. The war hadn't yet started.

"Serbs like Milosevic because he is serious," argued the advisor when the telephone rang. It was the "red line" telephone.

1

He gestured for me to stay.

The smile of a devil: "What a wonderful surprise!"

He covered the receiver, and whispered the name. At the other end of the phone was the political advisor of Croatian president Franjo Tudjman.

"How I am? Great! How should I be?! Ha, ha, ha. . . . You know us, Serbs! We are just enjoying the good life! We drink good schnapps, eat rosy, crunchy piglets, make juicy barbeques, love beautiful women. Yes, yes. . . . Don't forget: In our spare time we do polish our army boots! What would you like to share?!"

The performance went on, the usual arsenal of nationalistic jokes between a Serb and a Croat.

Then:

"He wants to meet Milosevic?! He would love to?! How nice of him! Yes, of course, I will pass a message on. No, no, no, I agree, it is serious. I will check with the president and give you a call as soon as I get the answer. Yes, sure, my friend, no one minds a joke or two. All the best. Talk to you soon."

He looked at me.

"You won't believe it. Tudjman wants to meet Milosevic! I have to talk to the boss straight away. Please wait, it won't last long."

It did not last long. He came back from Milosevic's office after few minutes and told the secretary:

"If Tudjman's advisor calls I am out of the office, on an urgent business trip. You don't know when I will be back. No, I didn't leave any message for him."

"Milosevic does not want to meet Tudjman?!"

He slowly repeated: "Milosevic does not want to meet Tudjman. Yeah . . ."

A moment in the history. No dead yet, no massacres, no mass graves, no refugees, no ruined economy, no brain drain. Not yet. June 1991. Within 2 months the Yugoslav bloodshed would start.

I went back to the office. I told the editor I had an 'exclusive,' The editor laughed: "That sort of a thing is not for publishing." I objected. We argued. After a while he said: "I have to check." We both knew, without a single word spoken, that this did not refer to the verification of facts.

He rang Milosevic to check if Politika could publish a story about Tudjman's phone call. Milosevic said that was fine. The story was published. The news text said that Tudjman had asked for a meeting. The editor suggested the sentence "No response yet from Milosevic's cabinet." I said: "But he rejected the meeting." The editor: "He might accept talks in few days, let's leave it open." I let it be.

I don't know if Milosevic and Tudjman met in June 1991. If they did, it wasn't reported. The war started soon after and the presidential palace

became the command center of the nightmare that brutally changed our lives.

In years to come, the advisor would become a shadow of the ambitious young man described at the beginning of this story, scared to talk, retrained to listen.

Milosevic's predecessor, the one from the brothel reference, would disappear. His body was found many years later. He was killed by Milosevic's secret police.

Tudjman's advisor was sacked soon after the event I am writing about; Tudjman himself would die as the greatest son of an independent Croatia.

Slobodan Milosevic, the autistic president from the presidential palace in Belgrade, would end his days in Shevingen Prison in The Hague.

The editor of my newspaper would become Milosevic's ambassador, and I would leave daily journalism and immigrate to New Zealand.

It isn't the biggest story of my career, nor the most challenging, when it comes to the question of the existence of journalism in countries with limited democracy. But it is a story that reappears every now and then to remind me of the richness of the environment within which journalism operates. Would anything have happened differently in Yugoslavia if *Politika* had published a story that said Milosevic initially rejected Tudjman's call for talks? Would an additional sentence about the rejection complete the news story on the event? Should the news say he initially rejected but might change his mind in days to come? How about other details? A description of silence in the palace? Would a description of the conversation between advisors—the "polishing army boots" detail for example—change the meaning of the story? How about the way the advisor asked "the boss" about the meeting? Let's complicate it further: Is it a story at all if we don't know exactly what Tudjman's advisor said? What were the words Milosevic used to reject the meeting? Did he swear, did he call his wife before making his decision (he had a very influential wife)? Would the story about Tudjman's offer to Milosevic be complete if the reporter insisted on a "full" story? How about a different editor, rather than one who complied with the authorities? How about the same type of event, but a different country, political, and legal system, and a different cultural tradition in reporting politics? It's easy to dismiss the power of this example by taking into account the authoritarian environment of the press in Belgrade, but does it mean that the special relationship between news makers and politicians does not exist elsewhere? What would a Swiss journalist report about this event? Would he or she find it important to report on? What is important for journalism's intersection with reality? How does journalism contribute to our understanding of the world? Does it matter at all?

This book is based on the belief that journalism plays a fundamental role in our understanding of the world. First, journalists write stories about events and issues beyond our own experience, and second, journalists enjoy the status of "experts" in writing about events and issues beyond the readers' experience. In times of rapid political change, a crisis like the disintegration of Yugoslavia, or cultural shifts such as the "tabloidization of culture," this expertise might be—and is—frequently challenged, but it never disappears.

The chapters in this volume aims to discuss some of the elements of journalism expertise. The volume suggests several theoretical platforms and methodological tools with which we may investigate journalism as a practice of making meaning about reality. The profession and the practice of journalism are so deeply rooted in social, political, and cultural contexts that it is difficult to extract the elements of journalism that overcome the singularity of its context. But, it is not impossible. It is easy to explain that part of the news about Milosevic and Tudjman that was missing as a result of the absence of press freedoms, but the fact is that the meaning of this news was created in a chain of communicative events where the dialogue between journalist and editor, to publish or not to publish, stands as an important part. This book highlights these less-explored spaces in journalism studies. It looks at journalism as a cultural form that is socially, politically, and economically rooted, a "dependent" factor in meaning-making (the editor rang Milosevic), and it looks at journalism as a community of practices, an "independent" factor (journalists fought for the right to report fully) in the construction of meaning in the public domain.

JOURNALISM AS A FIELD
AND COMMUNITY OF PRACTICES

The multilayered analysis of journalism presented in the chapters here highlights the spectrum of choices in approaching journalism as a field and a set of cultural practices. It explains that journalism's production of meaning goes beyond the representational function of the media not only because journalism is historically, socially, and politically positioned, but because the interplay between the individual and the structure is the dominant characteristic of the field (Bourdieu, 2005). The power of journalists to determine newspapers' representation, interpretation, and construction of reality is institutionally rooted, but it is the everyday practice that teaches journalists the ways things are and should be done in the newsroom.

The "feel of the game" or the "practical sense," allows a journalist to operate inside the field as a unique, creative, sole individual with a set of skills, knowledge, attitudes, value systems, cultural background, predispositions, judgments, and behaviors that generate and organize their practices

and representations. The most important characteristic of the journalistic field is that all those characteristics are developed in a long and complex process of socialization both inside *and* outside the newsroom. Many scholars have investigated the autonomy of the journalistic field and found that interactions with other fields leave their mark on news content. But not many of them have investigated how the logics of the journalistic field influence the field's product (the news text), and how this identified influence interacts with other fields of cultural production.

Since the two early studies of the 1950s—White's (1950) study of the gatekeeper editor and Breed's (1955) analysis of social control in the newsroom—a sizeable body of research has developed addressing the issue of the factors that influence news content. Zelizer (2004) noted that five different approaches to journalism—"journalism seen as a profession, as an institution, as a text, as people and as a set of practices" (p. 32)—still do not offer a comprehensive platform for a wide-ranging analysis of the relationship between journalism and society. Following her call for more interdisciplinarity in journalism scholarship, this collection of chapters conceptualizes journalistic practice by setting aside the overly exploited question of what journalism should be, and asks what journalism *is*. Focusing on newspaper discourse—still the most influential mode of journalism production—this volume puts the issue of making sense of reality at the center of the debate about journalism.

The tools journalists use in their work, the norms they apply, and the principles that lead them, leave a mark on their products. The journalist's job is to make things explicit, so journalists attempt to "legitimate categories of perception" (Bourdieu, 2005, p. 37), to set out rules that give legitimacy to their sense-making activity and, more importantly, the forum-creating capacity of the press. The question of the meaning of news has attracted many media scholars but there are not that many studies that seek an answer by looking at the elements of journalistic practice and their relation to the process of representation, interpretation, and construction of reality. One might ask why journalism matters at all. It matters because the journalistic field, along with the social sciences and politics, holds a central place in the wider field of power. Among those who compete to impose "the legitimate vision of the social world" (Bourdieu, 2005, p. 36), journalism is a crucial mediator. The distinctive character of the interaction between journalists and sources, for example, or journalists and editors, comes from "the fact that human beings interpret or 'define' each other's actions instead of merely reacting to each other's actions" (Blumer, 1969, p. 79). Seeing the world of journalism as the space, or the field, implies the understanding that the news text reflects a set of interactions that are in a constant and interwoven process of redefining reality. The job of the journalist is therefore more than a mere presentation of events and conversations—it is always a re-presentation, mediation that includes representation, interpretation, and construc-

tion. Knowledge about the event—a sudden phone call in the middle of the pre-war crisis—comes from the meaning the individual journalist gives to the event. But the meaning also is derived from journalist's interactions with other agents outside and within the journalistic field (the advisor and the editor in the Milosevic–Tudjman story), and that exchange of interpretations influences the meaning of the event.

WHAT INFLUENCES THE CHARACTER OF THE STORY THAT EMERGES?

The journalistic field is the community of practices where it is possible to read individual news text with a view to showing its scrupulous actualization of the spectrum of judgments journalists make when gathering and presenting information on a subject. The meaning of an event such as a press conference, for example, comes from the journalist's knowledge about press conferences in general—that there will be an announcement of something new or important; that it will probably start with an introductory speech by the host; that journalists can ask questions, but the number of questions one can ask will depend on the number of journalists attending; that it will be held at a certain location and probably last no more than 1 hour (the usual duration of a press conference). In addition to this "general meaning," the journalist's personal understanding of a press conference is supplemented by meaning gained through interactions with other journalists. This action and interaction, historically formed and structured in a process of socializing subjectivity engraved in the notion of habitus (Bourdieu, 2002), explain how the source of meaning (of an event such as press conference) does not emanate from the event itself, but is a "[creation] formed in and through the defining activities of people as they interact" (Blumer, 1969, p. 5).

Although the field's relations and interactions demonstrate how social practices are a reflection of structural history—can you imagine the "verification of facts" from Belgrade's newsroom taking place in Washington or Canberra?—the idea that meaning comes through the process of interaction seems universal. The individual journalist first "interacts" with him or herself—by indicating to herself the things that have meaning—and second, by virtue of this process, interpretation becomes a matter of handling meanings. What is important here is that the application of meaning is not an automatic process but "a formative process in which meanings are used and revised as instruments for the guidance and formation of action" (Blumer, 1969, p. 5). The interplay between different journalistic forms such as news reports and editorials, for example, gradually modifies the meaning of the story in a way that narrows the subject and does not allow an easy reversal of the process.

The interactions between various fields leave a mark on the autonomy of the journalistic field and on the news text, as the journalistic field's final product. Most studies devoted to cultural production take one or the other of two approaches or ways of a reading: "internalist," considering the text in itself and for itself, and "externalist," reading that relates the text to the context and society in general (Bourdieu, 2005). Of the internal and external approaches to the text, the latter is preferred and should include questions relating to who wrote the texts, and how and why they were written. Comprehensive analysis of journalism, therefore, includes all elements of the journalistic field, *including* individual journalists. This is important because journalists tend to define the world by making sense of reality, and "the imposition of a definition of the world is in itself an act of mobilization which tends to confirm or transform power relations" (Bourdieu, 2005, p. 39).

This volume situates journalism in its larger systemic environment and stresses that interrelations between fields are not static but changeable and not defined once and for all. The discussion about the role of journalism in shaping a society moves from the notion of journalism as performative discourse to the idea that journalists not only reproduce but also transform power relations in other fields of social and cultural production. This is an important and very useful point for media research because the production of "common ground"—a role the press takes across different media systems—is a far more complex phenomenon than the simple transmission of common sense from a position of power, as some other approaches suggest.

THE AUTONOMY OF THE JOURNALISTIC FIELD

Journalists are agents in the field with some degree of autonomy. They are not explicitly "governed" by either the state, their organization, cultural heritage, or the market, but at the same time they are considered to be working under the influence of all of those factors. To view the journalistic field as a dynamic and open system of constantly changing values and interpretations is to understand that it is linked to a set of forces that seek to shape its content. Shoemaker and Reese (1991) listed five of these forces: individual, routine, organizational, external (institutional) and ideological. These factors are implicitly incorporated into the analogies journalists use in describing the job they are doing: a "window," a "mirror," or a "forum" (McQuail, 2000, p. 66). Journalists may deny that they are subject to external or internal sets of forces or factors, and declare instead that they are driven by "norm factors" to achieve a high level of professional autonomy.

But what is this autonomy? What was it in Serbia, in the story at the beginning of this introduction? What is it in the United States, Denmark, New Zealand or Australia? Hallin (1986) claimed that the journalist's con-

ception of autonomy is a false consciousness, based on the idea that news judgments can be politically neutral. As such, "far from being a mere lie or illusion, it is a deeply held system of consciousness that profoundly affects both the structure of the news organization and the day-to-day practice of journalism" (Hallin, 1986, p. 23). The rise of professional journalism gave journalists grounds to claim their own authority in the sphere in which they communicate primarily to members of their own profession. Although there are conflicts between the journalists and corporations' authority, the trend is toward increased journalistic autonomy. When scholars warn that the line toward autonomy is not a straight one, but "an uncertain and changeable process, in which parts of the field of journalism . . . have sometimes won relative autonomy in relation to other fields, often then losing it again, or sometimes winning it in one direction while they simultaneously lose it in another" (Hallin, 2005, p. 229), they expand the scope of discussion toward the issue of the role of the press in society, and its capacity to create a forum for public debate. The press alerts the public to issues in a way that encourages judgment and makes people start thinking: "the community becomes filled with the public voice" that is heard by those in positions of power, and whose business is "to understand the nature of the public opinion developing around the subject" (Kovach & Rosenstiel, 2001, p. 134).

The journalist's duty to "alert the public" is related to the more universal questions of the role of the media in society, of power and disparity, of social integration and identity, and of social change. That is why journalism (still) matters. Journalism's position as mediator between reality and readers is unlikely to be a neutral process, because "'reality' will always be to some extent selected and constructed and there will be certain consistent biases" (McQuail, 2000, p. 67). Yet the representation, and subsequent interpretation and construction of reality in the news media is very important for the functioning of democracy. The position of journalism in defining issues in public debate, a position of a mediator, prevents the journalistic field from becoming a public sphere in Habermas' (1964) definition of the concept. Although it satisfies the first part of Habermas' definition—the public sphere is "a realm of our social life in which something approaching public opinion can be formed"—it misses the second part: "Access is guaranteed to all citizens. A portion of the public sphere comes into being in every conversation in which private individuals assemble to form a public body" (Habermas, 1964, p. 49). Habermas (1989) argued that party politics and the manipulation of mass media have resulted in a "refeudalization of the public sphere" where representation and appearances outweigh rational debate (p. 162).

The process of giving social meanings to events both assumes and constructs society as a "consensus" where members have access to the same maps of meaning. Hall, Critcher, Jefferson, Clarke, and Roberts (1978) explained that "not only are we all able to manipulate these 'maps of mean-

ing' to understand events, but we have fundamental interests, values and concerns in common, which these maps embody or reflect" (p. 55). Three fundamental areas of the epistemology of journalism that Ekstrom (2002) suggested—a form of knowledge, the production of knowledge, and public acceptance of knowledge claims—correspond with the communication triangle: sender, message, and receiver. When it comes to the form of knowledge, the analysis of a news text identifies what characteristics of knowledge journalism produces; the investigation of the production of knowledge addresses the question of journalistic norms, rules, routines, and procedures; and public acceptance of knowledge claims is related to the conditions that are important in the acceptance or rejection of knowledge claims.

Journalistic text is an "event-oriented form of knowledge" (Ekstrom, 2002, p. 266) and this preoccupation with events, instead of issues or process, for example, means that journalists are on the constant look-out for a particular segment of reality—events that are new, unexpected, and out of the ordinary. Events that are suitable for representation in the news satisfy news values criteria and have one significant universal characteristic: They are appropriate for easy contextualization. The concept of typification (Tuchman, 1973) demonstrates how the efficiency of journalism comes from the fact that meanings are ascribed to certain types of events. If the press release comes from the prime minister's office, it is first classified as a "political event" and consequently covered by the political reporter, although the real topic can, for example, be art (an invitation for an art exhibition that will be opened by the prime minister). Journalism's relationship to classifications, ready-made typifications, means that it reproduces an already "classified" reality, but it also enthusiastically "contributes to producing, reproducing and naturalizing collective conceptions of reality" (Ekstrom, 2002, p. 269).

JOURNALISM AND SOCIETY

The academic debate on contemporary journalism flourishes around its interactions with other fields and questions of growing economic pressures, the globalization of media industries, the influence of technological changes on journalistic protocols, audience apathy, and the pessimism found among journalism professionals. These discussions focus on the question of the future of journalism in a rapidly changing world. The blurring boundaries between the agents of mediated reality, journalists, public relations officers and readers, were highlighted year by year in the "state of the news media reports," Journalism certainly does not have the uncontested centrality in the public sphere it once had (Hallin, 2006); but what *does* it have, and where does it stand in relation to society?

The future of journalism cannot be addressed if there is no answer to the questions of what the past was, and what the present is, of journalism. The following chapters aim to highlight elements of journalism that function as "independent" variables in the constitution of meanings in the public domain.

This volume had its origin at the international symposium, "Form and Style in Journalism and Representation of News: Newspapers and Representation of News," which was held at University of Tasmania, Hobart, in 2006. The symposium was a continuation of a project organized 1 year earlier at the University of Groningen, The Netherlands, on the development of journalism form and style in European newspapers. Focused on newspaper discourse—still the most influential mode of journalism production—the project puts the issue of making sense of reality at the center of the debate about journalism.

The book presents chapters on a range of topics including journalistic style, the national and international context of its operation, its relation to social change, issues of ownership and convergence, tabloidization, the construction of social identities, and the discursive potential of layout. The organization of the book follows the logic of the journalistic field: First, it offers theoretical platforms for investigating the universal features of journalism across time and space (Part I: How the News Makes Sense), moves on to interactions between the field of journalism and surrounding fields (Part II: Journalism and Social Change), and concludes with detailed analyses of the practice itself (Part III: Journalism and Mediation of Reality).

Supported by a number of examples, this volume is directed at an academic as well as general audience interested in journalism and its place in our understanding of the world. Experts in the field of journalism studies explore journalism beyond "journalism," a profession that also transcends its context. Well-illustrated case studies from Australian, New Zealand, and European newspapers support historical, linguistic, sociological, and cultural analyses of the tools, techniques, and rules journalists use to create meaning that interacts with social, cultural, and political contexts. The book invites readers to think critically about the information circulating in the news media, and to explore the position of journalism in society. It moves conventional talk about biased reporting toward an understanding of the ways journalism constructs reality beyond our own experience. The analyses of the reporting of issues such as crime, environmental conflict, grief, and the status of asylum seekers, highlight the multilayered nature of newspaper text and the complexity of its diverse readings, calling on news makers to reflect on their own practice.

The book serves as an academic text addressing three interrelated problems in the study of journalism: the absence of a framework for conceptualizing journalism across time and space, the reluctance to overcome the artificial division between theory and practice, and the lack of models for examining journalism as an "independent" discursive practice.

Drawing together a range of theoretical and methodological approaches, *Journalism and Meaning-Making* creates a platform for studying journalism as an academic discipline. The fundamental questions of journalism studies—such as "What do we study when we think about journalism?"— are still marginalized in an environment where the main characteristics of the discipline are a deep fragmentation of its lines of inquiry, and a scholarship emerging more from journal articles than from academic books. The book aims to fill this gap by presenting a number of models for investigating different aspects of journalism in their historical and cultural contexts. The diversity of issues and approaches provides a set of suitable frameworks for conceptualizing journalism both in teaching and in research.

REFERENCES

Blumer, H. (1969). *Symbolic interactionism: Perspective and method.* Englewood Cliffs, NJ: Prentice-Hall.

Bourdieu, P. (2002). *Outline of a theory of practice.* Cambridge, UK: Cambridge University Press.

Bourdieu, P. (2005). The political field, the social science field, and the journalistic field. In R. Benson & E. Neveu (Eds.), *Bourdieu and the journalistic field* (pp. 29-48). Cambridge: Polity Press.

Breed, W. (1955). Social control in the newsroom: A functionalist analysis. *Social Forces, 33*, 326-355.

Ekstrom, M. (2002). Epistemologies of TV journalism: A theoretical framework. *Journalism, 3*(3), 259-282.

Habermas, J. (1964). The public sphere: An encyclopedia article. *New German Critique, 1*(4), 49-55.

Habermas, J. (1989). *The structural transformation of the public sphere: An inquiry into a category of bourgeois society.* Cambridge, MA: MIT Press.

Hall, S., Critcher, C., Jefferson, T., Clarke, J., & Roberts, B. (1978). *Policing the crisis.* London: McMillan.

Hallin, D. (1986). *The "uncensored war": The media and Vietnam.* New York: Oxford University Press.

Hallin, D. (2005). Field theory, differentiation theory, and comparative media research. In R. Benson & E. Neveu (Eds.), *Bourdieu and the journalistic field* (pp. 224-244). Cambridge, UK: Polity Press.

Hallin, D. (2006). The passing of the "high Modernism" of American journalism revisited. *Political Communication Report, 16*(1). Retrieved May 5, 2006, from http://www.mtsu.edu/~pcr/1601_2005_winter/roundtable_intro.htmt.

Kovach, B., & Rosenstiel, T. (2001). *The elements of journalism: What newspeople should know and the public should expect.* New York: Crown.

McQuail, D. (2000). *Mass communication theory.* London: Sage.

Shoemaker, P., & Reese, S. (1991). *Mediating the message: Theories of influences on mass media content.* White Plains, NY: Longman.

Tuchman, G. (1973). Making news by doing work: Routinizing the unexpected. *The American Journal of Sociology, 79*(1), 110-131.

White, D. M. (1950). The gatekeeper: A case study in the selection of news. *Journalism Quarterly, 27*, 282-290.

Zelizer, B. (2004). *Taking journalism seriously: News and the academia.* Thousand Oaks, CA: Sage.

PART I

HOW THE NEWS MAKES SENSE

Each day the content of a newspaper differs, but readers recognize its design, its way of writing, and its effort to provide a valid representation of the social world. The shared social code between journalists and the public is fundamental for understanding how the news makes sense. In other words, how does this social code develop, how does journalism becomes socially and historically embedded in the news text, and how can we interpret journalism as a meaning-making practice?

Three contributors explore this issue by making a critical overview of the dominant paradigms in journalism studies and offering new models for investigating the ways in which journalists and news audiences construct the meaning of the reality.

In Chapter 1, Marcel Broersma suggests approaching journalism as a performative discourse. He argues that journalists' claims to truthfulness hold the key to public trust. What makes people believe that a newspaper's representation of issues and events is valid is not only the content of news — as it is usually assumed — but the occupational tools of "form" and "style." Broersma claims that journalism, although staged and incomplete by nature, has the power to transcend the news because it provides the form in which news becomes visible. Using the example of the appearance of an interview, and the tension over the style between Anglo-American and European journalism, he develops a new framework for looking at journalism's mediation of reality and its interaction with the public sphere across national boundaries and in different historical contexts.

Inc Chapter 2, Donald Matheson makes a sharp critique of the narrative theory of news, to highlight the complex role of journalism in the circulation of knowledge within society. Arguing that attempts to understand news text only as narrative miss a number of elements, he specifies that news text is "a moment of the real," epistemologically distinct, always potentially a narrative but not constructed as one. The more a journalist takes readers into a narrative space, the more he or she takes them out of reality, says Matheson, demonstrating why the genre of the news must be understood in its own terms.

Svennik Høyer (Chap. 3) critically examines the idea that general conditions under which journalism operates linearly determine journalism practice, as many journalism histories try to prove. Interested in journalism change—an innovation and adaptation of genres and styles—Høyer offers a model for a holistic and systematic approach in the study of journalism. Høyer's invitation to compare journalism histories is based on a firm belief that it is first necessary to make cross-national comparisons, in order to better interpret, at a national level, the interface between journalism and its context.

1

JOURNALISM AS PERFORMATIVE DISCOURSE

The Importance of Form and Style in Journalism

Marcel Broersma

University of Groningen

Until April 2004 most people in the Western world had probably never heard of a place in Iraq called Abu Ghraib. CBS's *60 MINUTES 2* (2004) then exposed the torture and sexual humiliation of prisoners by U.S. military forces running the prison. CBS showed photographs of naked Iraqis in humiliating poses and grinning U.S. soldiers beside them to prove to the public that such misconduct had really taken place. The report ended with an army spokesman expressing regrets about the events and claiming that these were isolated incidents carried out by a few immoral and undisciplined soldiers. Two days later Seymour M. Hersh published a story in *The New Yorker* that revealed the existence of a secret military report by general Antonio M. Taguba, that described in detail the misconduct at Abu Ghraib. In a series of three articles over the next few weeks, Hersh (2004a, 2004b, 2004c, 2005) claimed that these practices of torture were part of an orchestrated attempt by the Pentagon to obtain intelligence in violation of the rules of war. The shocking photographs and news reports caused a general public outcry in the United States and throughout the rest of the world.

The coverage of the Abu Ghraib story draws attention to the performative power of journalism. Why do news consumers consider these kinds of reports convincing? They cannot know exactly what happened in the Abu Ghraib prison and they certainly cannot know if the Bush administration approved, or orchestrated these events. Viewers have to believe the representations of events provided by journalists such as Hersh or CBS's Dan Rather for their perceptions, which they do. Journalism is remarkably successful in

getting people to believe that it reports 'the truth.' This is why the public is so shocked when the news turns out to be 'fake.' As an example, take the case of the Janet Cook scandal which, in 1982, confronted journalism with its extremes, shortly after the triumph of the Watergate reports of the *Washington Post*. Cook authored a report about an eight-year-old heroin user and received a Pulitzer prize for the story, however, the boy turned out to be a fabrication. Not surprisingly, readers felt deceived and the young reporter was shunned by fellow journalists (Easton, 1986). Similarly, Dan Rather had to resign a few months after the Abu Ghraib scoop when the documents used by *60 MINUTES* to claim that then President Bush had evaded military service turned out to be false.

Journalism's claim to truthfulness and reliability is crucial for its existence. It is the basis of a shared social code between journalists and their public. In scholarship, however, after both the cultural and linguistic turns, the idea that media provide a daily mirror is no longer generally accepted (cf. Fowler, 1991). News does not neutrally reflect social reality or empirical facts at all. It is a social construction. Events and facts do not have 'intrinsic importance' but become important because they are selected by journalists who adhere to a culturally and ideologically determined set of selection criteria. After this first selection filter, social reality is transformed once again to fit into media formats that give it shape. As Habermas (1990) stated: 'communication is a symbolic process whereby reality is produced, maintained, repaired and transformed' (p. 23). By representing the world in language, journalists construct meaning upon which the public can act.

In this chapter I argue that journalism is a discourse that is first and foremost characterized by its *performative* nature. I will use the coverage of the incidents at Abu Ghraib to illustrate this. Most studies in media scholarship use the paradigm of Anglo-American journalism which is fact-centered, advocates objectivity and focuses on news. By doing so scholars have reduced journalism to *news* discourse (Hartley, 1982; van Dijk, 1988). However, news is merely one manifestation of journalistic discourse. A newspaper is more than its news section. Readers' perceptions of the social world are determined by the complete, interconnected content, style, and form of a paper. In addition, the ideology of a paper is recognizable throughout its departments, perhaps even more obviously in the non-news sections. Therefore it makes sense to look at journalism as an integral discourse instead of only focusing on news.

Furthermore, I argue that journalism derives its performative power from the forms and style employed and will demonstrate this by introducing a classification of styles. Journalism aims to impose and legitimize valid representations of the social world by the choice of form and stylistic devices. By way of conclusion, I will argue that the work of French sociologist Pierre Bourdieu offers a promising framework with which to analyze the performative power of journalism.

JOURNALISM AND PERFORMATIVITY

The notion of performativity has two interlinked connotations. First, that of *(re-)staging*; retelling events and by doing so putting meaning on events. On a daily basis journalism has to convince its public that what is written or broadcast actually happened in 'real' life. However, journalism attempts to construct meaning and is by definition incomplete and not authentic at all. To overcome this paradox and to make stories as convincing as possible journalism as a cultural form has developed a twofold strategy. On the one hand it tries to hide its shortcomings or inadequacies. It presents 'facts' as natural, generally implicitly, but also sometimes explicitly. "The photographs tell it all," Hersh (2004a, p. 43) states, for example, before beginning to describe the pictures of the torture at Abu Ghraib. Journalism also uses specific forms that aim to prove an article is truthful. For example, an interview, that is structured around questions and answers, suggests both a mimetic representation of a conversation and an actual chronology and temporality. It wants readers to forget that it is an interpretation of a conversation (Broersma, 2008). In addition, news and information are framed by media. Journalists use frames such as 'organizing principles that are socially shared and persistent over time, that work symbolically to meaningfully structure the social world' (Reese, 2003, p. 11). They organize and simplify complex events and issues in order to make sense of them. To be performative these hidden structures of representation appeal to cultural codes and the existing knowledge of the public.

On the other hand, to ensure the effect of authenticity and truthfulness, journalistic texts rely on a set of professional practices, routines and textual conventions that were developed during the 20th century to guarantee that this process of construction or representation is as accurate—or mimetic—as possible. Journalists give accounts of journalistic processes in their articles. Hersh (2004a, p. 43), for example, used documents from reliable sources such as the Taguba report: "A fifty-three-page report, obtained by the *New Yorker*, written by Major General Antonio M. Taguba and not meant for public release, was completed in late February. Its conclusions about the institutional failures of the Army prison system were devastating," Hersh states. Information is attributed and multiple sources, preferably eyewitnesses, are quoted. "One of the witnesses, specialist Matthew Wisdom, an M.P., told the courtroom what happened when he and other soldiers delivered seven prisoners . . ." (p. 44). The reliability of sources must be double-checked, and reporting balanced—both sides must be heard—as CBS attempts by asking the U.S. army to comment.

An article is a convincing representation when it successfully establishes a feeling of truthfulness. By doing so it transforms an interpretation into truth—into a reality on which the public can act. That brings us to the second connotation of performativity, which emphasizes that linguistic repre-

sentations have the power to describe and produce phenomena at the same time. They are, in other words, self-fulfilling prophecies. Scholars of linguistics such as J.L. Austin (1975) developed speech act theory, which argued that "performative utterances" are ways of acting through language. The utterance 'I now declare you man and wife' in a marriage ceremony, for example, is not just a description of what is happening, but a ritual act through which the marriage is actually established—or declared true. Austin suggested that performatives had to be valued on the basis of their success and not according to their relation to a fixed reality. Did these speech acts achieve what they intended? Are they convincing? Austin's book has the elegant title, *How to Do Things with Words*, and mainly focuses on the use of performatives in personal communication.

Bourdieu (1991) praised speech act theory for "calling attention to the social conditions of communication" (p. 9). Even more than Austin, he stressed the importance of analyzing texts in their social context rather than in purely linguistic terms. Performative utterances are after all only considered true when the person who utters them is authorized to do so and their authority is recognized by others: "Legitimate competence is the statutorily recognized capacity of an authorized person—an 'authority'—to use, on formal occasions, the legitimate (that is, formal) language, the authorized, authoritative language, speech that is accredited, worthy of being believed, or, in a word, *performative*, claiming (with the greatest chance of success) to be effective" (pp. 69–70). Its institutional context and social conventions determine if a speech act 'works.' According to Bourdieu (1991), communication is not just an exchange of information or opinions, but primarily the exercise of symbolic power.

Bourdieu and notably John R. Searle shifted "the apparent focus of Austin from a few rather specialized speech situations to a recognition of the performative nature of language in general." They emphasized the intentions of the producer and the effects on the public, and they focused on the social context (Carlson, p. 63). Scholarship on media, identity and performativity has especially focused on regional, gendered or queer discourses (Butler, 1990, 1997; Bourdieu, 1991). I argue that journalism in its entirety, as a specific discourse among other communicative discourses, has a performative nature. During the 19th century, journalism successfully developed an ideology which emphasized its indispensability to democracy: journalism as the fourth estate. It claimed the right to control other powers in society because it was authorized by citizens to do so. To legitimize this authority as well as its representations of social reality, journalism developed a specific discourse. However, I argue that though the basic assumptions of this discourse, such as truthfulness and authenticity, are generally accepted, its stylistic features differ depending on the historical and cultural context of journalistic practice.

Moreover, I consider the notion of *performative discourse* to clarify journalism studies because it draws attention to both the news item (the text or

radio or television story) and the context in which a journalistic story is produced. By doing so it links up discourse studies to Bourdieu's field theory. The authority of a news item is established through the way it is represented in language, the reputation of the journalist, the medium the item is published or presented in and the profession as a whole. When Hersh, for example, was asked why people should believe his articles, which were based on anonymous sources, he replied, referring to what Bourdieu would have called the reporter's and the magazine's cultural capital: "Yes, you have to trust *The New Yorker* and me. However, we have built up a track record in the past decades and we deserve some credit for that" (Arbouw, 2007; my translation). The textual structure of a news item—its form and style—represents the authority that stems from its social configuration. It "manifests and symbolizes" the credibility of the profession and its cultural codes (Bourdieu, 1991, p. 109).

Performative power is essential for journalism's status and position in society. Every day journalism stages the social world in language. Every day its authority has to be reconfirmed. Millions of people take part in this large-scale ritual of meaning-making undertaken by the media. For them it is not the material, "real" world that guides their opinions but the representations of the social world in the media. The occurrence of particular events is only apparent to a broader public when they become part of journalistic discourse. This "media reality" has performative power. It determines what citizens think about and how they act, and it shapes public debate.

The events following the publication of the Abu Ghraib pictures, and the ensuing stories, illustrates this social process. As Bennett, Lawrence and Livingston (2006, 2007) have shown, the media initially framed the events as torture and as a manifestation of new intelligence tactics in the War on Terror. As a result, public approval of the American intervention in Iraq dropped sharply in the United States. However, in the ensuing months the Bush administration succeeded in downplaying the events by framing them as regrettable though isolated instances of abuse. Although Hersh and other reporters had considerable evidence to refute these claims by the government, the mainstream media did not counterframe the events as systematic and orchestrated torture. As a result, public debate was only rekindled when influential politicians led by Senator John McCain in late 2005 started to question the Bush administration and its policy of torture as a means of conducting the War on Terror.

FORM AND STYLE AS RESEARCH CATEGORIES

At first glance one might say that the content of a news item determines its performative power and that form and style merely carry content—an article is considered true when it is factually true. However, as I have argued

above, events are in most cases multi-interpretable and not verifiable by the
public or even the actual journalist. People are not able to determine
whether journalistic articles are true, but will consider them true because
they seem plausible when based on existing public knowledge and cultural
codes. In other words, news is true because the journalist successfully argues
it to be true. Of course, I do not want to imply that the material, social world
is of no importance at all. However, when the claims of one article are refut-
ed by another which declares that it has found new sources or facts, these
new claims for their part are also judged by their persuasive force.

This implies that the performative power of a text not only lies in its
content but chiefly in its form and style—that is, in the expression of pro-
fessional routines and conventions that justify, and mask, the subjective
interpretation and news selection of the individual journalist. Since news
consumers are accustomed to the principles of form and style, they tend to
believe the content which comes with them. To take an example which is as
well-known as it is extreme: why did so many Americans on the East Coast
in 1938 believe that the events being portrayed in Orson Welles' radio play
The War of the Worlds were really happening? They should at least have
considered that the newsflashes stating that Martians were invading the
Earth were unlikely to be true. However, since these fictional events were
announced in news bulletins which were identical in form and style to those
the public was used to hearing every day on the same prominent radio sta-
tion, listeners believed the coverage.

While the content of an article is unique and incidental, form and style
are more universal and refer to broader cultural discourses as well as accept-
ed and widely used news conventions and routines. They ensure the ritual
function of news. The content of a paper differs day to day, but readers will
recognize its design, its writing style and its ideological background. This
familiarity generates confidence and credibility (Broersma, 2007a, pp. ix–xi).
Conventions concerning form and style are therefore essential to make peo-
ple believe that a newspaper's representation of the social world is valid.
They determine which stories are told and how they are told, and by doing
so they determine how we experience the world. As Michael Schudson
(1995) has put it: 'the power of media lies not only (and not even primarily)
in its power to declare things to be true, but in its power to provide the forms
in which the declarations appear' (p. 109). Form and style are important cat-
egories in ensuring journalism's claim to authenticity and veracity because
they embody the social code connecting journalists and their public.

The status and prestige of journalists depends on the performative
power of their stories. To retain and strengthen their social position journal-
ists employ stylistic innovations and 'invent' new forms without greatly
challenging professional rules. The introduction and development of news
forms is constrained by technological and economic conditions, but these
processes are primarily determined by sociocultural factors. To make their

representations of the social world performative journalists have to embed them in the cultural codes of their own society. In this dialectical process, journalism tries to reach a more autonomous position in society as well as fulfilling consumers' needs. As Barnhurst (1994) writes, journalism has to balance "authority with popular appeal"—the style of a newspaper and the forms it uses are guided by "those opposing poles" (p. 172). The use of journalistic forms reveals what is tolerable to the public. It reflects the boundaries of the public sphere.

Form refers to the level of textual conventions that structure the presentation of news in the broadest sense. As Barnhurst and Nerone (2001) stated: "*form* is everything a newspaper does to present the look of the news." It provides a newspaper with a "visible structure" (p. 3). Even more importantly, however, the form of the news offers ritual confirmation of the existence of the professional discourse that journalism developed in the late 19th century. Instead of merely transmitting public speeches and texts—by printing verbatim records of parliamentary proceedings or chronological mimetic accounts of speeches, for example—journalists started to frame this information in a professional discourse. They developed specific conventionalized forms that articulated the new routines they used. By doing so, reporters no longer simply relied on public knowledge, but asserted a knowledge of their own. These new forms made it possible to interpret the social and political meaning of statements, texts and actions. The editor evolved from a collector who merely presented what had been found, into an interpreter who reordered and rewrote fragments of information into larger narratives (Chalaby, 1998; Matheson, 2000; Schudson, 1995).

Form can be analyzed into three subcategories that cover structure, design and genre. The length of news items, for instance, reveals ideological and strategic choices. The space required by an item represents the importance editors attach to it, while the way a story is structured—linear or nonlinear, chronologically, by applying the conventions of the inverted pyramid, merely narrative or discursive, polemic or factual—stresses the interpretation of social reality that is voiced in a newspaper. The use of rhetorical devices does the same. In a study of the Serbian daily newspaper *Politika*, Rupar (2007) showed, for example, that the paper published more about politics on its front page when the political situation in the Balkans was insecure. However, stories were fragmented, with a large number of items in a loose hierarchy. News facts were not interpreted, with the readers instead only being provided with several versions of a particular event. The paper reinforced this strategy by using longer headlines, which again provided just a description of the event with no journalistic interpretation.

Newspaper design is the most captivating expression of form. Design determines the face of a newspaper. Through its arrangement of articles, departmentalization, typography and use of graphic elements such as photos, drawings and charts, the number and the size of articles and headlines,

a newspaper expresses how it wants to be read. Barnhurst and Nerone (2001) argued successfully that newspaper design embodies ideological positions about the social world. "The form includes the way the medium imagines itself to be and to act. In its physical arrangement, structure, and format, a newspaper reiterates an ideal for itself" (p. 3).

The ideological transformation of journalism is traceable in newspaper design. Elsewhere (Broersma, 2007b) I have argued how Dutch newspapers, before World War II, opposed Anglo-American news design. They feared that newspapers would become sensationalist and market-oriented if they took news value as the most important selection criterion. The use of visual tools such as headlines, typographical cues and photographs to make newspapers more comprehensible was despised as cultural degeneration. Dutch newspapers aimed to educate their readers, as well as express and reflect political or other opinions. They were organized into departments, combining a geographical and thematic classification of reality. Foreign, Home and Local sections were followed by Art, Finance and Economic News, and so on. Papers expected their readers to read the complete paper from the first sentence on the front page to the last sentence on the back page.

As a third category apart from structure and design, genres are textual forms, or patterns, that organize a story. They transcend individual articles and can be used to categorize them. There is an important difference between the notion of genre in Anglo-American journalism and European journalism. The first is centered around beats and practices: crime reporting or show business reporting, for example, are considered genres. In Europe, genre is interpreted as the character and organization of the text. An interview, for example, can be about a criminal, a sportsperson, or whomever, but it always contains the representation of a conversation and it is always structured according to the same genre conventions. Professional education and reporting are centered along these lines: journalists learn these conventions and then apply them in an interview or a feature, a situationer, a news analysis or a background article.

In other words, journalists write their stories according to culturally determined genre conventions and are aware readers are familiar with these. As such, genres represent an unspoken agreement between the journalist and the reader about what to expect. They structure the public's reception of information, making it possible for them to understand what is meant by the author. Genres help people to make sense of texts. However, genre conventions also influence what is included in or excluded from a story. A journalist who chooses to publish an interview as a monologue of the interviewee cannot include any background information that is not voiced by the interviewee. Alternatively, a hard news story will not contain comments by the author. Picking a genre implies a choice about the way in which a subject is represented in the newspaper.

Journalism uses forms to articulate different styles of reporting. Where form operates at the textual level, style is connected to the sociocultural context of journalism. It refers to both the level of practice and the level of routines, that is, cultural values that are commonly shared by groups of journalists and that underlie their practices. In scholarship, as well as in popular speech, style is often interpreted in terms of the personal qualities of individual journalists and "the aesthetics of language." This is, for example, voiced in the well-known aphorism: *le style c'est l'homme*. However, style is to a large extent not a personal quality of an individual journalist but a marker of sociocultural context and group identity.

When journalism became a distinct occupation, practices, routines and conventions that facilitated quick and reliable production were standardized. Writing had increasingly less to do with personal genius or literary talents but instead became an almost industrial process—"a skill anyone could learn" (Roggenkamp, 2005, p. 126). Through education and socialization in the newsroom journalists all relate to a shared set of rules that structure their stories. In many cases, these rules are even formalized in style guides. Style expresses ideological points of view about what journalism is, or what it should be to a certain group—what news is and how a journalist should act. Moreover, it articulates how the medium wants to be seen and how it wants its readers to experience social reality.

Style can be defined as "the choice between functional equivalents of language." As Bell said, "a 'that way' which could have been chosen instead of a 'this way' . . . and these different ways of speaking can carry different social meanings" (quoted in Mattheson, 2000, p. 560). However, as van Dijk (1988) argued—and I agree—a broader definition is possible and desirable. Van Dijk introduced the term *thematic style* which indicates that the choice of a particular topic is also a marker of style. In his definition, style is "the total set of characteristics, variable structural features of discourse that are an indication of the personal and social context of the speaker, given a semantic, pragmatic, or situational invariant" (p. 73). Within the various styles of journalism there are differing institutionalized rules of the game, or routines. These determine the selection of certain topics and what is included in and excluded from stories. Routines offer the ideological framework that structures the process of gathering, selecting and presenting news. Because they represent the ideological framework of a journalistic style and restrict a journalist's freedom of action, routines are much contested and defended by those actors in the journalistic field who want to retain or strengthen their positions. Routines are constantly at stake.

During the 20th century, journalism developed from a mainly partisan institution into an independent profession that emphasized its task as the fourth branch of government. I suggest that this ideological transformation of journalism expressed itself in stylistic changes and the "invention" of new

journalistic forms. To identify these journalistic ideologies and to offer a framework for the analysis of journalism, clarity is gained by distinguishing between three styles of journalistic discourse. I will first make a distinction between the reflective style and the news style. The latter can then be divided into the information model and the story model. To sharpen my argument I will link these styles to the three models of journalism discerned by Schudson (1999): the advocacy model, the trustee model and the market model, respectively. Because styles of journalistic discourse derive their performative power from their sociocultural context, they must link up with the expectations of news consumers to be persuasive. A model that distinguishes between different styles can be helpful in the analysis of the media landscape as a dynamic field of relations. Political, social or cultural transformations might lead to style changes that are articulated through the use of different forms.

The model presented aims to overcome the teleological perspective that dominates the study of media history. In this research tradition, the development of journalism and the press is interpreted as being predetermined by pre-eminently Anglo-American notions such as objectivity, balance, impartiality, and the distinction between facts and opinions. In this approach, the history of the press is a history of the struggle for press freedom. The focus on Anglo-American journalism has prevented serious analysis of other styles and forms—because in this approach these do not belong to the domain of *journalism*. Too often they are interpreted as just a necessary stage in the development of journalism as an "independent" profession. They are seen as a backward though necessary step towards 'modernization.' By contrast I argue that various styles can exist alongside each other in a single country—and at some transitional moments even in one medium—though usually one of them will dominate at a certain time in history. Therefore, this classification of styles does not represent a historical development or a strict periodization.

A CLASSIFICATION OF STYLES

The reflective style is first and foremost discursive. It has its roots in partisan journalism that wanted to educate, instruct and persuade readers of certain political or sociocultural positions. In this partisan approach the journalistic field has no autonomous position, on the contrary, it is closely connected to the fields of politics and literature. Journalists intentionally tell readers what they need to know from the standpoint of a political party or a social movement. The organizing principle of this kind of journalism is "the mediating subjectivity of the journalist," as Chalaby (1996) said in a comparison of French and Anglo-American journalism. "Journalists did not

only wrap information into their own observations but constructed their articles according to their interpretation of the related events, thus mediating between readers and reality" (p. 312). Reporting news is considered of less importance than judging the social world from political and sociocultural standpoints. Views rather than news is the credo of the reflective style.

This style derives its performative power from the use of genres reflecting on news facts instead of news reporting itself. It is centered around opinions and analysis. Editorials or background articles, for example, describe, explain and analyze events and comment on the news. In this style, reporters were held in low esteem. At least until World War II, they were despised as clerks who merely recorded events or what other people had said. Professional journalists considered themselves more literary artists or intellectuals than craftsmen. The great men of journalism wrote political commentaries and analytical essays. True journalists expressed their vision of the world in measured words and a superb literary style—they added *intelligence raisonnée* to the facts.

While the reflective style was organized around opinions, the news style that emerged in the United States after the 1830s derived its performative power from its factuality. According to Høyer and Pöttker (2005) "new American journalism" introduced five new elements to journalism. *News value* instead of political bias became the key principle of news selection. The increased speed of news supply that was triggered by the introduction of the telegraph caused the emergence of a *24 hour news cycle*. For an event to be newsworthy it must have occurred since the paper's last publication. The *news interview* became the most important tool for reporters, allowing them to gather fast and reliable information. Stories were structured by using the *inverted pyramid* formula and contained a summary lead. Finally, *objectivity* became the moral norm for reporting.

The emergence of the Anglo-American news style (Høyer, 2007; Williams, 2007) had much to do with the rise of a commercial press and a highly competitive market. This kind of journalism could only appear in democratic societies with no juridical or financial impediments. In the 1830s the U.S. press grew into a press for the masses. The spread of literacy and technological innovations in newsprint production, printing and distribution created profitable market conditions, whereas the growth of mass democracy, urbanization and the rise of a consumer society increased the demand for the news. Editors leapt to fill the needs of the "democratic market society" that had emerged (Schudson, 1978). While they were reaching for a mass market they were encouraged to take a non-partisan though not necessarily neutral stand in the race to increase their readership. The news style aimed to blur the boundaries of the public sphere in order to reach a more autonomous position in society as well as fulfill consumers' needs. Scoops and disclosures "sold," and also strengthened journalism's reputation as an independent social force.

To distinguish itself from the political and the literary fields, Anglo-American journalism concentrated on facts and information, and presented itself as a neutral and independent guardian of the public interest. In the United States, objectivity was firmly established as a leading norm in the 1920s (Schudson, 2001), with journalism affiliating itself with the rising public demand for facts as a basis for rational choices and actions. This need was stimulated by scientific progress and changes in the political culture that transformed voting from a partisan activity to a rational act. Furthermore, journalism, as an emerging profession, needed to distinguish itself from propaganda and the public relations industry. Additionally, the objectivity norm provided rules for the craft, making it easier for editors to discipline reporters, compelling them to conform to the industrial patterns of mass newspaper production. A single news format emerged which turned reporters into "machines, without prejudice, colour, and without style" of their own (Matheson, 2000, p. 565).

The news style can be used in either a story model or an information model. This distinction results from the ambiguous character of Anglo-American journalism which embodies the "journalism of action" employed by the yellow press, as well as the detached and impartial style of the quality papers (Campbell, 2006). As Williams (2007) stressed, Anglo-American journalism should be understood as "an eternal debate about expansion of mass culture and the deep seated ideological divisions between satisfying public wants and educating and improving the public taste" (p. 25).

The story model has a primarily narrative character. Newspapers that stress their storytelling function want to create for their readers "satisfying aesthetic experiences which help them to interpret their own lives and to relate them to the nation, town, or class to which they belong" (Schudson, 1978, p. 89). They follow the market and try to fulfill their readers' wants. Usually such newspapers are labeled popular or sensational. This style is emotive and aims to appeal to readers at this level (Broersma, 1999). The information model is just like the reflective style in being primarily discursive—that is, descriptive, explanatory, and involving argumentation. However, unlike the reflective model, papers conforming to the information model primarily want to inform and therefore favor the rational, positivist ideals of objectivity, balance, fairness and neutrality. Journalists consider themselves professionals who "provide news they believe citizens should have to be informed participants in democracy" (Schudson, 1999, p. 119). Generally, newspapers that operate in this trustee model are labeled quality papers. They use a restrained and detached style that, rather than reach for the hearts of their readers, tries to appeal to their minds (Broersma, 1999). The trustee model embodies the professional ideology that presently dominates journalism.

The Diffusion of Anglo-American Journalism

After the 1890s, the Anglo-American news style spread across Europe and the rest of the world. This process of diffusion required two preconditions: a substantial market for newspapers and a democratic political system. This is why diffusion progressed along the lines of the three media systems distinguished by Hallin and Mancini (2004). The North Atlantic or liberal model is characterized by the early development of a mass circulation press, the early professionalization of journalism, and its neutral and commercial character. It is market oriented, with the state removing legal impediments comparatively early in the 19th century. The United States, Canada, and Great Britain are included in this model.

In the Old World, Great Britain was fertile ground for the "new American journalism," as it was called. With hindsight, it can be said that while the news style has been dubbed "Anglo-American," British journalism had much in common with European journalism. Initially, the British press was just as reluctant to accept the American news style as the Continental newspapers. Schudson (2001) strikingly characterized British journalism as "a kind of a half-way house between American professionalism and continental traditions of party-governed journalism with high literary aspirations" (p. 167). British new journalism of the 1880s aimed to make newspapers more readable but strongly emphasized the role of the press as the Fourth Estate (Wiener, 1988).

Newspapers adhering to the northern European or democratic corporatist model were even more hesitant about what they called "Americanization." Germany, Austria, Switzerland, the Netherlands, Belgium, and the Scandinavian countries exhibited the characteristics of this model. They traditionally had a strong party press, which was opinion-based and noncommercial. Moreover, there was severe state intervention in the press. Close connections between newspapers and political parties or social movements, and strict press control by the government curbed the speed of commercialization and the rise of a mass circulation press. The Anglo-American news style and its practices were, as we have seen, closely connected to professionalization and commercialization.

Greece, Portugal, Italy, Spain and France can be included in the Mediterranean or polarized pluralist model, although France is a borderline case as it also displays characteristics of the democratic corporatist model. Newspaper circulation was low in these countries—their economies were underdeveloped, and journalism had strong political roots and weaker professional standards. There was also strong state intervention, which hindered the rise of a commercial press for much longer than in other areas. Newspapers in countries fitting this model were the most unwilling to adopt the Anglo-American news style.

Journalists and the elite in most European countries distrusted Americanization (Broersma, 1999; Requate, 2004). In a broader discourse of cultural pessimism it was seen as a degeneration and as a terrifying consequence of modernization. In Europe, articles were preferably written as essays, in contrast to the concise American news reports that used summary leads containing the most important news facts (the inverted pyramid). Because American journalism was fact-centered, it was considered stylishly poor and unattractive. Emile Zola, for example, wrote in 1894 that it was regrettable that "the uncontrolled flow of information pushed to the extreme . . . has transformed journalism, killed the great articles of discussion, killed literary critique, and increasingly gives more importance to news dispatches, trivial news, and to articles of reporters and interviewers" (cited in Chalaby, 1996, p. 309).

Those journalists working in the reflective style showed strong cultural resistance to Anglo-American journalism. Their arguments focused on the story model and paid little or no attention to the information model. By doing so they were able to proscribe the latter's emphasis on the spectacular and sensational, and its appeal to the emotions. Its links to commercialization and sensationalism were both to be rejected. Opinion leaders thought the introduction of American practices and conventions would cause social upheaval and were afraid that the standards of journalism would drop if the American focus on news was adopted. Interviewing, for example, was viewed as a "monstrous departure from the dignity and propriety of journalism" (Silvester, 1993, p. 7).

However, these journalistic innovations seemed to offer a formula for reaching the masses. In most cases, one newspaper, or a small number, took the lead in this process of so-called "Americanization." Press barons such as Lord Northcliffe in Great Britain, Henrik Cavling in Denmark, and Hak Holdert in the Netherlands considered the news style to be a promising tool to attract new readers. Journalists and the general public were ambivalent, as a French commentator observed: "The taste for the short and sharp, unadulterated news item is Anglo-American. It appeals to French taste but does not completely satisfy it" (as cited in Albert, 1972, p. 278). Nonetheless, in the course of the 20th century, journalism in all European countries adopted the new practices, routines, and conventions. They were adapted, moderated, and transformed within the confines of the bourgeois and political press—a process that took decades and which was only completed in the years after World War II. It started in Great Britain, then took off in the northern European countries before finally reaching the Mediterranean. The journalism we are familiar with today has even been described as an "Anglo-American invention" (Chalaby, 1998).

The extent to which the reflective style disappeared from the media landscape differs from region to region. In most southern European countries many characteristics of the reflective style are still present. For

instance, the French news media are still very opinionated, mixing facts and opinions, and they still reject an "objective," informative style of practicing journalism (Benson, 2002). In 2002, the editor-in-chief of the leading daily *Le Monde* still had to promote the Anglo-American news style to his reporters:

> A journalist at *Le Monde* should always ask himself what happened fac-tually (what, who, where, when, how?) before worrying about what to think of it intellectually. He must force himself to tell before judging, explain before commenting upon, demonstrate before condemning. To accept, day in day out, proof of the facts, is to admit that they are not immediately reducible to a single, unique explanatory scheme of which journalists in general and those at *Le Monde* in particular would be the favoured guardians. (as cited in Benson, 2002, p. 67)

The French media neither welcomed nor rejected American news practices, but adapted them into the reflective style: "from this original combination was born the French version of modern journalism" (Benson, 2002, p. 53).

Today, the reflective style still dominates journalism in countries in Africa and Asia, but in the Western world it is despised as a hangover from the days when journalism was closely connected to politics. Professional journalists cherish their hard-won freedom. Although the news style is gen-erally accepted, the dichotomy between the information and the story mod-els is still very present in the public debate on journalism. With the rise of commercial television and the decline of circulation, newspapers now tend to convert themselves from the information model to the story model. This results in complaints about infotainment and sensationalism. Furthermore, the rise of the Internet and 'new' digital media raises questions about the paradigms of journalism. The boundaries of the journalistic field are becom-ing increasingly blurred; every citizen can be a reporter and a media entre-preneur today. Those new "journalists" do not care about norms such as objectivity, neutrality and balance. They tend to use the reflective style, mix-ing facts and opinions, and they are openly partisan. Ironically, for profes-sional journalists, the postmodern citizen seems to like this style and it seems to fulfill present-day public needs. This might even lead to a revival of the reflective style in the mainstream media.

Style, Distinction and Autonomy

As a performative discourse, journalism has to appeal to broader cultural values that differ in time and place. To strengthen its performative power, it uses a particular style and textual forms. Therefore, journalism studies

should link texts to their context. In this respect Bourdieu's notion of *field* offers a useful complement to discourse analysis which tends to focus on texts. Field theory can illuminate how "external forces are translated into the semi-autonomous logic" of journalism (Benson, 1999, p. 479). According to Bourdieu, society is divided into multiple, semi-autonomous or autonomous fields. He defined a field as "a field of forces within which the agents occupy positions that statistically determine the positions they take with respect to the field, these position-takings being aimed either at conserving or transforming the structure of relations of forces that is constitutive of the field" (Bourdieu, 2005, p. 30). A field is an arena of conflict in which the actors strive for power. In addition, the various fields in society (politics, journalism, literature, academia and so on), which all belong to the general field of power, also strive for autonomy from each other. Fields are also interrelated. For example, politicians and journalists meet each other regularly. They have an interdependent relationship as they need each other to obtain either positive publicity or news, respectively. In this daily fight, they both strive for the power to control public discourse.

The position of the media in society rests on its ability to represent the social world to a broader public. In my opinion, journalism should therefore be studied as a continuous contestation of the boundaries between the public and the private sphere.[1] Journalists determine to a large extent which subjects are discussed in public. They are the gatekeepers of the public sphere. Furthermore, they determine how subjects are discussed and with which goal and effect. By making choices about the form and style of news, journalists affect how reality is experienced. Journalistic texts then should not primarily be understood as attempts to mimetically describe events, but as strategic interpretations of them, that offer journalists the possibility of asserting moral authority and, as a result, obtaining power. Each individual news story transcends its specific content and contributes to a larger story. A report about a death sentence, for example, describes a specific event, but it also—or chiefly—contributes to a discussion on crime, punishment, and cultural values.

Journalism can be conceptualized as a dynamic field of relations with specific conventions and routines—its *habitus*. According to Bourdieu, each field has its own "rules of the game" that sustain belief in the structures and

[1]Habermas' concept of the public sphere, which he first formulated in his *Strukturwandel der Öffentlichkeit* (1962), and reformulated in his *Theorie des Kommunikativen Handelns* (1995) and *Faktizität und Geltung* (1992), has been criticized extensively (for a good overview, see Calhoun, 1999). Although many of the historical and political-theoretical points of criticism are valid, the concept of the public sphere *in itself* still offers an inspiring conceptual device and cohesive theoretical framework.

principles of the field, and are at stake in a continuous battle for symbolic power at the same time. Field theory stresses the interplay among the individual journalist, social processes in the news room, the media company a journalist works for and the interdependence of cultural, economic, and political circumstances. The agents in the journalistic field try to distinguish themselves, striving for authority over and autonomy from other actors in the journalistic field as well as actors in other social fields. On the one hand, they do so by using methods such as investigative reporting and scoops (exclusive and new information that is both striking and persuasive), by writing brilliant analyses, or producing well-written columns. On the other hand, they try to distinguish themselves by contesting the habitus of the field—by contesting conventions of form and style. To exist in a field is "to differ," to impose "principles of vision and division," while a "dialectic of distinction" causes constant transformation (Bourdieu, 2005, p. 36; cf. Schultz, 2007).

A historical example might illustrate this mechanism and the comprehensive character of field theory. The nature of the interview as a journalistic form, which was introduced in the 1870s as one of the key elements of the news style, can be elucidated if one takes into account that it was a strategy designed to strengthen the position of an individual reporter, win readers, acquire authority, and gain autonomy from politics (Broersma, 2008). Interviewing was one of the practices that was helpful in developing journalism into a separate field, independent of politics, and in the establishment of a distinct journalistic discourse. Well-chosen quotations and the attribution of speech increased the credibility of stories and journalism's claim to truth. Additionally, the new practice, as a joint enterprise and also as a power struggle, allowed a sense of equality to develop between journalists, politicians and other public figures. One-way communication—reporting a speech without the possibility of interruption—was replaced by a dialogue that provided the opportunity for journalists to intervene, change the subject, or even take the lead in the conversation. The interview gave journalists more control over public discourse and strengthened journalism's position as an autonomous field (Chalaby, 1998, p. 128).

The economic capital of journalism increased because newspapers developed into mass media. Dramatic interviews were a selling point for papers, which aimed at expanding their market. They were helpful in fulfilling the public need for "the real thing," the "state of mind of the nineteenth century," as an 1887 commentator wrote (Roggenkamp, 2005, p. 20). Readers liked the new genre because it revealed new facts, but they also liked "the illusion it conveys of intimacy with celebrities and those who are the witnesses of momentous events" (Silvester, 1993, p. 5). Human interest stories attracted readers, who were given an insight into the private lives and thoughts of public figures. In these news organizations, reporters who succeeded in interviewing important politicians and celebrities were held in

high esteem. For individual reporters, the interview was a tool with which to distinguish oneself and which could make one's career.

The diffusion of the interview stresses the importance of cultural differences in the adoption and adaptation of journalistic forms. The interview was pre-eminently an "invention" of American journalism. In European countries that had embraced the reflective style interviewing was adapted reluctantly because the division between the private and the public sphere was more strict and because reporting was held in low esteem. Journalists considered themselves as meaning makers rather than news makers (Broersma, 2008). This emphasizes the importance of choosing both a historical and a comparative approach when researching the structure of the journalistic field and the nature of journalistic discourse. The configuration of the journalistic field differs both historically and in the various styles of journalism I discussed here.

Although organizational and extra-organizational conditions are culturally situated, comparative research can shed light on the diffusion and adaptation of forms and styles in national contexts and it can elucidate the performative power of journalism. The organization of newsrooms, for example, represents the ideological foundations of journalism and also determines the processing of news and the representation of social reality, as Esser (1998) showed in a comparative study of editorial structures and work principles in Germany and Great Britain. British newsrooms are centrally organized and the division of labor is high, whereas German journalists reject editorial control and consider themselves all-round professionals. "News reporting, writing editorials, editing, and technical production are all regarded as equally relevant for the job profile of the German redakteur" (p. 379). Esser concluded that German journalism after World War II, adapted the Anglo-American news style only in terms of form, that is, in its presentation of news. However, in terms of style and routines, that is, their editorial work processes, it still embodies the reflective style. Therefore, reporters' personal biases have more impact on news coverage than in Great Britain (cf. Wilke, 2007).

Studying the struggles over journalism's habitus—its routines and conventions—as well as struggles with the boundaries of the public sphere will thus deepen our understanding of the nature and function of journalistic discourse. If we want to understand media and the "logic" of the public sphere, we have to examine the forms and styles of journalism that embody its performative power. Such an approach stresses how societies are shaped by representations of social reality through journalistic media. It reveals how newspapers function as 'social maps,' that is, how they construct meaning, how they articulate social worlds and how they build communities. And it allows us to reveal the strategies of journalism understood as performative discourse.

REFERENCES

Albert, P. (1972). La presse Française de 1871 a 1940. In C. Bellanger, J. Godechot, P. Guiral & F. Terrou (Eds.), *Histoire générale de la presse Française* III (pp. 135-623). Paris: Presses Universitaires de France.

Arbouw, E. (2007, October 25). Kotsziek van de oorlog in Irak. Journalist Seymour Hersh spreekt over falen Amerikaans beleid. *Universiteitskrant Groningen* [Newspaper University of Groningen].

Austin, J.L. (1975). *How to do things with words*. Oxford, UK: Clarendon Press.

Barnhurst, K.G. (1994). *Seeing the newspaper*. New York: St. Martin's Press.

Barnhurst, K.G., & Nerone, J. (2001). *The form of news: A history*. New York & London: Guilford.

Bennett, W.L., Lawrence, R.G. & Livingston, S. (2006). None dare call it torture: Indexing and the limits of press independence in the Abu Ghraib scandal. *Journal of Communication, 56,* 467-485.

Bennett, W.L., Lawrence, R.G. & Livingston, S. (2007). *When the press fails. Political power and the news media from Iraq to Katrina.* Chicago: The University of Chicago Press.

Benson, R. (1999). Field theory in comparative context: A new paradigm for media studies. *Theory and Society, 28,* 463-498.

Benson, R. (2002). The political/literary model of French journalism: Change and continuity in immigration news coverage, 1973-1991. *Journal of European Area Studies, 10,* 49-70.

Bourdieu, P. (1991). *Language and symbolic power*. Cambridge, UK: Polity Press.

Bourdieu, P. (2005). The political field, the social science field, and the journalistic field. In R. Benson & E. Neveu (Eds.), *Bourdieu and the journalistic field* (pp. 29-47). Cambridge, UK: Polity.

Broersma, M. (1999). Botsende Stijlen. De Eerste Wereldoorlog en de Nederlandse journalistieke cultuur. *Tijdschrift voor Mediageschiedenis, 2*(2), 40-68.

Broersma, M. (2007a). Form, style and journalistic strategies. An introduction. In M. Broersma (Ed.), *Form and style in journalism. European newspapers and the representation of news, 1880-2005* (pp. ix-xxix). Leuven, Paris & Dudley, MA: Peeters.

Broersma, M. (2007b). Visual strategies. Dutch newspaper design between text and image, 1900-2000. In M. Broersma (Ed.), *Form and style in journalism. European newspapers and the representation of news 1880-2005* (pp. 177-198). Leuven, Paris & Dudley, MA: Peeters.

Broersma, M. (2008). The discursive strategy of a subversive genre. The introduction of the interview in US and European journalism. In H.W. Hoen & M.G. Kemperink (Eds.), *Vision in text and image* (pp. 143-158). Leuven, Paris & Dudley, MA: Peeters.

Butler, J. (1990). *Gender trouble. Feminism and the subversion of identity*. London & New York: Routledge.

Butler, J. (1997). *Excitable speech. A politics of the performative*. London & New York: Routledge.

Calhoun, C. (Ed.). (1999). *Habermas and the public sphere*. Cambridge, MA: MIT Press.

Campbell, W. J. (2006). *The year that defined American journalism. 1897 and the clash of paradigms*. New York & London: Routledge.

Carlson, M. (2004). *Performance. A critical introduction*. London & New York: Routledge.

CBS 60 MINUTES 2. (2004). Abuse of Iraqi POWs by GIs probed, April 28. Retrieved January 12, 2008, from http://www.cbsnews.com/stories/2004/04/27/60II/main 614063.shtml?source=search_story.

Chalaby, J.K. (1996). Journalism as an Anglo-American invention. A comparison of the development of French and Anglo-American journalism, 1830s-1920s. *European Journal of Communication, 11*, 303-326.

Chalaby, J.K. (1998). *The invention of journalism*. London: MacMillan Press.

Dijk, T.A. van (1988). *News as discourse*. Hillsdale, NJ, Hove, & London: Erlbaum.

Easton, D. L. (1986). On journalistic authority: The Janet Cooke scandal. *Critical Studies in Mass Communication, 3*, 429-447.

Esser, F. (1998). Editorial structures and work principles in British and German newsrooms. *European Journal of Communication, 13*, 375-405.

Fowler, R. (1991). *Language in the news. Discourse and ideology in the press*. London & New York: Routledge.

Habermas, J. (1962). *Strukturwandel der Öffentlichkeit. Untersuchungen zu einer Kategorie der bürgerlichen Gesellschaft*. Neuwied: Herman Luchterhand Verlag.

Habermas, J. (1990). *Moral consciousness and communicative action*. Cambridge, MA: MIT Press.

Habermas, J. (1992). *Faktizität und Geltung. Beiträge zur Diskurstheorie des Rechts und des democratischen Rechtsstaat*. Frankfurt am Main: Suhrkamp.

Habermas, J. (1995). *Theorie des Kommunikativen Handelns*. Frankfurt am Main: Suhrkamp.

Hallin, D.C. & Mancini, P. (2004). *Comparing media systems. Three models of media and politics*. Cambridge, UK: Cambridge University Press.

Hartley, J. (1982). *Understanding news*. London & New York: Routledge.

Hersh, S.M. (2004a, 10 May). Torture at Abu Ghraib. *The New Yorker*, pp. 42-47.

Hersh, S.M. (2004b, 17 May). Chain of command. *The New Yorker*, pp. 38-43.

Hersh, S.M. (2004c, 24 May). The gray zone. *The New Yorker*, pp. 38-44.

Hersh, S.M. (2005). *Chain of command. The road from 9/11 to Abu Ghraib* (2nd ed.). London: Penguin Books.

Høyer, S. (2007). Rumours of modernity. How new American journalism spread to Europe. In M. Broersma (Ed.), *Form and style in journalism. European newspapers and the representation of news 1880-2005* (pp. 27-46). Leuven, Paris & Dudley, MA: Peeters.

Høyer, S. & Pottker, H. (Eds.) (2005). *Diffusion of the news paradigm 1850-2000*. Göteborg: Nordicom.

Matheson, D. (2000). The birth of news discourse: Changes in news language in British newspapers, 1880-1930. *Media, Culture & Society, 22*, 557-573.

Reese, S.D. (2003). Prologue—framing public life: A bridging model for media research. In S.D. Reese, O.H. Gandy, Jr. & A.E. Grant (Eds.), *Framing public life. Perspectives on media and our understanding of the social world* (pp. 7-31). Mahwah, NJ & London: Erlbaum.

Requate, J. (2004). Protesting against "America" as the icon of modernity: The reception of muckraking in Germany. In N. Finzsch & U. Lehmkuhl (Eds.), *Atlantic communications. The media in American and German history from the seventeenth to the twentieth century* (pp. 205-224). Oxford & New York: Berg.

Roggenkamp, K. (2005). *Narrating the news. New journalism and literary genre in late nineteenth-century American newspapers and fiction.* Kent & London: Kent State University Press.

Rupar, V. (2007). Journalism, political change and front-page design. A case study of the Belgrade daily *Politika*. In M. Broersma (Ed.), *Form and style in journalism. European newspapers and the representation of news, 1880-2005* (pp. 199-217). Leuven, Paris & Dudley, MA: Peeters.

Schudson, M. (1978). *Discovering the news. A social history of American newspapers.* New York: Basic Books.

Schudson, M. (1995). *The power of news.* Cambridge, MA & London: Harvard University Press.

Schudson, M. (1999). What public journalism knows about journalism but doesn't know about "public." In T.L. Glasser (Ed.), *The idea of public journalism* (pp. 118-133). New York: Guilford.

Schudson, M. (2001). The objectivity norm in American journalism. *Journalism, 2,* 149-170.

Schultz, I. (2007). The journalistic gut feeling. Journalistic doxa, news habitus and orthodox news value. *Journalism Practice, 1,* 190-207.

Silvester, C. (Ed.). (1993). *The penguin book of interviews. An anthology from 1859 to the present day.* London: Viking.

Wiener, J. (Ed.). (1988). *Papers for the millions. The new journalism in Britain, 1850s to 1914.* New York: Greenwood.

Wilke, J. (2007). Belated modernization. Form and style in German journalism 1880-1980. In M. Broersma (Ed.), *Form and style in journalism European newspapers and the representation of news, 1880-2005* (pp. 47-60). Leuven, Paris & Dudley, MA: Peeters.

Williams, K. (2007). Anglo-American journalism. The historical development of practice, form and style. In M. Broersma (Ed.), *Form and style in journalism. European newspapers and the representation of news, 1880-2005* (pp. 1-26). Leuven, Paris & Dudley, MA: Peeters.

2

WHAT'S WRONG WITH NARRATIVE MODELS OF THE NEWS?

Donald Matheson

University of Canterbury

Since structuralism took hold of media theory in the 1960s, claims by Bruner, Barthes, Propp, Frye, and others that narratives constitute deep and universal structures by which people make sense of the world have taken strong hold in the textual analysis of journalism. Additionally, key figures from narratology and discourse analysis, including Toolan (1988) and Bell (1991), have argued that the text structure of news needs to be understood as a form of narrative. "Journalists do not write articles," Bell said. "They tell stories" (p. 147). It is almost a form of academic common sense now that the news instantiates narratives and fits ideas and occurrences into narrative structures. I want to make this academic story a bit more complicated. In the following critique of the literature, I argue that such understandings are overly reductive and risk misrepresenting the textual practices and the forms of knowledge of news journalism. Perhaps, ironically, because narrative analysis is so rich and productive of insights, there is a tendency for analysts to slip from using the insights of narrative theory toward conflating the genres of news and story. The emergence of journalism studies as a distinct field illustrates moves in academic thought to 'take journalism seriously' (Zelizer, 2004) as a meaning-making practice, and as one that is not a simple by-product of external forces. In line with that movement in academic thought from what anthropologists would term an *etic* to an *emic* approach toward journalism, this chapter describes a more complex relationship between news journalism and the cultural forms that it makes relevant to interpretation than narrative analysis often suggests.

I argue that attempts to understand news texts predominantly as narratives miss a number of elements. They miss the extent to which journalists deploy story forms but subsume these within the news' own form of knowledge. They miss the work that journalists do in newswriting to establish the news text as part of the audience's already existing world. They also miss other forms of coherence that are at work in news texts, particularly the typical structuring of news around the initial sentence or "intro." This chapter argues that narrative analysis remains highly useful to discourse analyses of the news, but perhaps more in helping critics identify the particularities of the news and the ways in which news journalists reorient other forms of knowledge than as a higher level mode of meaning-making within which journalism sits. Understanding the complexity of the relationship of journalism to other narrative practices points toward ways of critiquing journalism's role in the circulation of knowledge in society more richly.

NARRATIVE THEORY AND THE NEWS

Narrative theory makes strong claims about the importance of narrative in consciousness and culture, claims that have opened up a rich tradition of narrative analysis of the news. Thus, Bruner (1991) argued, from a sociopsychology perspective, that the self is constructed reflexively, largely according to narrative structures. He wrote that: "we organize our experience and our memory of human happenings mainly in the form of narrative—stories, excuses, myths, reasons for doing and not doing, and so on" (p. 1).

Others (e.g., Gergen & Gergen, 1983; Giddens, 1991) have argued for the particular importance of narratives of the self in contemporary Western society. Barthes (1977), from a cultural theoretical perspective, went further still, giving narrative a basic ontological status in his theory of culture. Stories, he proposed, are universals of human meaning-making:

> Narrative is presented in myth, legend, fable, tale, novella, epic, history, tragedy, drama, comedy, mime, painting, stained glass windows, cinema, comics, news items, conversation. . . . Narrative is present in every age, in every place, in every society. . . . It is simply there, like life itself. (p. 79, cited in Schokkenbroek, 1999)

Storytelling emerges in this large academic literature as a key—often expressed as *the* key—structure in consciousness and in the sharing of meaning within culture.

Many critics of the news have built on this primacy accorded to narrative in meaning-making, arguing that the meaning of the news also lies primarily at this level. Bird and Dardenne (1997), for example, stated:

> The news as narrative approach does not deny that news informs; of course readers learn from the news. However, much of what they learn may have little to do with the "facts," "names" and "figures" that journalists try to present so accurately. These details—both significant and insignificant—all contribute to the larger symbolic system of news. The facts, names, and details change almost daily, but the framework into which they fit—the symbolic system—is more enduring. (p. 135)

The claims made here are a direct attack on journalism's claim to reflect reality. For Bird and Dardenne, the narrative "symbolic system" of the news has precedence over the events, causing some events to emerge as newsworthy, determining the way elements are linked together and shaping, therefore, how the news makes sense. The structuralist school of literary theory, beginning with the likes of Propp's analyses of Russian folk tales, has organized much of this thinking. Analysts identify character roles, including hero, villain, and victim. They also identify themes from traditions of narrative, such as a fall from grace, redemption, the quest, or unrequited love. The news is often seen as instantiating, and thereby reinscribing, such cultural resources.

Analyses along these lines thus are also an attempt to place journalism—which sees itself as a quintessentially modern form—within the context of popular and traditional culture. Fiske and Hartley (1978), for example, argued that television journalism has taken on the role that bards played in some oral cultures. Lule (2001) interpreted many news stories as instantiations of archetypal myths. Thus, for example, during news coverage in 1991-1992 of his trial and conviction for rape, Mike Tyson was the Trickster, a figure combining animal and human cunning but also ultimately stupidity, bringing on himself mockery and condemnation. Vincent, Crow, and Davis (1989) interpreted television news reports of air crashes as following age-old narratives of rupture and recuperation. They emphasized how explorations of blame and of the actions of authority figures help assimilate such events to narratives that contain the moral that "elites can continue to be trusted" (p. 360). The news narrative, in this view, provides a kind of ontological security that the world and established values will continue and prevail. Analyzing news as narrative thus directs us to reflect on the moralizing force of the news text and its explanation of the news in terms of a culture's stock of wisdom.

Analyses of this kind also often provide evidence of the ideological capture of journalism by dominant groups in society. Bird and Dardenne (1997) pointed out that journalists' assignment of people and groups to categories of hero or villain cannot reasonably be considered as arbitrary decisions but

must be seen as evidence of the alignment of the news' stories with the stories of certain groups. Citing a host of studies from the 1970s, they argued that journalists' stories tend to align with the stories of groups that have the power to define the normal, the commonsensical, and the natural. In Hall's terms (Hall, Critcher, Jefferson, Clarke, & Roberts, 1978), narrative emerges as a central part of the "cultural maps of the social world," without which journalists could not bring the unpredictable events that make up the news "within the horizon of the meaningful" (p. 54). News stories are mythic (Barthes, 1977; see also Chandler, 1995), in the sense of forcing experiences of life to conform to ideas of how life should be experienced, or closing the gap between "what happened" in one particular event and "what happens" in a culture's self-understanding (Frye, 1964; cited in Lule, 2001, p. 37).

Sometimes this kind of analysis is compelling. I have just finished supervising a Master's that showed clearly how a New Zealand yachtsman was constructed in news reports as a hero who became a traitor, in the context of a competition described as "yachting's Holy Grail" (see Gajevic, 2007). Sometimes, as in Vincent et al.'s (1989) study of air crash coverage noted, the critical interpretation could be argued to be only one among a range of possible interpretations. Indeed, an analysis that depends on the identification of hidden, deep structures will necessarily often struggle to show that those structures are invoked in a text. The difference between convincing and unconvincing studies is often a matter of being able to find textual evidence for the narrative structures identified by the critic. Gajevic focused on metaphors and other lexical details. Analysts also have looked to the findings of literary and textually based forms of narratology for detailed structural and functional models of narrative texts that can be overlaid on texts to explore their narrativity. These models have been influential in analyses of the news, allowing scholars to compare the news with other textual forms and therefore to tease out the precise ways in which the news tells stories about the world. However, a reliance on these models is, I argue here, flawed and leads to a limited view of how news texts make sense.

NARRATIVE DISCOURSE ANALYSIS

A recurring concern of discourse analysts of narrative has been to describe the essential, defining characteristics of a narrative. They often isolate two features. First, a story must have at least two events, separated in time. Second, the two events must be related. In Toolan's (1988) phrase, it must be "a perceived sequence of non-randomly connected events" (cited in Schokkenbroek, 1999, p. 61). Many narratologists also observe that any two textual events will tend to slide toward this narrative structure because of a universal cultural "fallacy of sequentiality" (Barthes, 1977, p. 94): We have

all learned to read two events in succession as if the first event caused the second. Consider Forster's (1947) classic example: "The king died. The queen died" (p. 116). Here the storyline begins to slide toward a plot or narrative structure, even before Forster changes sentence two to read: "The queen died of grief." As Wright (1995) pointed out, a basic narrative convention dictates that details in the story world are never incidental, but always have some significance: they are "maximumly meaningful." Readers (or listeners, viewers, or users) know that the act of telling a story always makes something of experience, linking it together via structures of causation, thematic unity, and the like (see also Matheson, 2005). Thus, unless causation between adjacent events is clearly *not* present in narrative texts, it can be assumed. The extravagance of narrative analysis, critiqued in more detail later, is apparent here in its foundations. All texts of all genres cohere in some way, so that two adjacent textual elements can always be assumed to be relevant to each other (otherwise, the text could not be described as belonging to a genre).[1] So, the fact that elements in a text are "nonrandomly connected" does not prove that the connections are narrative links of causation, and further theoretical work is needed to establish what kind of coherence is at work within a particular genre.

Identification of these basic elements of narrative can be very useful in analyzing the way the news text connects its elements. Bird and Dardenne (1997), following historiographer Hayden White (e.g., 1987), showed that some news texts merely chronicle events, linking them together as co-occurrences rather than causative sequences, in a similar way to that in which the historical chronicles that White described list events or genealogies in chronological order. News chronicles detail the government business of the day or the movement of ships in and out of the harbor or what took place at a council meeting. Narrative analysis thus opens up for us questions of the circumstances in which the news approaches narrative and the circumstances in which it does not. However, too often the analysis is used to force the news into boxes predefined by narrative theory. Lule (2001) used the distinction of narrative and chronicle as critique, seeing news that follows "easy formulas for writing speeches, sports results, or fire stories"—that is, merely chronicling—as inadequate (p. 18). Bird and Dardenne, for their part, see news as subsumed under either narrative or chronicle. The dichotomy seems to me to be false, and part of a larger critical move that I take issue with in this chapter. The news, I argue, is neither chronicle nor story, but a complex genre that draws on both forms (among others). Although narrative analysis can help the analyst to identify echoes and intertexts for the news, I move away from the structuralist assumptions of age-old underlying forms, which

[1]An example that goes some way to proving the rule is the shopping list, which has almost no ordering of its elements. Items can be changed around without loss of meaning in terms of the shopping trip (see Hoey, 2001; Stubbs, 1983; van Dijk, 1997).

are implicit in such arguments. As I detail later, a number of analysts have shown that the news text does not cohere simply as story but in a range of ways. Indeed, I argue, it is epistemologically quite distinct and needs to be extracted to some extent from narrative analytical models.

NARRATIVE ANALYSIS OF FACTUAL GENRES

Extracting the news from these models involves, as Pietilä (1992) noted, rethinking the category "story," which must mean something quite different in a factual text than in a fictional one. The underlying sequence of events that is the story can be distinguished from its telling, and each of these moments contains the text's meaning in a different way. Following Culler, Pietilä noted first that a story cannot exist except when it is told, suggesting that the telling is where meaning is being made. Yet second, any story can be retold in a different telling, suggesting that the underlying story is where the meaning has already been made (Pietilä, 1992). Rather than give priority to either of these levels, Culler (1981) spoke of a double logic, in that every narrative operates by:

> presenting its plot as a sequence of events which is prior to and inde-
> pendent of the given perspective on these events and, at the same time,
> suggesting . . . that these events are justified by their appropriateness to
> a thematic structure. (p. 178; cited in Pietilä, 1992, p. 40)

To tell a story means to posit, at least implicitly, both these things. Yet Culler's analysis applies differently to factual texts, where the underlying sequence of events is not just a story-world sequence—something imaginable as a tidy, complete entity, and one that tends toward the mythic—but also is a life-world series of events—something that can never be fully known, and that also can be partially known through other texts. Culler's double logic is still present in the sense that the journalist presupposes a set of events while giving a particular ordering to that sequence, but that logic is always only partial. For interfering in the story-discourse balance is the knowledge that the events exceed the ability of any one telling to describe them—they are not contained within the telling, but have an empirical existence. Although narrativizing events tends to close that gap, the gap will always remain because readers bring other real-world resources to bear on their identification of what has happened. The strength of narrative analyses of news texts thus has been to show the presence of narrative forms in shaping the text; the weakness has been their neglect of what else is shaping news discourse.

Moreover, journalism is among the genres where the surrounding production and reception factors play a large role in shaping the text, requiring discourse analysis to be particularly aware of the extra-textual (see Philo, 2007). Right at the heart of the genre are widely shared expectations about what kind of knowledge is being produced there. As Ekström (2002) described the knowledge claim of journalism:

> Characteristic of journalism is its claim to present, on a regular basis, reliable, neutral and current factual information that is important and valuable for the citizens in a democracy. (p. 274)

He argued that, regardless of whether journalism always meets these criteria, journalists produce texts within such a rhetoric, constructing the text so that it will appear as reliable, neutral, current, and factual. Therefore, this form of knowledge is defined in relation to the present time; it invokes a particular not an abstract citizenry; and in other ways reflects its context. In particular, news journalism depends on a sense that it is information that directly reflects its world. Indeed, for journalists, the notion of the "news story" means both the facts of the news event and the journalist's account of those facts (see Glasser, 1996; Matheson, 2003). Thus, in telling the news, the ideal is less a matter of encompassing the full story—as Culler's ideal narrator does—than in sustaining a claim to realness. This includes the possibility that the (real) story will have changed by the time of the next news cycle, requiring the (textual) story to be rewritten. Culler's couplet of story and discourse is thus always a step away from unity in the news, and necessarily so for its knowledge claim. Analysis of news as narrative, then, must take cognizance of a considerable complexity and peculiarity to the story within journalism.

LABOV'S SCHEMA AND BELL'S ANALYSIS

Yet instead, narrative analyses of the news have been inclined to spend more time seeking out the affinities of the news with narrative models and are thus often at risk of over-interpreting the narrativity of the text. Many analysts of news narrative start from Labov and Waletsky's (1967) structural model of personal oral narratives, contrasting the formal and functional elements of the news text with this model (e.g., Teo, 2000; van Dijk, 1985). Why Labov and Waletzky's model is so influential is rarely discussed, although conversation is often regarded as a base state in discourse—thus Ochs (1997) gave conversational stories a special status within the realm of discourse, arguing that the highly interactive, multiply authored nature of conversation makes

it an important site where some of the conventions we take to other narrative texts are formed. Labov and Waletzky identified six structural elements in their texts, which occur largely in order as the telling of the story unfolds. They are:

1. *Abstract*: introduces the narrative, telling listeners what the point of the story is, as well as taking them from their life world into the story world.
2. *Orientation*: introduces the setting (time and place) and the characters.
3. *Complicating action*: details a disruption to the equilibrium implied in the orientation; there may be a number of complications in the story
4. *Evaluation*: halts the action to provide the narrator's interpretation of or judgment on the action; evaluations occur after action has happened, but may be scattered throughout the text.
5. *Resolution*: brings the action to a close, establishing a new equilibrium.
6. *Coda*: takes the narrator and listeners back from the story world into their life world.

Bell (1991) provided a detailed analysis of a news text in terms of this model, which I focus on as it is a clear exposition of the argument, yet one that also illustrates the difficulty of describing news texts through narrative models. In particular, I argue that Bell's analysis of narrative is unconvincing when the function of textual elements within the whole text is considered.

Bell concluded, on the basis of analysis of a wire service news text using Labov's model, that the news is narrative, but of a peculiar kind. He identified much in the news text that is different from Labov's, giving four significant points of contrast. First, he found that the news text is rarely ordered according to a simple narrative arc from equilibrium to complication to new equilibrium. Instead, it moves around in time, often returning to the same moment in time at various points in the text, adding detail and competing interpretations. Orienting details are similarly scattered, not gathered together in the opening clauses, as Labov and Waletzky predicted. Bell accounted for this difference in terms of the varied newsworthiness of the elements of the story, and the convention that the most newsworthy material should come first. Second, Bell found news texts rarely have any resolution because they describe moments in ongoing narratives that have not yet concluded. The entire narrative is literally in medias res. In a crime story, for example, "The criminal was arrested, but the trial is in the future" (Bell, 1991, p. 154). Third, news texts rarely have any coda, for there is no distinction in the news between story world and life world, and thus no need to

return the audience from the time and place of the action to the time and place of the telling. Fourth, news texts have third-person narrators, for the obvious reason that they are rarely experiential narratives, but are accounts of someone else's experiences, and also because of the convention of impartiality, which precludes inclusion of the journalist's own perspectives. Given these substantial differences, one might be tempted to ask whether narrative models are insufficient to describe the way the news text organizes its material. Bell concluded, however, that news texts belong to the domain of narrative, but that they constitute a distinctive form of narrative, on the basis of a number of similarities between his text and Labov's model.[2]

Important to his analysis of these similarities is that Bell can locate the elements of abstract, orientation, action, and evaluation in news stories. It is here that I significantly disagree with him, for the news appears distorted when fitted into this model. This is true at the formal level: Most of the time, Bell finds Labov and Waletzky's categories scattered throughout the text, as he acknowledged. More seriously, it does not work well at the functional level either, that is, at the level of how these elements produce meaning.

Bell argued that a news text begins with an abstract that, like the personal oral narrative's abstract, sums up the story in terms of its main story. In Bell's example, the headline and intro read:

1 US TROOPS AMBUSHED IN HONDURAS

2 Tegucigalpa

3 UNITED STATES troops in Honduras were put on high alert after at least six American soldiers were wounded, two seriously, in a suspected leftist guerrilla ambush yesterday, United States officials said.

[text continues]

The main events of the story are indeed summarized here, ahead of the detailed account in the succeeding five paragraphs. From the perspective of the text's construction of meaning, however, this analysis is much weaker. Labov's abstract is first preparatory, signalling an unfolding account that is to follow, and second it bridges between the audience's and narrrator's life world and the story world. The news headline (1) does this. But the introduction (3), by contrast, functions by itself as a micro-story (as Bell, 1991, indeed noted later in his analysis), to which the rest of the text is subsidiary.

[2]See Schokkenbroek (1999) for an argument that news texts differ no more than other narratives from relating the action in a simple narrative arc. See Frank (2003) for an argument that Bell overlooked the extent to which journalism embeds personal narratives in its third-person news texts.

As P.R. White (1995) showed, the paragraphs that come after the introduction act as satellites around that introduction, and can usually be reordered without any damage to sense. Economou (chap. 10, this volume) makes the same point about the visual and verbal elements in the layout of news-related feature articles. This structure is quite different from one of abstract plus story. The introduction also, unlike an abstract, makes no acknowledgement of any difference between the life world and story world, for the same reason that the news text has no coda: To do so would reduce the claim to realness characteristic of the genre. This is not an inevitable part of news. The 19th-century Anglo-American news text, which was much more narrative in structure (Schudson, 1982), did contain such an initial sentence. *The Times*, for example, starts one article:

> We have this morning to make the startling announcement that the Chancellor of the Exchequer has placed his resignation in the hands of Lord Salisbury. (*Times*, Jan. 1, 1901, p. 6)

This sentence works to open a channel of communication with the reader, telling of a narrative to come and establishing the narrative voice (see Matheson, 2000). The modern news text, by contrast, operates within a rhetoric that requires no such narrative opening. It belongs, after all, to the same moment and space as the audience, as devices such as the live "piece to cam" of television or the emphasis on recency in newspaper reports emphasize. The fact that abstracts often are optional in personal narratives, yet headlines and introductions are fundamental to the news, also gives one cause to consider that they may be quite different formal and functional objects.

Bell's identification of the orientation element is problematic for similar reasons. He found orienting elements scattered through the text, although concentrated in the introduction. As he noted, journalists are taught to put details of the who, what, where, and when of an event in the introduction (Bell, 1991). Again, however, I argue that there is no orienting element, at least as narrative theory understands it, to a news text. To do so would acknowledge the text's role in constructing narrative's world apart and thus posit a difference between the journalist's world and the audience's. In other words, the news genre diverges markedly here from genres that are governed by a narrative logic because it rejects the power to imagine an elsewhere or elsewhen or to construct characters who drift toward the archetypal. The reader is not released from the here and now.

This can be seen by examining texts that appear, when read within the frame of narrative analysis, to be doing storytelling work. The following text from the *Los Angeles Times*, for example, clearly conjures up a scene to draw readers into a narrative space. I argue that it does so in a quite limited way and within the structure of news discourse that situates the text firmly in a

shared life-world context. In other words, narrative can be read as a technique deployed for effect within the news rather than an archetypal structure underpinning its meaning-making.

1 PRECISION NIGHTTIME FLYING WAS CRUCIAL TO
 HALTING FIRE

2 By Paul Pringle, Times Staff Writer

3 Specially trained copter pilots braved towering flames and blinding smoke to hit the blaze.

4 Hour after hour, Scott Bowman flew into smoke and darkness, piloting his Fire One helicopter over towering flames, then swooping in low as a gull to bombard them with salvos of water.

5 The daring nighttime work of Bowman and his fellow Los Angeles Fire Department pilots is largely credited with preventing the Griffith Park blaze from jumping darkened ridges and charging into homes that had been evacuated by moonlight.

6 "I'm exhausted," Bowman said Wednesday after nearly 14 hours in the sooty skies, repeatedly dousing the fire line as it advanced on backyards in the Los Feliz area and threatened storied attractions such as the Griffith Park merry-go-round.

[text continues]

(*Los Angeles Times*, May 10, 2007)

This text's "drop intro" or "color intro" in (3) and (4) contains rich orienting detail about the scale of the fire, the smallness of the helicopters, and the bravery of the pilots, invoking a particular scene and taking the reader into the mythic territory of heroes and battles. These two sentences begin also, in their temporal structure, to tell a story of flying into darkness and swooping in low, hour after hour. But a narrative analysis that failed to note the position of these sentences within the larger text would be missing the way they operate as knowledge. In my reading, the text hastens us back into the here and now in Paragraph 5, compressing the story into the nominalization, "daring nighttime work," and a series of subordinate clauses in Paragraphs 5 and 6, all of which work to summarize and evaluate the events from the position of the present shared by reporter and audience. The article's main point of information, that the flying skills and the halting of the

fire were connected, is signaled in the headline (1) and stated in full in Paragraph 5. This is the heart of what the reader is being told. The narrative aspects of the drop intro are, then, enclosed by, and immediately recuperated to, the news' form of knowledge. The orienting details are marked as rhetorical devices—similes or synecdoches or examples—and therefore subordinate to the idea contained in the "real" introduction. This does not mean, of course, that readers will not have firefighting as heroism available to them as a way of understanding the text. But it does mean that this is only part of its meaning and that the text works to limit the extent to which the event is narrativized.

Because the event takes place within the newspaper readership's own world and news journalism's epistemology, that status is repeatedly emphasized. The more the journalist takes readers into a narrative space the more he or she takes them out of that reality. Thus, rather than orient readers to a narrative world, the job of the news text primarily is to connect the details of the text with other aspects of the world the reader inhabits. That is, the text acknowledges and builds on the fact that the reader is, to a substantial extent, already oriented. It is useful to discuss this in pragmatic terms. In the language of Sperber and Wilson's (1986) relevance theory, the news text can be assumed to communicate information that makes most efficient sense in terms of the collective knowledge shared by that readership. The readers of the *LA Times* story presented earlier can be assumed to know already that there was a major fire in a park near Los Angeles, that people had been evacuated, that firefighters are brave, that the newspaper report is factual, that it aims to communicate the most important details of what happened in relation to the fire, that the news monitors the actions of civic actors in terms of their competency, and much more. The need for such a heuristic on the part of readers is signaled through details such as the definite article on "the blaze" (3), which signals that readers should invoke their knowledge of the one particular fire that is most likely being referred to. That context is then further reinforced by reference to specific helicopters ("Fire One"), to suburbs, to the park's title, and the like as the text proceeds. These lexical items orient the reader much more toward the world of shared public knowledge and personal experience than to a story.

The remaining element of Labov and Waletsky's typology is evaluation. Evaluation is potentially of value in critiquing the news' claim to simply reflect the world: If stories require evaluative clauses and if news texts are stories, pinning these down in news texts takes one a significant step down the route of analyzing whose understandings are being privileged in the news. Yet finding the evaluation in narrative is not always easy. Unlike the other elements of oral narrative, evaluation is scattered throughout the telling, functioning wherever needed in the flow of the talk "to establish the significance of what is being told, to focus the events, and to justify claiming the audience's attention" (Bell 1991, pp. 151-152). Zorman (2004) noted

that Labov proposed that evaluations in personal oral narratives may be signaled by an interruption in the narrative flow and sometimes by "clause internal" devices that intensify, compare, correlate, or explicate the things being described. She argued that the definition should be "widened to include any sign of the narrator's personal involvement which gives rise to narratorial distortion, suspension of neutrality in the presentation or determination of conversational factors such as topic, social relations among participants and situation" (Zorman, 2004). Evaluation comes to look very much like communicative intention, and so loses shape as a formal element, for intention is implicit in nearly every clause. The fact that Bell found evaluative material scattered throughout the news text tells us neither that the news is or is not narrative in form. The fact that he found evaluative material tells us simply that the text is not unmotivated. I do not want to critique Bell in particular here. But I hope I have shown that such attempts to force the news text into a narrative model do not, in the end, take us that much further in explicating the news and that they miss important aspects. They remind us that news texts evaluate, that they summarize and that they concatenate material in coherent ways. But then I could imagine few genres that do not do this.

REVALUING NARRATIVE ANALYSIS

Instead, it is from the differences from the specifics of narrative form and function described by literary and discourse-analytic narratology that we learn the most. Pietilä (1992), for example, used the narratological taxonomy of narrative point of view to explore how the news represents action. He distinguished between moments where the narrator's discourse "interferes" in its representation of actors' discourses (the narrator interprets, comments, evaluates) and moments where the actors' discourse dominates. Thus, text such as the following from the news articles analyzed in Pietilä's paper gives clear evidence of the journalist reorganizing the actor's actions and talk:

> Mr Väyrynen contacted the FBC radio newsroom yesterday to express his concern. He said that several newspapers had already been harassing him asking questions about possible treason. (p. 47)

The actor's statement paraphrased in the second sentence is summarized in the first with a phrase explaining the purpose of the statement. In combination with other statements, a narrative of a man angrily responding to attacks can be inferred. Yet, Pietilä also noted that this is no narrative, where the narrator can invent what the actors say. In narrative:

the narrator can shape and steer [the discourses of the characters] as he or she pleases to suit the purpose of the narrative. The situation is different in the case of news. Here the narrator's discourse cannot dominate over the actors' discourses in the same way because the reporter is not allowed to interfere directly in the things they are talking about. The answer to the question of whether the narrative discourse [or the actors' discourse] is dominant cannot be given by an a priori definition . . . ; it must be based on an a posteriori empirical investigation of the power relations between the narrator's and actors' discourses and of any struggle going on between them. (p. 44)

A news text is therefore in a state of tension. If the narrator dominates, it fails as factual news. Yet if the actors' discourses dominate, it fails as a coherent news text and remains a jumble of quotations and details.[3] This strategy of using categories drawn from narrative theory as heuristic devices to explore the news genre makes more sense to me than beginning from an assumption that news is indeed narrative. Pietilä draws on the notion of a narrator and contrasts the news text's voice with that found in narratives. In so doing, he opens up for examination aspects of the struggle for power in the text.

OTHER FORMS OF COHERENCE

The greatest contribution of narrative analysis to news analysis is to show how larger units of sense are drawn on in news discourse's imposition of shape upon actors' discourses. News magazines' descriptions of the Kennedy family as "touched by a dynastic curse" after the death of John F. Kennedy, Jr. are not just asides but ways to "explain JFK Jr.'s plane crash (which occurred in bad weather) as part of a larger narrative of predestined calamity" (Kitch, 2002, p. 302). Such widely shared cultural tropes are certainly part of how news texts tell the news. Yet it is a mistake to regard these as the only form of coherence in the news. Hoey (2001) listed a number of other ways texts hang together. Above the clause, text may cohere as an argument, where one thing follows another in ways that make it more convincing, or it may cohere as matching pairs, such as questions and answers, contrasting pairs, an idea and example, and so on (see Hoey, 2001). The "inverted pyramid" structure gives the news text part of its shape. Analyses by P.R. White (1995) and Economou (Chap. 10) stating that news elements are satellites around an introduction, suggest that news coheres around a

[3]Public relations complicates matters by producing actor discourse that is already adapted to journalism's textual practices, but the general point holds.

central piece of information, the news angle. This is indeed widely taught in journalism: The news text should contain the most important information first, and less important details later. Bell's (1991) finding, cited earlier, that the elements that a narrative model expects to find in sequence are scattered throughout the text, is consistent with this. I conclude that the news text is primarily structured as justification and elaboration of the introduction, not as an unfolding story.

But to what extent does this ordering of elements shape the way meaning can be constructed from the text? The scattered elements could still make sense primarily in terms of an underlying narrative. Van Dijk's (e.g., 1985, 1988) cognitive model of the news text as a hierarchy of propositions provides strong evidence that meaning is constructed in the text in accordance with the inverted pyramid. He argued that the human brain remembers information by processes of summarizing, deleting, and generalizing, reducing that information down to its theme or gist in ideologically patterned ways. These "macro-propositions" are what language users most easily recall from texts. He found the same logical processes in the construction of news texts, particularly in the reduction of the content of the news text down to introductions and headlines that express the gist of the overall content. In other words, to van Dijk the headline and introduction mirror the way the mind stores information. Additionally, he argued that material below the introduction is organized according to its relevance to the macro-proposition, resulting in a series of sentences that skip around in time sequence, in subject, and in kind (quotations, background paragraphs, commentary, etc.), and that become less focused on significance and more focused on detail the further down the text they are. Narrative structure is not excluded from this model of the news text, but it plays a minor role. At times, van Dijk discussed scripts that organize the way information is reduced to macro-propositions as if they were narratives, but more often he spoke of "general knowledge scripts" (e.g., van Dijk, 1991) and in later work linked these scripts to ideology (van Dijk, 1998). His model, therefore, provides support for the argument made in relation to the *LA Times* firefighter story that narrative meaning-making may well not be central to the way news texts make sense.

CONCLUSION

I do not argue against the richness of insight of narrative analysis of the news. Indeed, the aim has been to build on that tradition by seeking ways to specify the role that narrative modes of meaning-making play in the news. The news clearly makes sense to an extent in terms of narrative structures. The argument of this chapter has been that the narrativity of the news is only

a part of the way journalists and news audiences construct meaning. I argue, then, that the extravagance of narrative theory needs to be curbed so that the particularities of the news genre can be better studied: The news cannot be conflated with the story. I also argue that studies that seek traces of narrative models in news texts are flawed because they have a tendency to look only for what concords with their models. The genre of the news must be understood in its own terms in order for the extent of its narrativity to be explored. To that end, rather than follow those who completely reject journalism's self-understanding and its rhetorical self-presentation as factual text, as cultural scholars do with their argument that the news instantiates archetypal myths, I follow critics such as Ekström (2002) who explore the knowledge claims of journalism that are embedded in its texts. As a factual genre whose claims to knowledge are tightly connected to social context, the news is written so as to emphasize its realness.

From these perspectives, two main points emerge. The first is that the news text's coherence is less in terms of a narrative sequence than in terms of the introduction, as both P.R. White's (1995) image of satellite sentences orbiting the first sentence and van Dijk's (1988) model of the next text organized around macro-propositions demonstrate. The news text is centered on the moment described in its first sentence. A narrative can be read into the text and into series of texts on the same topic, but importantly the news text is epistemologically distinct. It describes a moment of the real. The second point follows on. The news text exists, then, in a state of tension, always potentially a narrative but not constructed as one. As the journalist's term *news story* indicates, the story slips toward being a process as much as an object; it is what is happening in the world and it is also the repeatedly revised account of that. It is this difference of the news story to the stories narratologists describe that is of interest here. As scholars such as Pietilä show, tracing the way narrative categories map inadequately and partially onto the news reveals more than attempting to make it fit those categories.

REFERENCES

Barthes, R. (1977). *Image-music-text*. London: Fontana.
Bell, A. (1991). *The language of news media*. Oxford, UK: Blackwell.
Bird, S. E., & Dardenne, R. W. (1997). Myth, chronicle and story: Exploring the narrative qualities of news. In D. Berkowitz (Ed.), *Social meanings of news: A text-reader* (pp. 333-350). London: Sage.
Bruner, J. S. (1991). The narrative construction of reality. *Critical Inquiry, 18*, 1-21.
Chandler, D. (1995). Denotation, connotation and myth. *Semiotics for beginners* (chap. 6). Retrieved November 5, 2004, from http://www.aber.ac.uk/media/Documents/S4B/sem06.html.

Culler, J. (1981). *The pursuit of signs: Semiotics, literature, deconstruction.* London: Routledge & Kegan Paul.

Ekström, M. (2002). Epistemologies of TV journalism. *Journalism, 3,* 259-282.

Fiske, J., & Hartley, J. (1978). *Reading television.* London: Methuen.

Forster, E.M. (1947). *Aspects of the novel* (8th impression). London: Edward Arnold.

Frank, R. (2003). Folklore in a hurry: The community experience narrative in newspaper coverage of the Loma Prieta earthquake. *Journal of American Folklore, 116,* 159-175.

Frye, N. (1964). *The educated imagination.* Bloomington: Indiana University Press.

Gajevic, S. (2007). *Constructing a traitor: How New Zealand newspapers framed Russell Coutts' role in the America's Cup 2003.* Unpublished master's thesis, University of Canterbury, Christchurch, NZ.

Gergen, K. J., & Gergen, M. (1983). Narratives of the self. In T. R. Sarbin & K. E. Scheibe (Eds.), *Studies in social identity* (pp. 233-253). New York: Praeger.

Giddens, A. (1991). *Modernity and self-identity: Self and society in the late modern age.* Cambridge, UK: Polity.

Glasser, T. L. (1996). Journalism's glassy essence. Preface to a special section on The language of news. *Journalism and Mass Communication Quarterly, 73,* 784-786.

Hall, S., Critcher, C., Jefferson, T., Clarke, J., & Roberts, B. (1978). *Policing the crisis: Mugging, the state, and law and order.* London: Macmillan.

Hoey, M. (2001). *Textual interaction.* London: Routledge.

Kitch, C. (2002). "A death in the American family": Myth, memory, and national values in the media mourning of John F. Kennedy Jr. *Journalism & Mass Communication Quarterly, 79,* 294-309.

Labov, W., & Waletzky, J. (1967). Narrative analysis. In J. Helm (Ed.), *Essays on the verbal and visual arts* (pp. 12-44). Seattle: University of Washington Press.

Lule, J. (2001). *Daily news, eternal stories: The mythological role of journalism.* New York: Guilford.

Matheson, D. (2000). The birth of new discourse: Changes in news language in British newspapers, 1880-1930. *Media, Culture and Society, 27,* 557-573.

Matheson, D. (2003). Scowling at their notebooks: The management of writing within British journalism's reflexive identity. *Journalism, 4,* 165-183.

Matheson, D. (2005). *Media discourses: Analysing media discourse.* Maidenhead, UK: Open University Press.

Ochs, E. (1997). Narrative. In T. van Dijk (Ed.), *Discourse as structure and process* (Vol. 1, pp. 185-207). London: Sage.

Philo, G. (2007). Can discourse analysis successfully explain the content of media and journalistic practice? *Journalism Studies, 8,* 175-196.

Pietilä, V. (1992). Beyond the news story: News as discursive composition. *European Journal of Communication, 7*(1), 37-67.

Schokkenbroek, C. (1999). News stories: Structure, time and evaluation. *Time & Society, 8*(1), 59-98.

Schudson, M. (1982). The politics of narrative form: The emergence of news conventions in print and television. *Daedalus, 111,* 97-112.

Sperber, D., & Wilson, D. (1986). *Relevance: Communication and cognition.* Cambridge, MA: Harvard University Press.

Stubbs, M. (1983). *Discourse analysis: The sociolinguistic analysis of natural language.* Oxford, UK: Basil Blackwell.

Teo, P. (2000). Racism in the news: A critical discourse analysis of news reporting in two Australian newspapers. *Discourse and Society, 11*(1), 7-49.

Toolan, M. J. (1988). *Narrative: A critical linguistic introduction.* London: Routledge.

van Dijk, T. (1985). Structures of news in the press. In T. van Dijk (Ed.), *Discourse and communication: New approaches to the analysis of mass media discourse and communication* (pp. 69-93). Berlin: Walter de Gruyter.

van Dijk, T. (1988). *News as discourse.* Hillsdale, NJ: Erlbaum.

van Dijk, T. (1991). *Racism and the press.* London: Routledge.

van Dijk, T. (1997). The study of discourse. In T. van Dijk (Ed.), *Discourse as structure and process. Discourse studies: A multidisciplinary introduction* (Vol. 1, pp. 1-34). London: Sage.

van Dijk, T. (1998). *Ideology: A multidisciplinary study.* London: Sage.

Vincent, R.C., Crow, B. W., & Davis, D. K. (1989). When technology fails: The drama of airline crashes in network television news. *Journalism Monographs, 117*, 1-6, 21-26.

White, H. (1987). *The content of the form: Narrative discourse and historical representation.* Baltimore, MD: John Hopkins University Press.

White, P.R. (1995). News and story telling: Generic structure. *Telling media tales: The news story as rhetoric.* (chap. 5). Unpublished doctoral dissertation, University of Sydney, Sydney, Australia.

Wright, W. (1995). Myth and meaning. In O. Boyd-Barrett & C. Newbold (Eds.), *Approaches to media: A reader* (pp. 446-452). London: Arnold.

Zelizer, B. (2004). *Taking journalism seriously: News and the academy.* Thousand Oaks, CA: Sage.

Zorman, M. (2004). Some modes, functions and aims of implicit evaluation. In S. Bracic, D. Cuden, S. Podgorsek, & V. Pogacnik (Eds.), *Linguistische Studien in Europäischan Jahr der Sprachen* (pp. 743-752). Frankfurt: Peter Lang. Retrieved October 2, 2007, from http://www.utexas.edu/cola/centers/lrc/iedocctr/ie-pubs/marina.zorman.html.

3

AN INVITATION TO COMPARE JOURNALISM HISTORIES

Svennik Høyer

University of Oslo

Most historians agree that *epochs* are a useful concept. They embody a combination of certain important material conditions, or highlight the style and ideas that prevail over a period. Opinions differ, however, when the succession of epochs are discussed at higher levels of abstractions. Some claim that epochs serve as stages in a wider process of development, which binds them together in a grander design covering several decades or even centuries.

The empirically oriented historian is more likely to insist that there are no simple causal agents; each epoch has its peculiar contingencies, which cannot be transferred easily to later epochs. In practice, however, empirical studies often apply ideas of causalities. Chronology serves as an implied causal chain between the events described. More specifically, empirical history operates with alternating causes and consequences. The outcome of one event serves as a causal input in a succeeding similar situation where in turn the original causal agent is transformed into a new causal input for following events—and so on, in an endless chronology.

To bring some order to historical complexities, social scientists often postulate an inferred standard of developments.[1] Even descriptive histories occasionally include tacit anticipations of standard regularities. In the so-

[1]Among the more well known in social science is Rostow's (1960) *The Stages of Economic Growth* in which he classified national economies according to five stages: the traditional society, preconditions for take-off, the take-off, the drive to maturity, and the age of high mass consumption. This type of phase model is similar to Rogers' (1962) diffusion model, as well as others, which explains the form of diffusion of new inventions and products by an S-curve and a varying degree of interpersonal communication.

called Whig interpretation of press history, the basic idea is the long-term progress toward a separate social institution, depicting development as a succession of victories for freedom of the press.

Comparative journalism history aspires to diverse kinds of interpretations. One idea is simply through cross-national comparisons to demonstrate the complexities and similarities of the interface between social institutions and media. By comparing journalism cross-nationally and diachronically we may lift ourselves mentally out of the present time frame and discover that contemporary or local practices are not self-evident. Many alternative practices of organizing the editorial work exist either in other places or in other times. Yet a cursory survey of media histories will reveal many common traits in the development of national journalism, traits that often follow each other in an identifiable sequence. Even if these sequences occur in different periods of true time, their internal chronologies may be comparable.

Another idea, bent on disclosing regularities, is that what turns out as variations in journalism cross-nationally may be caused by characteristic differences in prevailing conditions, which can be identified and compared universally. In this chapter, I discuss issues and topics in comparative journalism history, by rendering some studies that share these research strategies.

IDEATIONAL, MATERIALISTIC AND MULTI-FUNCTIONAL ANALYSIS OF JOURNALISM HISTORY

Mass communication may be seen within a wider context belonging to institutions of politics and culture, and in a more narrow one comprising the requirement to publish media content regularly. I first discuss the narrower context, near to journalism work, focusing on variations in the material base of news; more specifically on the capacity to mediate and disseminate messages. This implies mixing ideational and material conditions, which is sacrilegious in the view of many humanists. Humanists deny that material and ideational culture can blend. Primacy, it is opined, must be given to reciprocal personal relations and to social conditions, which is mainly upheld by communication through a common cultural experience.

The autonomy of journalism as an integrative part of culture is sometimes defended by arguments, similar to a Cartesian dualism that separates mind from body. Journalism can control its material environment; it is sometimes maintained, but not the other way around. Ryle (2006) claimed that as a "form of culture, news cannot be reduced to a function of some other economic, social, or political process" (p. 61). He joined Schudson (1991), who declared somewhat less definitively: "I take important internal changes in journalism to be explicable only with reference to broader social changes encompassing journalism. . . . Communication media must be

understood as social practises and cultural affordances, not distinct technologies" (p. 178). "Remember," Schudson (2001) wrote in another article on the objectivity norm in journalism, "that what is at issue is not a new style of prose but the self-conscious articulation of rules with moral force that direct how that prose shall be written. . . . Here the technological and economic explanations by themselves help not at all" (p. 159).

We may describe Ryle's and Schudson's position as a culturally deterministic way of studying communication phenomena—this is in stark contrast to the technological determinists, with Marshall McLuhan and his mentor Harold Innis leading the field for many years. Despite the low esteem for technology-inspired explanations of journalism, media technology still provides essential tools that increase production capacities, making larger audiences possible, which have clear repercussions for the mediating process and the possibilities for expressing journalism. Technology as an important economic and journalistic parameter for the media industry is being rediscovered in the age of Internet.

Reese (2006) took a huge step in the direction of a holistic view with his model of a hierarchy of influences. He began with a communicator-centered approach, including the socialization and attitudes of journalists, expanding the model to media organizations and routines and widening it to social institutions in order to find the major influences on journalism. It seems wise to start theories with the necessary conditions for publishing news media regularly.[2] What we are really looking for in communication research is a more general theory of journalism that comprises both messages and the means of communicating media as well as their environments, including both markets and the audience, as Reese proposed. Through cross-national comparative studies we can hopefully assess more accurately the impact of various cultural and political conditions on journalism as Hallin and Manchini (2004) have demonstrated.

CONDITIONS FOR JOURNALISM STYLES

History of journalism and comparative journalism studies vary in many respects from traditional press and broadcast histories by emphasizing the general conditions under which journalism operates. There is a widespread difference in opinion between those who see changes in media organizations and journalism as caused by entrepreneurs and press lords, and those who

[2]Reese also depicted the impact of ideological and hegemonic ideas as a pressure on media to maintain status quo in society. This perhaps may be a characteristic trait of present-day media conglomerates. However, it does not apply to media history in general. Forerunners of modern media in the 18th and 19th centuries were often opposed to the established political and religious regimes.

work from the premise that changes in journalism are mainly contingent on more enduring changes in the regular communicative situation of media.[3] As expressed by Köcher (1986), "Comparative studies address themselves to the different conditions that prevail rather than to those who practice their profession under these conditions" (p. 44).

Some of the conditions that prevail are known in literature, and refer to properties of the markets where media operate or to the nature of the audience of media, present or intended. Differences in journalistic style and content have been found between nations and international regions, as well as between the local press operating in small and socially tight markets and the metropolitan press operating in cityscapes with diffuse borders. There are obvious differences between the tabloid press operating in a nationwide, or socially indistinct, market and local newspapers; and both of them are different from the socially up-market quality press; journalism also differs between the business press and regular omnibus newspapers—and so on. In all of these cases there are easily discernable connections between differences in the wider context of social institutions and the narrower contexts of the media organization; between market conditions, which evoke journalistic strategies towards target groups of readers, on the one hand, and styles of print journalism on the other. However, in the scholarly literature these connections between conditions and journalism are often hidden in the classifications of types of newspapers. Taxonomies by themselves, give no explanation.

Conditions usually are stable over some time, as observed by many historians. It takes time to change the form of journalism, sometimes many decades, because changes also involve a complicated social process within and outside media organizations. In the individually oriented school of historiography first occurrences of journalistic methods, like the first interview or the first inverted pyramid, are an important index for new beginnings. The sociological school of journalism studies views an initial occurrence of a stylistic feature as an isolated fact until the new method is routinely practiced. Stensaas (1986-1987) demonstrated this clearly in his content analysis of the emergence of modern journalism in seven American dailies between 1865 and 1954:

> Both inverted pyramid and authoritative sources were rare in the 1865-1885 period and both were nearly universal after 1925. Based on the data, the general standard news report, after 1905, was an objective report written in inverted pyramid format and citing authoritative sources for the information. (Stensaas, 2005, pp. 41-42)

[3]In this context we understand *entrepreneurs* in the common meaning of the word as individuals who are able to combine money, machines, and men in new ways. *Conditions*, in the narrow context of media organizations, designate routines where certain ways of making and producing journalism are taken for granted. In a wider context, such routines depend on prevailing social conditions like the role of journalists and content providers, the political regimes, and censorship, as well as technology and the market for media, to mention some important examples.

A MATRIX OF CAUSES

Journalism is a product not only of cultural and political trends to which journalists are exposed; journalists are part of a multifunctional organization, which comprises not only the editorial department, but also divisions for production and distribution, in addition to divisions for advertising and for economy in general. By necessity, these subsystems coordinate their procedures to meet the regularly returning deadlines for publishing. The advertising department and the typographical division of a newspaper, for example, give the editorial department a dummy of the next issue with a number of columns to be filled, frames that influence the deadlines for delivery of copy, and sometimes the kind of copy delivered, as well.

The various departments are both autonomous and interdependent. This sounds like a contradiction, but jobs in the various departments are not readily interchangeable. Machines contain no recipe for journalism, so engineers cannot produce media content, but neither can journalists run the technology department. This makes the different professions semi-autonomous.

All of the three major subsystems just depicted—technology, economy, and journalism—can alternate in the role of a "key mover," which periodically brings about certain instabilities. What was changed first, of the three subsystems, and what followed next may vary from one period to another. As a consequence, these subsystems have separate chronologies. When chronologies are compared, they may reveal more about the configuration of conditions in the narrow or wider context under which journalism changed.

This is exactly what Kevin Barnhurst and John Nerone (2001) do in *The Form of News*. They delimited epochs in the development of American journalism by specifying the correlations between the environmental conditions (technological, economic, etc.) in the newspaper industry with changes in layout and journalism. Periods containing specific configurations of these conditions also are indirectly adapted to political and cultural periods in American history. There is, for instance, a printer's paper, an editor's paper, and a publisher's paper within the federal, transitional, partisan, imperial, Victorian, and modern periods in U.S. political history.

This is an open-ended way of anticipating and then observing changes, which may or may not support our initial expectations of connectedness between the narrow and the wider context for publishing. By contrast, some authors claim that epochs are irreversible and serve as stages in a grander teleological design. Habermas is a prominent representative for this kind of thinking in media history. In his *Structurwandel der Öffentlichkeit* (Habermas, 1962) his aim was, he recollected 29 years later, to construct an ideal public sphere—ideal in the sense of Max Weber—from various histor-

ical contexts (Habermas, 1991). Habermas found his "golden age" in London's coffee houses at the end of the 17th century; but by doing so he also anticipated some inherent mechanisms of decay.[4] Changes in the press, he pointed out, ran through different irreversible stages. Open discussion between equals, with the communicative reason as a guiding rule, was replaced by frozen postures in journals of opinions and party newspapers, or by political opportunism in the commercialized press. Open, unrestrained deliberations and discussions were replaced by inflexible ideological mass-mediated debates; insincerity had infected public life. Basically, the Frankfurter school and Marxism informed Habermas' dystrophies, as well as his interpretation of historical examples.

THE NATURE OF CHANGES
IN THE ORGANIZATION OF JOURNALISM

What exists, as adjustments of daily routines in present time, must also apply during historical transformation. When perspectives are widened, it is revealed that in the long run journalism was, and still is, influenced by fluctuations in the market for media products, by the professionalization of journalists and by the capacities of the whole media system to disseminate journalistic content to an ever-larger audience. Thus, the development of journalism also is influenced by the technology, which provides important means for handling a sufficient number of messages to a widening public.

To this historical outline must be added a gestation period of varying length where publishers, editors, and journalists discover the possibilities and limitations that a new technology offers for developing new methods of presentations. Thus, there may be a period of varying length before changes in technology have an observable impact on journalism. A lengthened period, however, makes it difficult to find the causal linkages between changes, responses, and adaptations. It may be easier to discover patterns of variable conditions in a wider historical perspective.

The latter half of the 19th century is described as a continuous revolution in printing and related technologies, which comprised most of the production factors in the newspaper industry, like the rotary press, newsprint, setting, and so on. To this were added inventions in editorial technology like the telegraph, newswires, typewriters, the telephone, and the like. In metropolitan areas, such as London and New York, these inventions greatly expanded the numbers of potential readers, increased newspaper competition and the number of journalists employed full time, and also invited advertisers to contribute to this phenomenal growth toward a mass medium.

[4]For a more recent criticism of Habermas' periods see Juraj Kittler (2009).

All these changes naturally initiated a collective search for new methods and formulae in journalism to harness the potential gains.[5] In this spirit, Conboy (2004) gave, in his *Journalism. A Critical History,* the following overview of the history of the British press for the past 150 years:

> Newspaper journalism moves in a complex and sometimes surprising fashion, from its liberalization after the lifting of taxes from 1855 to the twenty-first century, but certain patterns have persisted. The economics of the market have combined with technology to produce significant changes in its organization, distribution and content. (Conboy, 2004, p. 165)

This interpretation—of interrelationships between technology, economy, and journalism—does not necessarily deny the cultural dynamics behind changes in journalism. As just observed, technology by itself gives no guidelines for how to use it in a given cultural setting. On the other hand, technological innovations are rarely found in an economic and cultural vacuum. The social or cultural impact of new technology is much easier to understand when one takes into consideration the market context and the presiding cultural demands, which originally inspired technological innovations. New technology is preceded by ideas of market potentialities and followed by social inventions in new content.

THE ECONOMIC DIMENSION

Technology regularly promises an improved and updated journalistic product, but at a price. In a historical perspective, the demand for ever-increasing investments in technology gradually raised the threshold for entering the newspaper market and completely restructured the newspaper industry over time. A contributing factor both to investments and to the ensuing market concentration was increasing advertising revenues, which introduced modern consumer capitalism to newspaper making.

Economy has about the same low esteem in journalism studies, as has technology. "Cultural purists" in journalism studies claim there should be no economic influences on content and policy. The more cynically minded declare that the type of content of a medium to large extent can be guessed from the nature of its market situation.

Publishers, even if not allowed into the premises of the editorial department, have much influence over the kind of journalism that can be produced

[5]Such challenges to journalism are recognized in the Internet revolution today.

by their newspapers. Publishers control the budget and decide the share of investments given to the editorial department: How many and what kind of journalists are hired, and so on. Journalism has a price list: Investigative reporting is expensive and sometimes causes problems, whereas syndicated columns and features cost less (McManus, 1994). Local reporting also is costly compared with newswire. The demanded margin of profit by publishers may thus influence which kind of journalism receives priority.

The kinds of journalism needed also can be read from the market context of a publication, or from the kind of readers a newspaper tries to attract. There is a wide difference in living conditions, social life, and politics, between a village and a city. This also relates to the way media serves and addresses the public.

Tichenor, Donohue, and Olien (1980) compared newspaper coverage in local communities within small and large urban areas. They identified two distinct profiles in the coverage of public affairs. The small community-oriented newspapers, with little or no competition, adapted a "local ideology" in their journalism of idyllic harmony where the lines for emerging conflicts were regularly drawn between the community and institutions outside, not within the community itself. By contrast, metropolitan newspapers pursued a journalistic strategy of "conflict management" between groups and institutions in their socially and politically heterogeneous circulation district, realizing that some kinds of conflicts rarely disappear.

These differences in strategies may also change over time as efficient printing presses and improved transportation made wider circulation areas possible. Barnhurst (2007), for example, demonstrated how such changes affected policy in a sample of American newspapers over a 100-year period. Gradually, the newspapers gave less emphasis to individuals, and instead highlighted specific people portrayed as metonyms of social groups, for instance by being victims of diseases, natural disasters, and the like. To save space, editors and journalists widened the scope of each story to appeal to the interests of larger segments of the population. As a result, the trend was toward longer stories, not toward shorter as guessed by the many professionals whom Barnhurst asked for a calculated opinion.

A BRIDGE BETWEEN WIDE AND NARROW
CONTEXTS: THE INTERVIEW

Some forms of journalism compel journalists to actively face the world outside, and not only report or edit what comes to light by rumor or through the post. The interview is such an efficient form, as well as an essential tool, for journalists to find information on their own initiative. This is a relative-

ly modern method of information retrieval. Initially, interviewing met with opposition from the elite because it changed the balance of power. Even today, the journalistic interview is strongly restricted and regulated in authoritarian regimes. The same goes for the so-called inverted pyramid, not to mention investigative reporting, which implicitly transfers the role of a storyteller from the sources of information to the journalist. Media take charge in evaluating what is interesting and encapsulate events, which they find important. The history of journalistic forms thus has more than a chance relationship to social mores and political control in a society. Comparative studies of journalism may disclose details in this relationship.

By means of the interview, journalists ask experts to provide information and advice free of charge, and give the experts publicity in return. It is a form of bargaining. During the interview session the journalist demands answers, but gives very few responses in return. The silent third part, to which both participants are addressed, but on different terms, is of course the public. Another essential element of the same bargaining is the social position and power of the participants. The interviewee regularly represents important opinions, which can inform or influence various groups of citizens, followers, members, or customers. On their own part, journalists represent an audience of varying sizes and a potential impact for the message of the interviewee.

Over time, new technology has changed the character of interviews. The telephone and more modern forms of telecommunications made queries to outside sources a journalistic routine. Before the interview became customary, journalists had to find information by direct observation and from reporting on meetings where the information sources were speakers of varying importance. These rather passive types of journalism were the prominent forms at the beginning of the 20th century.

Roksvold (2001) observed the use of verbal sources in a sample of five Norwegian newspapers. Simple interviews or interviews used in combination with either observations made by the journalist or with information from documents was classified as *active* journalism. By this measurement, Roksvold found that active journalism had increased more than twofold between 1903 and 1993, from 26% to 59% of coded stories.

Høyer and Nonseid (2005) also documented the tendency toward more active reporting in their content analysis of four Oslo papers from 1908 to 1940. Activity was measured by three categories: Active journalism was stories based on either interviews or on observations, which were transcribed into feature stories. Passive journalism was stories where information was taken from documents, or received from outsiders without any effort from the journalist, or it was reports from meetings and arrangements. The third category, neither passive nor active, was comment. By this measurement the same tendency came out clearly: 78% of stories were passive in 1908, and

36% in 1940. By contrast, active journalism increased from 5% in 1908 to 48% in 1940.

Another explanation of the popularity for the news interview is the rising amount of professionalization in society. An increasing number of vocation and social functions have been formalized with their own education and research, thus providing many neutral "experts." As a rule, the more institutionalized interests there are in a pluralistic society, the more of these interests have an address: a head office, a spokesperson, with a telephone, e-mail, and the like. Thus, it has become much easier for journalists to access informants, who have both an overview and the authority to give relevant answers.

At the opposite end of the political continuum are totalitarian or autocratic political systems where the information that can be published is rarely negotiable. Instead, rules of censorship define the relationship between reporters and sources—who can be an informant, which kinds of information are allowed, how shall the information be written up, what kind of stories and propaganda do censors prefer? (Lauk, 2005).

The manner of interview practice as a journalistic tool can reveal much about the social status of journalism in general. Ekström (2006) thus gave more than a detail of journalism when he studied the use of the interview, among other methods of information retrieval, in two important Stockholm dailies between 1915 and 1995.[6] The period covers a transition from a multiparty press to a politically more independent journalism.

Ekström found that in the old-style journalism, reports from Parliament comprised 38% to 43% of quotations from events in 1915, and in total between 76% and 92% of these quotations in 1915 were taken from political institutions. The shift to 1995 is dramatic with between 0% and 9% of quotations from Parliament, and overall, 2% to 22% from other political institutions. The modern interview was almost nonexistent (0%-4%) in 1915, whereas in 1995 the interview was the dominant method of retrieving information (23% and 74%). It was only in the post-World War II period that the interview clearly became the most preferred method for journalists in Stockholm. As seen, these findings are supported by Norwegian results.

When we review the pattern of empirical findings in this chapter, of which I have only reported a few, we discover a cultural lag in the introduction of modern forms of journalism in Scandinavia as compared with the United States and Great Britain, with some possible exceptions in Denmark. One likely explanation of these phenomena is the politically committed multiparty press, which was common in Scandinavia until the 1980s as compared with the Anglo-American, politically more independent journalism. In other words, and not surprisingly, textual conventions are part of their cultural environment.

[6]*Dagens Nyheter* and *Aftonbladet*, both circulation leaders in their respective categories: quality newspapers and tabloids.

THE IMPACT OF CULTURE
ON JOURNALISTIC FORMS

By studying variations in journalistic forms, we may shed light on the rising journalistic autonomy over time. By comparing journalism in different cultural settings, we also may understand more of the relationship between the professional values of journalists and characteristics of their national or regional cultures.

Schudson was certainly right when he argued that changes in journalism must be understood as part of broader cultural and political currents. Not only did journalism and communication technology change greatly from the turn of the 19th century, but also lifestyles, scientific ideas, and cultural and religious values changed concurrently. We may expect culture to intervene in the diffusion of journalistic styles internationally, and even to resist the globalizing effects of the international newswire.[7] Even without many systematic studies, some marked differences are clearly discernable between regions.

The most noted disparity in journalistic cultures internationally occurs between Anglo-American journalism on the one hand, and the continental European on the other: a difference that persists despite similar developments in technology. The "new journalism,"[8] which emerged in the United States at the beginning of the 20th century, took some time to be accepted, as seen in the case of Sweden and Norway and on the continent of Europe.

Chalaby (1996) went back in history and looked at how news was evaluated in Great Britain and France in the 1830s and 1930s. He found a char-

[7]In a content analysis of four Oslo dailies from 1908 to 1940, Høyer and Nonseid (2005) found that far from dominating the news pages, newswires declined in number between 1915 and 1940, despite a threefold increase of total copies. By 1930 and 1940, self-made articles outnumbered newswire stories more than fourfold. One exception was in 1915: Newswires and self-made copies were in equal numbers, as a result of newswires about World War I. The strong influence of newswires on the general styles and attitudes of newswriting in newspapers has been postulated by many, most notably by Shaw (1967). A prominent feature of newswires is the inverted pyramid construction. In our sample, the inverted pyramid was used three times as often in newswires compared with the self-made copies. But, we also found that newswires were by far outnumbered by self-made articles using alternative story constructions. The influence on the style in Norwegian journalism from the international news bureaus during this period seems limited.

[8]Changes toward more popular and investigative journalistic genres occurred over many decades in widely different regions internationally, and were seemingly uncoordinated. The "new journalism," which developed in the United States over a 40-year period around the turn of the 19th century, as Stensaas and others demonstrate, did not diffuse easily to most parts of Europe as pointed out by Köcher, Chalaby, Donsbach, and others. Important parts of the "new journalism" only became a routine in Scandinavia in the post-World War II period, as Ekström found in the case of interviewing in Sweden, whereas it was nearly universal in the United States after 1925. The delay may be the result of differences in journalistic cultures, aptly described by Hallin and Mancini (2004).

acteristic difference in style and genre. French journalism emphasized com-
ments and a literary style compared with the factual and neutral journalism
in the British press. Chalaby then outlined some consequences of such dif-
ferences in the amount of informational news presented, the variety of jour-
nalistic genres, the volume of advertising, the number of pages and of hired
journalists, and so on—more of this in the British press, less in the French.
In France, as in Germany, journalism was an intellectual calling within a
more limited and highbrow readership, and with more highly educated jour-
nalists, as compared with Great Britain and the United States. In Germany,
the opinionated editor and commentator was seen as the epitome of the
journalistic profession (Donsbach & Klett, 1993; Retallack, 1993). In
England, by contrast, journalism became a regular occupation of a rather
low social standing within a socially diffuse mass audience. Despite all these
differences, the French press gradually adopted the American-inspired news
journalism from the 1920s (Chalaby, 1996, 1998).

In a comparative interview survey of West German and British journal-
ists from the 1980s, Köcher (1986) observed a characteristic difference in
their attitudes toward sources of information. British journalists were more
aggressive and willing to use nontraditional or covert methods for obtaining
information, and were less concerned with the writing up of the story in a
literary style, compared with the West German journalists. Esser (1999)
found a similar difference in journalistic style between Germany and Great
Britain. There is a higher rate of approval among English compared with
German journalists of investigative, partly covert, methods of retrieving
information for their stories.

Donsbach and Klett (1993) found some ambivalence in attitudes toward
neutral reporting among continental European journalists: On the one hand
there was a widespread and favorable attitude toward the "objectivity
norm" among journalists from Italy and Germany and their colleagues in
the United States and Great Britain. However, journalists differed marked-
ly on the question of whether this norm was consistently applied in their
own media organization. The Anglo-American respondents were the most
satisfied with their own media organization in this respect.

Indirectly, part of these findings of cultural differences are supported by
Shoemaker's and Cohen's (2006) wide-ranging study of how the concept of
news is perceived in professional milieus in ten countries around the world:
Australia, Chile, China, India, Jordan, Israel, Russia, South Africa,
Germany, and the United States. Twenty-three researchers were involved
using the same codebook to analyze news content in newspapers, radio, and
television in the same sampled week. Also, focus groups consisting of jour-
nalists and public relations people were invited in each country to comment
on what they thought were the main characteristics of news in general. The
results demonstrated great variability in the selection of news by media
cross-nationally. Media differed widely in what news they brought in the

sampled week. By contrast, the focus groups demonstrated a strong consensus cross-nationally about the newsworthiness of events. From this, Pamela Shoemaker and Akiba Cohen conclude that what differs mostly between countries is not the perception of newsworthiness, but the norms of proper journalism, exercised by various media organizations cross-nationally: "a major finding of our study is that what people—even journalists—think is newsworthy is not necessarily what becomes news" (p. 337).

As these findings illustrate, not only literary culture, but even more journalism over time have developed their preferred genres of textual expressions. These conventions probably have inertia of their own, which delays the adaptation of new forms from abroad.

RECONTEXTUALISATION AND RECREATIONS

In this chapter I suggested several propositions about what to compare in journalism history, illustrated with findings from the scientific literature. To better understand long-term changes in journalism, I suggest it be studied in two inter-connected contexts: a wider one belonging to politics and culture, and a narrower one including the requirements to publish media content regularly.

In the *wider context* there exist variations in the freedom of expression and in litigation laws between nations, which not only influence what can be expressed but also clearly influence the style and genres of journalism. Censorship, for instance, inspires writing between the lines and the use of allegoric styles of telling stories. Thus, political and cultural conditions form filters, and sometimes barriers, toward ideas of telling news and opinions in a more straightforward manner. Relations in the web of contacts, which media maintain with information sources, are more or less strictly regulated by formal and informal rules. Thus, the retrieval of information changes from one society to another, as evidenced by comparisons between Anglo-American and continental European journalism cultures.

The *narrower context* contains three interdependent and semi-autonomous parts: one for economy, one for technology, and one for journalism. These divisions are interdependent and must adapt their work routines to each other within both a short- and a medium-range schedule. This gives the narrow context a kind of systemic character, which is rather similar from one media market to another in its main outline, all other things being considered equal. Technicalities of the editorial organization and production technologies will probably change more with the size of local markets than between nations. These cross-national similarities will primarily affect how journalism is produced, but they may also influence media content.

Historically, changes toward more popular and investigative journalistic genres occurred over many decades in widely different regions internationally, and were seemingly uncoordinated.

The adoption of journalistic ideas is probably a kind of negotiation of different cultural values, which produce a national hybrid rather than a replica of international styles. This, however, also may vary between newspapers in different market segments: between the more experienced and traditional newspapers and upstarts, more open for experiments. For instance, the journalism of popular tabloids seems to have spread faster to a few but often very successful European newspapers, in London, Paris, Copenhagen, and so on, which adopted the new journalism almost from their first day of publication.

The long temporal leaps between innovations and adaptations, found in cross-national comparisons, between the United States, continental Europe, and Scandinavia make it difficult to imagine the diffusion of journalistic ideas in terms of a simple linear causality. An alternative to linearity may be to imagine a sort of recreation of a new journalism under recontextualized circumstances: When a given constellation of conditions in the narrower and wider context of publishing is present, it will inspire certain strategies in journalism, which turn out as changes in journalism, which have been observed elsewhere earlier. The nature of these constellations must now be further explored.

REFERENCES

Barnhurst, K.G. (2007). Ideology and the two industrial revolutions of the twentieth century. In M. Broersma (Ed.), *Form and style in journalism. European newspapers and the representation of news, 1880-2005.* Leuven: Peeters.

Barnhurst, K.G, & Nerone, J. (2001). *The form of news. A history* (pp. 219-235). New York: Guilford.

Chalaby, J.K. (1996). Journalism as an Anglo-American invention: A comparison of the development of French and Anglo-American journalism, 1830s-1920s. *European Journal of Communication, 11*(3), 303-326.

Chalaby, J.K. (1998). *The invention of journalism.* Basingstoke: Macmillan.

Conboy, M. (2004). *Journalism. A critical history.* London: Sage.

Donsbach, W., & Klett, B. (1993). Subjective objectivity: How journalists in four countries define a key term of their profession. *Gazette, 51,* 53-83.

Donsbach, W. (1995). Lapdogs, watchdogs and junkyard dogs. *Media Studies Journal, 9,* 17-30.

Ekström, M. (2006). Interviewing, quoting and the development of modern news journalism: A study of the Swedish press, 1915-1995. In M. Ekström, A. Kroon, & M. Nylund (Eds.), *News from the International Interview Society* (pp. 21-48). Göteborg: Nordicom.

Esser, F. (1999). "Tabloidization" of the news: A comparative analysis of Anglo-American and German press journalism. *European Journal of Communication*, 14(3), 291-324.

Habermas, J. (1962). *Strukturwandel der Öffentlichkeit. Untersuchungen zu einer Kategorie der bürgerlichen Gesellschaft.* Neuwied und Berlin: Hermann Luchterhand.

Hallin, D.C., & Mancini, P. (2004). *Comparing media systems. Three models of media and politics,* Cambridge: Cambridge University Press.

Høyer, S., & Nonseid, J. (2005). The half-hearted modernisation of Norwegian journalism, 1908-1940. In S. Høyer & H. Pöttker (Eds.), *Diffusion of the news paradigm 1850-2000* (pp. 123-136). Göteborg: Nordicom.

Kittler, J. (2009). *Historical metamorphosis of the Athenian agora: Changing communication technologies and the enduring quest for an ideal public sphere.* Unpublished doctoral dissertation, The Pennsylvania State University.

Köcher, R. (1986). Bloodhounds or missionaries: Role definitions of German and British journalists. *European Journal of Communication*, 1(1), 43-64.

Lauk, E. (2005). The antitheses of the Anglo-American news paradigm: News practices in Soviet journalism. In S. Høyer & H. Pöttker (Eds.), *Diffusion of the news paradigm, 1850-2000* (pp. 169-183). Göteborg: Nordicom.

McManus, J.H. (1994). *Market-driven journalism. Let the citizen beware?* (pp.85-91). Thousand Oaks, CA: Sage.

Reese, S.D. (2006, November). *Journalism research and the hierarchy of influences model: A global perspective.* Paper presented at the conference, Rethinking Journalism Across National Boundaries: New Challenges and Emergent Perspectives, Porto Alegre, Brazil.

Rettallack, J. (1993). From pariah to professional? The journalist in German society and politics, from the Late Enlightenment to the rise of Hitler. *German Studies Review, 16*(2), 175-223.

Rogers, E.M. (1962). *Diffusion of innovations.* New York: The Free Press

Roksvold, T. (2001). Norske advisers innenriksnyheter i et hundreårsperspektiv [Domestic news in Norwegian newspapers over a century]. In H.G. Bastiansen & Ø. Meland (Eds.), *Fra Eidsvoll til Marienlyst. Studier i norske mediers historie fra Grunnloven til TV-alderen.* Kristiansand: Høyskoleforlaget.

Rostow, W.W. (1960). *The stages of economic growth.* Cambridge, MA: Cambridge University Press.

Ryle, D.M. (2006). News culture and public life: A study of 19th-century American journalism. *Journalism Studies, 7*(1), 61.

Schudson, M. (1991). Historical approaches to communication studies. In K. Bruhn Jensen & N.W. Jankowski (Eds.), *Qualitative methodologies for mass communication research.* London: Routledge.

Schudson, M. (2001). The objectivity norm in American journalism. *Journalism, 2*(2), 149-170.

Shaw, D.L. (1967). News bias and the telegraph: A study of historical change. *Journalism Quarterly, 44*, 3-12, 31.

Shoemaker, P.J., & Cohen, A.A. (2006). *News around the world. Content, practitioners, and the public.* London: Routledge.

Stensaas, H.S. (1986-1987). Development of the objectivity ethic in US daily newspapers. *Journal of Mass Media Ethics, 2*(1), 50-60.

Stensaas, H.S. (2005). The rise of the news paradigm. A review of the scientific literature. In S. Høyer & H. Pöttker (Eds.), *Diffusion of the news paradigm, 1850-2000* (pp. 37-49). Göteborg: Nordicom.

Tichenor, P.J., Donohue, G.A., & Olien, C. (1980). *Community conflict & the press.* Beverly Hills: Sage.

PART II

JOURNALISM
AND SOCIAL CHANGE

Despite the importance of journalism as an institution affecting social change, and regardless of the relevance of news media as sites "in which contests over meaning must succeed politically" (Gamson 1998, p. 59), the scholarship on historical changes in journalism practice is scarce. A newspaper carries the power to produce knowledge, and is itself a social institution with a status and reputation that greatly impacts on judgments of reality. The interactions among journalism and politics, economy, organizational structure, and culture at large, highlight the multilayered nature of newspaper text and the complexity of its diverse readings, calling on news makers to reflect on their own practice.

Using examples from New Zealand, Denmark, and Australia, four authors take a closer look at the extent to which changes in journalism reflect and participate in sociocultural change.

Verica Rupar (Chap. 4) presents a study of New Zealand newspaper *The Dominion* (*Post*) and the development of its editorial page over the course of a century. Investigating different features of newspaper design, and analyzing the self-reflective anniversary editorials, she identifies mechanisms by which the newspaper maps reality for its readers, and the professional ideology that underpins the process of meaning-making. Rupar invites readers to re-examine the long-standing concept of the twofold nature of a newspaper, its moral and material existence, arguing that this description of news business narrowly frames the relationship between journalism and society.

In Chapter 5, Grant Hannis discusses the relationship among owner-ship, cooperation, and the news. There is a common belief that with new conglomerates comes more "soft" news and less diversity of views. However, Hannis' study of the *New Zealand Press Association* (NZPA) paints a slightly different picture: The competitive instinct of journalism appears stronger than commercial interests when a situation forces a choice between the two. The history of the NZPA demonstrates that even in a frag-mented newspaper market such as New Zealand, the journalistic ethos to "scoop" the competition and provide exclusive content to its readers trig-gered ownership change, not the other way around.

Ebbe Grunwald, in Chapter 6, uses the case study of the newly estab-lished Danish media house *Nordjuske Medier*—a media organization that incorporates television, radio, newspaper, and a Web site—to compare the reporting practices of different media platforms. He investigates one partic-ular news story about a murder during a local school ball to examine the cul-ture of cooperation at each media platform. What he finds is that innovation that takes place economically, ideologically, technically, and organizational-ly seems to be met with resistance: tradition, in terms of genre and style, takes precedence over innovation.

David Rowe (Chap. 7) examines three Australian newspapers (two broadsheets and one tabloid) to test the important and influential "tabloidization thesis." The proposition that all media have moved toward more direct, simplified, succinct, and spectacular modes of news and enter-tainment is commonly referred as a part of the wider "tabloidization of soci-ety." Rowe argues that these considerations raise difficult questions of causality, in particular the extent to which changes in newspapers and media reflect or precipitate sociocultural change. His detailed quantitative analyses of features that define a tabloid newspaper show that there is no consistent evidence of a tabloidization trend in the conventional sense of the word. Tabloidization appears as a new type of engagement with the audience, a process that runs in parallel with increasing media competition and a decline in the authority of the news media.

4

JOURNALISM AND SOCIAL CHANGE

100 Years of the New Zealand Daily
The Dominion (Post)

Verica Rupar

Cardiff University

The front page of a daily newspaper, *The Dominion Post*,[1] published on September 26, 2007, announces the centenary anniversary of two important events in New Zealand history: the change of the country's status from colony to dominion, and the birth of the newspaper. The judgment of the most important events of the day, reflected on the front page, is further elaborated on the editorial page, indicating the newspaper's pride at being a witness and an actor in making national history. The editorial specifies that the celebrations are "significant signposts," but stresses how "neither marks the end of a journey" (p. B4). The newspaper explains that, for New Zealand, the journey will certainly at some stage include a shift from monarchy to republic because the ties with Britain have weakened, and a head of state based in Europe hardly makes any sense for the increasing number of New Zealand citizens. As for the voyage of the newspaper itself, "today's newspaper is virtually unrecognisable compared with the first edition a century ago" said the editorial, and promises that it would "continue to do what it has for the past 100 years—cover the issues that matter to our readers, whether they are local, national or international" (p. B4).

It is the journey of a newspaper that is the focus of this study. Between the cheerful lines of the celebratory articles that underline the importance of the newspaper in the life of the nation, many questions emerge. What exact-

[1]The name of the newspaper was *The Dominion* from 1907 to 2002, when it became *The Dominion Post* after merging with Wellington's evening newspaper *The Evening Post*. It is referred to herein as *The Dominion Post*.

ly does the current editorial team promise when it says it will cover issues
that matter to readers? How did they know what mattered in the past? What
influenced the transformation of the newspaper over the course of a centu-
ry? To what does the newspaper allude when claiming, "*The Dom* sought to
record social change" (p. A1)? Does the change go along the lines described
by the long-serving editor of the *Manchester Guardian* C. P. Scott (1997[2]) as
the twofold nature of press?

> It is a business, like any other and has to pay in the material sense in
> order to live. But it is much more than a business; it is an institution. . . .
> It may educate, stimulate, assist, or it may do the opposite. It has, there-
> fore, a moral as well as a material existence, and its character and influ-
> ence are in the main determined by the balance of these two factors. (p.
> 108)

How does a newspaper, in all its moral and material existence (Scott, 1997),
become part of readers' lives? What matters more, profit or public service?
How does it change? What are the elements of the cultural and social
processes that underlie the change?

It seems it is easier to list the questions that underpin the study of jour-
nalism as a cultural system than to provide the framework for answering
them. Despite the importance of journalism as an institution affecting social
change, and regardless of the relevance of news media, the scholarship on his-
torical changes in journalism practice is scarce. A newspaper—such as *The
Dominion Post*—carries the power to produce that knowledge, and is itself a
social and cultural institution with a status and reputation that greatly
impacts on judgments of reality. The question of practice in any cultural sys-
tem is far more than a matter of following already established rules. In the
case of journalism, the meaning of a news text includes both the facts about
the reported event or an issue and the journalist's account of those facts, as
Matheson eloquently explains in Chapter 2 of this book. This account, or to
be more precise, journalism's production of meaning, is a cultural phenome-
non that links together structure and action. Journalism production comes as
a manifestation and an outcome of the interplay between the individual and
the "pre-law" or the "customary rules" (Bourdieu, 2002, p. 16) that exist in
a professional group memory and "are themselves the product of a small
batch of schemes enabling agents to generate an infinity of practices adapted
to endlessly changing situations" (p. 16). The "customary rules" in the jour-
nalistic field are the explicit[3] and implicit schemes that both regulate and

[2]Scott was the editor of the *Manchester Guardian* from 1872 to 1929.
[3]Newspaper style guides, used in New Zealand dailies, are focused on stylistic questions,
whereas the Press Council's Code of Ethics and Statement of Principles provide a broad frame-
work for everyday work.

define the work of the journalists in the field. The field itself also is histori-
cally positioned within the broader social, political, and cultural environ-
ment consisting of semi-autonomous specialized spheres of action (e.g., the
field of politics, the economy, cultural production, or science) where the rela-
tions of power, not only among the fields, but within the fields as well, struc-
ture human action (Bourdieu, 2005). The incorporation of the "field" pro-
vides a framework for the following analysis of journalism and social change.

To address the question of the production of meaning and the relation-
ship between journalism and social change, this study looks at the historical
development of one specific New Zealand daily, *The Dominion Post*, from
its foundation in 1907 to its anniversary in 2007. The investigation of jour-
nalism as a way of grasping and constructing reality focuses on different
design features of the editorial page, and on the content of the self-reflective
leader[4] articles published in *The Dominion Post* over the course of the cen-
tury. It looks at the individual texts, but aims to grasp journalism as a prac-
tice that situates the production and reproduction of other social fields. It
follows Bourdieu (2005), who explained that it is important to talk about the
journalistic field and not individual journalists because "so long as one talks
about journalists, one is talking within a logic of personal responsibility,"
and if one talks in terms of a field there is an opportunity to investigate not
only individuals but "the structure of the journalistic field and the mecha-
nisms that operate within it" (p. 41).

Many anecdotes from the anniversary issue of *The Dominion Post* illus-
trate how journalism practice has been structured by the social, political, and
cultural milieu within which the newspaper has operated. The newspaper
proudly lists its most successful investigative projects, signaling, but not
fully revealing the opposite process—how the "rules of the game" have pro-
gressed and developed as autonomous elements in the process of meaning-
making in society. In the words of Benson (2004), news content is influenced
by political or economic factors, but it also functions "as an *independent*
variable, as part of the process of political meaning-making rather than just
a convenient indicator of the outcome" (p. 276). How can we identify the
independent variable component of news? Does it sit in the text, as many
ideological analyses of news suggest, or does this independence come from
journalistic action that is embedded in a news organization?

This study starts with the analysis of some of the less-explored features
of journalism, seeking to bring to light the autonomous elements of the
practice, something that might be called a system of structured improvisa-
tions in journalism. The development of *The Dominion Post* explains how
social context determines the rise of a new daily, and how specific elements
of newspaper design reveal a pattern of change within journalism. The study
shows how the editorial page, arguably the most prominent site for provid-

[4]The terms *leader article* and *editorial* are used interchangeably.

ing an arena for public debate, has historically articulated the newspaper's mission and its understanding of the role of journalism in society. This study of a New Zealand newspaper makes reference to similar investigations of the American and Serbian press (Barnhurst & Nerone, 1991, 2001; Rupar, 2007). It explores how considerably different news cultures and significantly different journalism trajectories trace the route by which the field of journalism appears as an indicator of a discrete phenomenon—the meaning-making process—in society.

The editorial page is selected because it transparently articulates a newspaper's position as mediator between the reader and reality. This page demonstrates how, among those who compete to impose "the legitimate vision of the social world" (Bourdieu, 2005, p. 36), journalism is a crucial mediator. Unlike the front page of a daily newspaper that simultaneously reflects the most important events of the previous day (representation of social reality) and reveals journalism's approach to those events (interpretation and construction of reality), the editorial page expresses the newspaper's reactions to issues of public concern. Whereas the front page sells the newspaper's judgment of the most important events of a day, the editorial page indicates the position of the newspaper in the wider public arena (Hilgartner & Bosk, 1988).

Journalism is seen as a cultural practice, created by the interaction between an individual and a group, and between the actual and the historical. It is possible to detect mechanisms by which it maps reality for its readers, and contributes to the formation of a news culture based on "the ideological assumptions, modes of perception and even unconscious expectations which need to be sustained by journalists and audience member alike if a news account's claim to be a factual representation of reality is to be upheld" (Allan, 2004, p. 4). The study concludes with some observations on the "twofold nature of newspaper" that has become a well-established structure for describing a news business over the century. *The Dominion Post* has framed its own existence by using moral and material imperatives to describe the daily running of a newsroom. This frame turns out to be the most persistent organizing principle that symbolically portrays journalism in New Zealand.

THE IMPORTANCE OF NEWS CULTURE

What we know from existing comparative studies is that news culture comes about as a result of an "intervening variable between people—journalists, sources or public—and a given 'objective' situation—media events, organisations, infrastructures, and systems—through which citizens inform or are informed" (Deuze, 2002, p. 134). The understanding of journalism's role,

therefore, differs around the globe, but not many studies have been undertaken to identify those differences and discuss their implications for the interactions among the fields of political, social, and cultural production. According to a 2004 survey (Lealand, 2004),[5] New Zealand journalists value their profession for its abilities to "provide objective reportage," "influence public debate and discussion," and "communicate between the various sectors of society" (p. 190). But what is objective reportage and what else has to be assumed before we start thinking about journalism across the century?

New Zealand journalism shares the characteristics of Anglo-American journalism: detached reporting style, fairness and balance of sources, distinction between facts and views, and empiricism over intellectualism. The prevailing British influence on the development of the press has been colorfully described as a kind of "enduring hangover from the days of the British Empire" (Norris, 2001, p. 85). Although the history of national journalism has still to be written,[6] Day (1990), who pioneered the teaching of media studies in New Zealand, explained that newspapers in the first half of the 19th century in New Zealand, like the press in the United States and the United Kingdom a few decades earlier, generally reflected the point of view of one person—the publisher. Newspapers acted as political advocates for individual politicians until the 1860s when, with the establishment of the *Otago Daily Times*, New Zealand newspapers' circulation began to grow as "the increase in population made it possible for the first time for newspapers to be profitable commercial concerns" (Day, 1990, p. 235).[7]

Commercial interests were important in the formation of *The Dominion*, but were not the only interests. The newspaper was founded in 1907[8] by an influential group of farmers, merchants, and professionals. Media historians (Du Fresne, 2007) stress that *The Dominion*'s initial intention was to give a voice to conservative, right-wing political causes. Du Fresne explained that "the wealthy landowners who set up the Wellington Publishing Company, publisher of *The Dominion*, were particularly incensed by the Liberal's policy of breaking up big rural estates to enable settlement by small farmers" (p. F3).

[5]The very low rate of survey responses casts a shadow over these findings and prevents the survey from being seen as a national one. The author expressed reservations in relation to the sample size of the survey because there was only a 30% response rate (297 journalists responded), but still presented some of the results.

[6]The most recent attempt to profile the historical development of the profession of journalism is Nadia Elsaka's PhD study *Beyond Consensus?: New Zealand Journalists and the Appeal of "Professionalism" as a Model for Occupational Reform*, University of Canterbury, 2004.

[7]Day's study puts an emphasis on economic factors that have influenced newspaper development in New Zealand and, following the classical "political economy approach" to the media, investigates the pattern of wider political and economic changes in society in order to explain the position of the press.

[8]It appeared later than other prominent metropolitan dailies. *The Press* was founded in 1861 and *The New Zealand Herald* in 1863.

However, the paper attempted to honor the boundary between journalism and politics. The first editorial, which appears on September 26, 1907, declared the paper's duty to be

> . . . a truly representative one, giving full and free representation to the views of every class and interest in the community—pandering to none—reserving to ourselves the right to comment in our editorials as we shall think fit—and desiring only from every class the tribute that, whatever the editorial opinions may be the reports of news are full and absolutely without bias or feeling. (p. 6)

This approach to media, known as "liberal pluralist," puts the newspaper in the position of a fourth estate, and the journalist at the center of public life "with the crucial mission of ensuring that members of the public are able to draw upon a 'diverse market place of ideas' to both sustain and challenge their sense of the world around them" (Allan, 2004, p. 47). The news media have a set of roles they are supposed to play: facilitate the formation of public opinion, foster public engagement with the issues of the day, allow clashes over decision making, have a "watchdog" function in relation to the government, and participate in general arenas of arbitration. The fact is that the journalistic field itself consists of a plurality of viewpoints, and clashes between different interests (owners, editors, journalists, managers) ensure that a single set of interests will never prevail. That is the theory. In reality, it is hard to place journalism within a continuum that allows such a linear development of its everyday practice. The analysis of the development of *The Dominion Post*'s design, shows how difficult it is to grasp the newspaper's ethos in the absence of written norms that generate and regulate the process of mapping reality for its readers. But it is worth trying.

THE STORY OF DESIGN

To identify the development of editorial page design, I systematically counted all the features on the editorial page across the century: number of items, then specifically classified news, opinions and letters to the editor,[9] the number of photos, illustrations and columns, words in the editorial headlines, and the number of advertisements and classifieds. The objective was to cap-

[9]The classification of news, opinions, and letters to the editor serves the objective of the study to identify "informative" and "argumentative" discourse on the page. For more detailed analyses of the form of newspaper text on the editorial page, it would be necessary to further refine genres or subgenres, such as "news" on interviews and features for example, or "opinions" in the editorial and personal columns.

ture any design changes, assuming that a "newspaper design" is an idea, plan, and application of the page's layout and content.

The content analysis of the features on 85 editorial pages[10] of *The Dominion Post* signals two patterns. First, the change in layout has been gradual, somewhat slower but in line with the change identified in the American and Serbian press (Barnhurst & Nerone, 1991, 2001). Second, the development of the content of *The Dominion*'s editorial page challenges the conventional assumption that this page is a historically constructed site for public dialogue, and a form of public sphere. It is true that the strongly argued viewpoints and benchmarks against which readers can test their own opinions (Hynds & Archibald, 1996, p. 16) can be identified in editorials from very early in the 20th century, but the forum-creating capacity of the whole editorial page comes as a far more novel phenomenon. In the New Zealand press, the "public arena" model of the editorial page appears only in the second half of the 20th century.

The layout of *The Dominion*'s editorial page bears the characteristics of the Victorian newspaper page up to the 1950s. The pages are dense and heavy, filled with text, using banner-like headlines, one-column articles, and "headless" news (text separated by a printed line rather than a headline). The first photography appeared on the September 26 editorial page in 1944. Du Fresne (1997) found that news pictures started appearing in the *The Dominion* in the early 1930s, and initially all on one page. This analysis shows that the real, significant change of the layout did not occur until 1964, when the number of the items published on a page dropped from 12 to 6 (Fig. 4.1).

In the U.S. press, the first change from the Victorian layout occurred in the 1920s (Barnhurst & Nerone, 1991) and again, more radically, between 1955 and 1965. In Serbian newspapers, the first radical shift from Victorian layout is evident in the 1930s and again between 1955 and 1965 (Rupar, 2007)—later than in the United States, but earlier than in New Zealand.

The slowness in moving toward a more modern appearance also can be seen in the number of columns used to compose the editorial page itself. It has changed from year to year, and within the page (e.g., 9 columns upper half of the page, 10 columns lower part of the page in 1972). The ease of playing with the number of columns per page might indicate the editorial team's unawareness of or resistance to the notion that design continuity has an important role in the formation of a newspaper's identity. For comparison, this point turned out to be of great importance for Serbian editors, who changed the number of columns on the front page only twice in the course

[10]The sample for analysis consists of pages published on the day *The Dominion* was founded September 26 for each year in the specified period. There are only 85 pages because the newspaper is not published on Sunday and some dates fall on Sunday, and because some copies in the New Zealand National Library were either missing or unreadable.

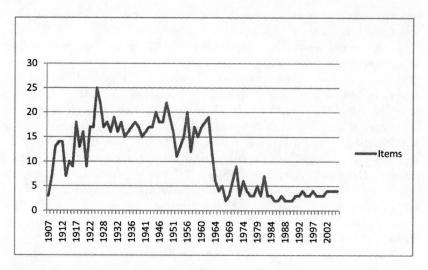

Fig. 4.1. **Number of items per page.**

of the 20th century, as the study of the leading newspaper *Politika* shows. *The Dominion Post* was slow to use modern tools of newspaper design. The first illustration in *The Dominion* appeared in 1907 (a copy of the front page of the *New Zealand Gazette*, the first newspaper in New Zealand), but it was almost 50 years (1952) before the next illustration, a drawing, was published on the editorial page.

The newspaper's reluctance to make radical design shifts, its visual conservatism—far from the modernity promised in the editorial of the inaugural issue of *The Dominion*—has several possible explanations. First, it resembles the conservatism of British broadsheet newspapers such as *The Times*. Founded in 1785, *The Times* refused to put the news on the front page until 1967. For nearly 200 years the front page was filled not with news but with small classified advertisements. *The Dominion Post* published such classifieds until 1963. Second, the late appearance of modernity in newspaper layout shows correspondences with other domains of cultural production. In art, for example, Colin McCahon, now widely regarded as the most important modern artist New Zealand has produced, especially in his landscape work, struggled until the end of his career in the 1980s to gain recognition for his masterly shift way from the British-influenced landscape style to which people were accustomed. The third possible reason for the late appearance of a fresh, well-organized, and clearly articulated editorial page might lie in the professional standards that are specific to New Zealand newspaper culture. Although the first two reasons link the field of journalism with the fields of art and culture, the third points toward the balance between the autonomous and heteronomous poles of the journalistic field.

Although it is true that the field interacts with other spheres of cultural production such as politics and the economy, it also develops the autonomy described by Hallin (2005) as "distinctive forms of practice, conceptions of (their) social role, and standards for judging cultural production and assigning status to cultural producers" (p. 230).

The tight and complex relationship between journalism, politics, and the economy, reflected in all anniversary editorials published in *The Dominion Post*, demonstrates how the journalistic field—seen as a "site of actions and reactions performed by social agents endowed with permanent dispositions, partly acquired in their experience of the social fields" (Bourdieu, 2005, p. 30)—gains and maintains its relative autonomy in relation to its institutional setting. As Scott (1997) said, the balance between a newspaper's moral and material existence determine its character and influence.

MORAL AND MATERIAL EXISTENCE OF JOURNALISM

The editorial page of *The Dominion Post* throughout the century plainly reflects the twofold nature of the newspaper, as a commodity and as a public service. In 1908, for example, the page consisted of three columns of advertisements, two editorials (one on new legislation, the other on the first anniversary of the paper), a column of "personal items" and a column of "New Zealand news" (13 separate items). Whereas the editorial content is dense and flat, the advertising section has more white space, and plays more freely with fonts and layout. The personal items, a very provincial diary of births, promotions, weddings, family celebrations, and so on, was published on the editorial page until 1963. The advertisements lasted longer: The last advertisement on the editorial page was published in 1995.

Selling advertising space on the editorial page reflects the newspaper's objective to generate profits, whereas the editorials hint at the goal of becoming a social institution that aims to be "a truly national newspaper; a journal which, while holding strong convictions on various matters of public concern, would be actuated only by the highest motives, and guided by the one desire to advance the best interests of the whole community" (1908, p. 4). The anniversary editorials of 1908, 1911, 1932, 1957, 1977, and 1997[11] all make reference to the balance between the two objectives of profit and public service. *The Dominion* was founded by merchants and farmers to support the conservative political cause, but the newspaper stresses its duty

[11]In other years, the newspaper's anniversary was either mentioned in a brief note ("The Dominion's Day") at the bottom of the page along with a note about the country's status change from colony to dominion, or completely omitted.

to give full and fair representation of all views in society. An echo of the same message runs through all editorials, even when the newspaper admits its historical alliance with one political option: "*The Dominion* has always refused to tie itself to any party, preferring to stand for principles rather than party. It has given general support to the Reform Party and assisted it in 1911 to attain office, believing the party's policy to conform most closely to the principles for which the paper stands" (1932, p. 8). The welfare of society is in the interests of the newspaper, stresses the editorial of 1957, and "allows no sectional or party interests to interfere with its adherence to them" (p. 10).

At the same time, its profit orientation remains equally important. It is the "rapid increase of circulation month by month [that] has afforded convincing testimony of public approval" (1908, p. 4); it is a firm orientation "against the policy of extravagant borrowing" (1932, p. 8); it is an admission that "the establishment of a daily newspaper, either 50 years ago or today, is a hazardous financial enterprise, beset with peculiar risks and technical problems" (1957, p. 10); and it is a revelation of what *The Dominion Post* is all about: "Though over the years its editorial views have fluctuated it has remained basically free market in philosophy and outlook" (1997, p. 8).

How does the free-market philosophy affect the structure of a newspaper system? How does it influence organization, innovations, norms, managerial style, editorial stance, and the day-to-day operation of a newsroom? The current editor-in-chief, Tim Pankhurst, said the newspaper's position is "center-center/right" and uses the relationship with owners and advertisers to explain editorial policy:

> Our relationship with our owners is one of independence. They do not dictate editorial policy. Neither do advertisers. We obviously need to be fair and professional in our coverage to retain reader and advertiser support and you do not want to be too far out of step with them but advertisers generally accept that the product must be credible and that is in their interests too. (personal correspondence, 2005).\

Pankhurst defined the newspaper as "a fast-moving consumer good" (objective: profit) but cited Kovach and Rosenstiel (2001) to stress that the main purpose of journalism is to provide citizens with the information they need to be free and self-governing (objective: public service). Pankhurst's words echo the claims made by generations of journalists and editors. Throughout the century, *The Dominion Post*'s anniversary texts emphasize the importance of balance, reinforcing the message that the intertwining of "money" and "common good" define the mission of New Zealand journalism. The headline "Tones of Our History Revealed in The Dom," in the September 26, 2007 edition, underlines the relationship between the newspaper and

society. The actual relationship with the community, however, remains vague. How can we identify the interactions between journalism and society beyond a simple description of the ways the newspaper covered or ignored events in history?

The analysis of the visual components of the newspaper's layout, and discussion of its historical setting, underlines the fact that the newspaper does not simply reflect the social setting, but also constitutes it. The improvement of the editorial pages' visual appearance is part of the development of print culture in New Zealand, not only a reflection of its history. The links signaled in self-reflective editorial texts indicate that the newspaper simultaneously represents and constructs the social and economic spheres. The question that follows is: "What are the elements of the construction of meaning or, more precisely, what segments of journalistic practice serve the purpose of representing, interpreting, and constructing reality in the press?"

CREATION OF MEANING

To examine the ways a newspaper mediates reality, I analyzed the forms of the texts on the editorial page. The analysis shows that the proportions of news, editorials, and letters to the editor on the page differ over a century: The numbers of the letters to the editor significantly increased at the expense of news items (see Fig. 4.2).

However, the pattern is not that straightforward. The drop in news items and the increase in letters occurred in 1963, the year the front page and the editorial page were redesigned. Classifieds disappeared from the front page, the size of headlines and white space increased, and the number of items on all pages fell, giving space for larger photos, graphics, cartoons, and other "info-graphics" that constitute modern broadsheet design. The letters to the editor moved to the editorial page in 1944, but it was not their first appearance in the paper. Letters were published from the very beginning of *The Dominion Post*. The first were printed on September 30, 1907, on page 6; the next day letters to the editor appeared on page 3, and later moved from page to page until they finally settled on the editorial page.

The "editorial page" itself has had a problem of self-definition. This study defines the editorial page as the page that prints an editorial, or leader article: an unsigned text under the logo of *The Dominion Post*. But the news makers do not necessarily agree with this academic definition. The page did not have a banner (a name) until 1972 when a black-and-white box was printed at the top of the page with the words EDITORIAL (white letters, black background) FEATURES (black letters, white background). In 1984,

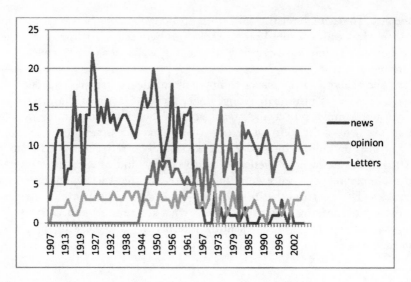

Fig. 4.2. **News, opinions, and letters to the editors.**

the name of the page—and the banner at the top—was "Features," and from 2002 it has been called "Opinion." Nowadays, the two pages follow each other: "Opinion" with the editorial article is a left-hand page and the "Features" are on the facing right-hand page.[12]

Close readings of the editorial texts in the newspaper reveal some of the devices used to refine Opinions as the public service of the newspaper. Headlines, one of the most powerful tools, were historically always used to formulate the standpoint of the newspaper. Early headlines gave a general indication of the text topic, such as "Two Newspapers" (headline of the editorial published in 1907), but unlike U.S. newspapers that used the same style of disinterested statement of content as a formula for creating a meaning, the New Zealand press introduced the subhead to strongly clarify its own position—a device that again points toward the prevailing influence of the British partisan press. The headline "Two newspapers" is followed by the subhead "Primitive journalism in New Zealand." Such a strong statement clarifies the position of the newspaper in relation to professional standards and the state of the national press.

An analysis of the number of words used in the editorial headlines across the century shows that *The Dominion Post* editorial teams used the long, descriptive headline as a tool for protecting the newspaper from making the mistake of evaluating ambiguous events[13] (Fig. 4.3).

[12]The division is provisional: The majority of features are opinion pieces written either by the newspaper's most prominent journalists and editors, or guest writers.

[13]The trend is also identified in the Serbian press.

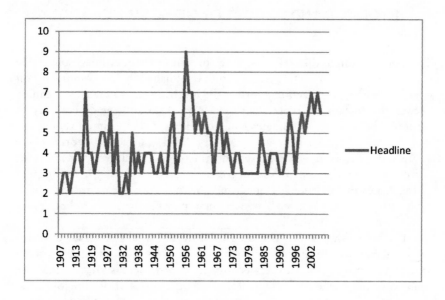

Fig. 4.3. **Number of words in headlines.**

The longest headline, published in 1956—"The Cost to World Trade of Egypt's Suez Action" (p. 8)—describes the topic and the underlying question (what would the cost be?) but does not say much about the newspaper's own position in relation to the event. The headline of the editorial published in 2002, "Supporters Will Put PM to the Test" (p. B4), helps the editorial team soften disappointing election results (re-election of the existing prime minister), and protect its editorial team from being labeled as pro-National. The National Party is the conservative party, and the prime minister in 2002 was from the Labour Party.

The newspaper's reluctance to move from having a voice in public debate to providing a space for public debate demonstrates that its nature is far more complex than twofold moral and material existence. When the editorial stands as the only commentary on the page, the press has exclusivity in raising opinion, and when surrounded by other opinion pieces and letters to the editor, it is only one (albeit a privileged one) of the voices in the wider social dialogue. Creation of meaning in today's editorial page goes through at least three opinions: the editorial, the column written by one of the few newspaper's columnists, and the letters to the editor. Contemporary editorial pages function as an arena for the establishment of common interest, and a public sphere understood as a metaphorical arena of social life. What are the ways newspapers facilitate social change?

PRODUCT AND PRODUCER OF SOCIAL CHANGE

The investigation of different design features of the editorial page and of the content of the self-reflective leader articles published in *The Dominion Post* over the course of the century reveals the mechanisms for creating meaning deepen the social connections between journalism and the community of readers. The analysis illuminates some of the explicit and implicit schemes that historically have generated and regulated journalists' work. These strategic mechanisms are deep-seated in a professional group memory as customary rules that are evoked, negotiated, and occasionally mythologized as the "rules of the game" (Bourdieu, 2002, p. 16) in the journalistic field. One such rule is the balance between a newspaper's objectives to both make a profit and serve the public.

This study shows how the identity of the editorial page as an arena for public debate has developed over the past 25 years. Prior to this, strongly argued viewpoints were expressed by the newspaper's staff, whereas the opinion of the wider public was clearly segregated from both the journalistic and advertising text. Journalistic and advertising texts went hand-in-hand for a long time. A more detailed discourse analysis of both the editorials and the letters to the editor would be necessary before conclusions can be drawn about the ways discussion was developed around issues of public concern.

What the current study indicates is that journalism sensed the power of the forum-creating capacity of the press early on. All anniversary editorials make reference to the importance of the newspaper in relation to the public interest. But it seems that it took more than half a century to apply this knowledge. The framework for the creation of a forum for public debate developed much later. The rules of the game in the composition of the editorial page are defined after long and usually complex negotiations among the agents in the journalistic field: journalists, editors, other news professionals, as well as owners and advertisers. The knowledge about "the ways things should be done," or who writes what and under what conditions, are part of the newsroom's oral history and not a matter of fixed, written rules—as is the case with established public arenas such as parliament.

When we look at the organization of the editorial page as a strategic act in the newspaper's creation of meaning, it becomes obvious that the New Zealand daily stayed with the same message for 100 years. The power of a firmly established explanatory frame—the newspaper seen both as a product and a producer of social change—comes from the simplicity of describing the position of the newspaper in society. Does the mantra about the newspaper being a business and a public service marginalize the dialogical nature of journalism, its ongoing dialogue with the practices in other fields? *The Dominion Post* in 2007 easily wraps up 100 years of its history in two dominant paradigms that situate journalism within society, neglecting to

further explain what else underlies its longevity. The anniversary issue celebrates the newspaper's reputation for ground-breaking investigative journalism, its visual transformation, and the use of modern technology. But it cannot resist making a reference to the current state of affairs. In the article "Tabloid a Temporary Murdoch Mistake" (p. F4) the newspaper concludes:

> Much of the paper's content can be accessed [nowadays] via the Internet—a communications revolution that not even the most far-sighted visionary could have imagined in 1907. And, since 2003, the paper has had new owners—the Sydney based Fairfax Media group. Perhaps even more startling, from *The Dominion* founders' point of view, is that New Zealand has a Labour Government. In that respect, they might consider the paper has failed in its mission. But in every other it has been a success story.

This comment reveals the newspaper's manner in rationalizing dialogue in the public arena, a manner that goes beyond the profit–public service rationalization of its place in society. The "invisible structures" (Bourdieu, 2005, p. 30) that create, sustain, and modify the relationship between the newspaper and the community, the journalistic field and the fields with which it interrelates are not a passive by-product of political or economic forces. Journalists' authority to produce the meaning, their habitual reactions to an event (a newspaper's own anniversary included), is socially, culturally, and economically rooted. But, as the case of *The Dominion Post* illustrates, it also appears as an independent cultural form that reflects a complex set of strategies for inserting information into news text. From the number of columns, length of the headlines, and layout of the page, to the selection of facts, choice of narrative technique, and storytelling frames in the editorial articles, it contributes to the representation, interpretation and construction of reality. The discursive structure of the editorial page in its historical context, as the case study of *The Dominion Post* shows, demonstrates the richness of journalism as a cultural form and the importance of journalism as a field of cultural production that influences our understanding of social reality.

REFERENCES

A newspaper reaches its half-century. (1957, September 26). *The Dominion Post*, p. 10.

Allan, S. (2004). *News culture*. Maidenhead: Open University Press.

Barnhurst, K., & Nerone, J. (1991). Design changes in U.S. front pages, 1885-1985. *Journalism Quarterly, 68*, 796-804.

Barnhurst, K., & Nerone, J. (2001). *The form of news: A history*. New York: Guilford.

Benson, R. (2004). Bringing the sociology of media back in. *Political Communication, 21*, 275-292.

Bourdieu, P. (2002). *Outline of a theory of practice*. Cambridge: Cambridge University Press.

Bourdieu, P. (2005). The political field, the social science field, and the journalistic field. In R. Benson & E. Neveu (Eds.), *Bourdieu and the journalistic field* (pp. 29-48). Cambridge, UK: Polity Press.

Day, P. (1990). *The making of the New Zealand Press*. Wellington: Victoria University.

Deuze, M. (2002). National news cultures: A comparison of Dutch, German, British, Australian and U.S. journalists. *Journalism and Mass Communication Quarterly, 79*(1), 134-150.

Du Fresne, K. (2007, September 26). A political type dawn. *The Dominion Post*, p. F3.

Elsaka, N. (2004). *Beyond consensus?: New Zealand journalists and the appeal of "professionalism" as a model for occupational reform*. Unpublished doctoral dissertation, University of Canterbury, Christchurch, NZ.

Hallin, D. (2005). Field theory, differentiation theory, and comparative media research. In R. Benson & E. Neveu (Eds.), *Bourdieu and the journalistic field* (pp. 224-244). Cambridge: Polity.

Hilgartner, S., & Bosk, C. (1988). The rise and fall of social problems: A public arenas model. *American Journal of Sociology, 94*(1), 53-78.

Hynds, E., & Archibald, E. (1996). Improved editorial pages can help papers, communities. *Newspaper Research Journal, 17*(1-2), 14-24.

Independence for NZ our first headline 70 years ago. (1977, September 26). *The Dominion Post*, p. 4.

In retrospect. (1932, September 26). *The Dominion Post*, p. 8.

Kovach, B., & Rosenstiel, T. (2001). *The elements of journalism: What newspeople should know and the public should expect*. New York: Crown.

Lealand, G. (2004). Still young and female: A (modest) survey of New Zealand journalists. *Pacific Journalism Review, 10*(2), 173-196.

Ninety, and still going strong. (1997, September 26). *The Dominion Post*, p. 8.

Norris, P. (2001). News through alien filters: The impact of imported news on a small nation. In T. Silvia (Ed.), *Global news: Perspectives on the information age* (pp. 85-101). Ames: Iowa State Press.

Reflecting on a national milestone. (2007, September 26). *The Dominion Post*, p. B4.

Rupar, V. (2007). Journalism, political change and front-page design. In M. Broersma (Ed.), *Form and style in journalism: European newspapers and the representation of news, 1880-2005* (pp. 199-219). Leuven: Peeters .

Scott, C.P. (1997). The *Manchester Guardian's* first hundred years. In M. Bromley & T. O'Malley (Eds.) *A journalism reader* (pp. 108-109). London: Routledge.

The Dominion. (1908, September 26). *The Dominion Post*, p. 4.

5

OWNERSHIP, COOPERATION, AND THE NEWS

A Case Study of the New Zealand Press Association

Grant Hannis

Massey University

For more than a century, the news agency that supplies national and international news copy to New Zealand newspapers, the New Zealand Press Association (NZPA), operated as a cooperative news-gathering service. Although NZPA did use some reporters to gather news, the agency's primary role was to share news copy supplied by its member newspapers. A profound change occurred at NZPA in 2006 when it abandoned this copy-sharing arrangement, reinventing itself as a conventional agency that primarily relies on its own reporters gathering and reporting news, which NZPA sells to whoever wishes to buy it. This chapter examines that change and its impact on NZPA's news-reporting activities.

NZPA's abandonment of copy sharing was a change forced on the agency by circumstances. One of the primary causal factors was the rise of concentrated ownership of newspapers in New Zealand. I begin by discussing ownership and the news media, before moving on to consider the events at NZPA.

OWNERSHIP AND ITS IMPACT ON NEWS

There is a considerable literature on the relationship between the ownership of the news media and the gathering and content of the resulting news. The focus of the discussion has been on the increased concentration of media

ownership, which is generally held to have had a deleterious effect on the quality of news coverage.

In the United States and England, the rise of mass circulation newspapers in the 19th century, with the accompanying growth in advertising revenues, helped the news media break free from the rigid controls of government (Clarke, 2004; Stephens, 2007). This gave the news media a strong independent voice, informing its readers and playing a major role in national political discussions. It is generally the case that a country characterized by privately owned news media has a freer press than that of a country where the press is primarily government-owned (Djankov, McLiesh, Nenova, & Shleifer, 2003).

News media reports can stimulate conversation between government and citizens, and evidence suggests that the more people read the news media, the more likely they are to express political opinions and participate in political activity (Joohan, Wyatt, & Katz, 1999; Moy, McCluskey, McCoy, & Spratt, 2004; Myers, 2003). The information provided by the news media may be profoundly empowering. The news media can supply its audience with mobilizing information, that is, information that allows citizens to become involved in political activity, such as details on where political meetings are to be held, deadlines for public submissions on policy proposals, and details of how to stand in local elections (Lemert, 1981).

But not all commentators believe the news media play such a positive role, arguing that the concentration of news media ownership in the 20th century has had a detrimental impact. In the 19th century, the ownership of newspapers was generally fragmented, but by the latter part of the 20th century, a small number of companies came to own many of the leading news media organizations. For instance, in the 1940s, 80% of American newspapers were independently owned, but by the 1990s more than 80% were owned by media conglomerates or newspaper chains (Alger, 1997). Such ownership concentration is frequently across different news media technologies and is multinational. For instance, Rupert Murdoch's News Corporation owns a multitude of newspapers and television stations throughout Australia, Great Britain, and the United States (Baker, 1998). Media barons, such as Murdoch and Kerry Packer, who died in 2005, epitomize the modern age of highly concentrated media ownership.

Some commentators believe this ownership structure is undemocratic (Bagdikian, 2004; McChesney, 1999). Two reasons exist for this. First, because owners can use their economic power to pressure editors and reporters to generate profit from the news, highly concentrated ownership leads to an increasingly trivial and sensationalized form of reporting that appeals to the market, but lacks important informational content. Carl Bernstein (1992), the journalist who helped break the Watergate scandal that eventually led to the resignation of then-president Richard Nixon, has complained that the urge by conglomerates to generate profit has eroded jour-

nalistic standards. He cited the example of a major company's bestselling book about a gangster that is

> riddled with inventions and lies, with conspiracies that never happened, with misinformation and disinformation, all designed to line somebody's pockets. . . . Surely the publisher . . . has no business publishing a book that its executives and its editors know is a historical hoax, with no redeeming value except financial. (pp. 25, 28)

Indeed, various studies have found that, compared with independently owned newspapers, newspaper chains publish relatively less hard news, receive fewer journalism awards, and focus on crime, disasters, and other similar topics (Alger, 1997). But an appraisal of newspaper coverage of Britain's 1996 general election found that, despite criticism that the news media focused on trivialities, the majority of the coverage was about important public issues (McNair, 2000). McNair also defended the more frivolous news media coverage, observing that articles about Tony Blair's thinning hair, for example, were in fact an example of journalists undermining the carefully manicured look the Labour leader was trying to portray. For a further discussion on tabloidization and the news media, see Rowe (chap. 7, this volume).

The second reason that concentrated ownership is held to be undemocratic is that it prevents diversity in reportage. It has long been observed that the news media operates as a gatekeeper, determining which events will be deemed newsworthy and therefore reported (Tuchman, 1980). Critics of concentrated news media ownership argue that the concerns expressed in the news media will be confined to the concerns of the few who own the news media—people, the commentators say, who benefit from maintaining inequalities (McChesney, 2001). The news media may quite overtly self-censor in the interests of commerce. When Murdoch entered the lucrative Chinese broadcasting market, he removed, at the request of the Chinese government, the BBC World Service from the suite of programs offered, as the communist regime did not like a program the BBC had aired on Mao (Baker, 1998). Similarly, journalists have related how their newsroom managers have moved stories away from fact-based findings, to avoid antagonizing business or government agencies (Borjesson, 2004). Some commentators have called for regulation to encourage diversity of opinion in the highly concentrated news media sphere (Doyle, 2002).

News media ownership in New Zealand also is highly concentrated, with only a handful of companies owning many of the main broadcasters and newspapers. In the daily newspaper industry, for instance by circulation, the Australian firm Fairfax owns approximately 48% of the newspapers and the Australian company APN News & Media owns 43%. The remainder are independently owned. It is no surprise, then, that similar con-

cerns have been expressed about the impact of concentrated ownership on the New Zealand news media. For instance, the main television news organizations have been accused of sensationalizing the news and cutting back on regional news in an effort to improve profits and reduce costs (Norris, 2002; Rosenberg, 2007; Skudder, 2006).

Of course, the conventional firm is not the only form of organization that operates in the commercial world. One of the alternatives is the cooperative, which is an organization owned by those who purchase its products. The cooperative form of business enterprise can be traced back to classical times and the workers' guilds in the Middle Ages. Today, cooperatives play a major role in many national economies, including the agricultural, fishing, and financial sectors, as well as in the consumer and labor areas (Cobia, 1989; Deiter, 1997; Merrett & Walzer, 2001). Despite such success, however, the cooperative form of organization does suffer several inherent weaknesses. A cooperative is likely to dissolve if the partners no longer have a shared sense of identity and/or begrudge making their products available to fellow members (Child, Faulkner, & Tallman, 2005; Fulton, 1995). As is seen here, it was the end of this shared sense of purpose that spelled the demise of NZPA's cooperative system.

In considering NZPA in light of this theoretical discussion, the following research question was posed: Did NZPA's change from a cooperative to a conventional, commercial form of organization lead to a change in the way NZPA gathers and reports news?

To answer this question, relevant documentation was consulted, including narrative histories of NZPA and New Zealand journalism (Sanders, 1980; Scholefield, 1958), newspaper reports, and minutes from NZPA board meetings.

I also conducted a series of interviews with key participants, clarifying various points in the narrative history and providing further insight on the theoretical issues. The interviewees were:

1. Nick Brown, editor at NZPA, who experienced the changes at NZPA firsthand and was able to comment on the changing nature of NZPA's news content.
2. Lincoln Gould, NZPA's chief executive, who implemented the recent reforms at NZPA.
3. Rick Neville, an APN representative on NZPA's board, deputy chief executive of national publishing at APN in New Zealand, and publisher of the *Herald on Sunday*, the paper whose establishment set in motion the events that led to the change at NZPA.
4. Peter O'Hara, who until 2007 was the NZPA chairman and a Fairfax representative on NZPA's board, was closely involved with the changes at NZPA. He was Fairfax New Zealand's

chief operating officer and editor-in-chief. Furthermore, during the late 1980s and early 1990s, he worked at NZPA in a variety of roles, including journalist, editor, and chief executive.

5. Colin Warren, editor of *The News*, a small independent newspaper in New Zealand, who publicly expressed concern over the changes at NZPA and was able to comment on the impact of the changes on his newspaper.

THE CHANGES AT NZPA

By the middle of the 19th century, the British colony of New Zealand operated as a collection of largely self-contained provinces, concentrated around coastal towns. The colonial newspapers of the time were stand-alone businesses servicing their local town or province, carrying news that focused on local events, as well as whatever news could be obtained from ships calling into the nearby ports. This fragmented nature of the early New Zealand newspaper industry meant it was impossible for any newspaper to establish a national network of reporters.

Several attempts to establish a news agency to provide these individual newspapers with national and international news culminated in the establishment of NZPA in 1880. One major history of New Zealand newspapers says that NZPA "was an early example of that co-operation which was to be a dominating feature of our national life" (Scholefield, 1958, p. 11), and the main official history of NZPA talks about NZPA's early members sharing a "unity of purpose" (Sanders, 1980, p. 7). This suggests that NZPA was for many years regarded by journalism historians as providing a public service, a mechanism whereby the papers could help each other inform the public about national and international life.

For most of its life to date, NZPA operated as a not-for-profit cooperative company owned by its member newspapers. Each newspaper paid an annual membership fee based on its circulation. To join NZPA, a news organization had to be a daily newspaper and make its local news copy available to all other members. NZPA gathered news itself, by way of a network of journalists it employed or retained, but generated much of its material from the copy-sharing arrangement. NZPA's main office was in Wellington, where its editorial staff spent much of its time subediting and posting copy received from member newspapers around the country, as well as from agencies overseas. By 2000, NZPA was producing approximately 150 national news stories per day, about 50% from shared copy.

Throughout the 20th century virtually all New Zealand newspapers continued to operate within defined geographical areas, and so, in order to gain access to national news, continued to belong to NZPA. There was some

overlap in the distribution areas of the various papers, but the effect was marginal. For instance, the circulation areas of Auckland's *The New Zealand Herald* and Wellington's *The Dominion* overlapped to some extent in the middle of the North Island. The only national papers were the Sunday and weekly business newspapers. The Sunday papers belonged to NZPA, as they were regarded as offshoots of the daily newspapers. The business papers used their own reporters, situated in the country's main commercial centers, to provide national business news.

Most copy from the member newspapers flowed between the papers via NZPA in a timely way, but there was a persistent niggling problem that suggested copy sharing would not go on forever. Although each newspaper still essentially operated unmolested in its own distribution area, member newspapers would sometimes file copy late or withhold it altogether. O'Hara, then a senior manager at NZPA, investigated these various breaches. "It was a continual thorn in the side of the organization," he recalled. "There was suspicion on all sides. . . . There was a lot of frustration going back many years about how the system actually worked."

The newspapers made various excuses for failing to file, such as technical breakdowns or human error. But O'Hara thought the basic reason was the competitive instinct to publish their story first—each newspaper wanted to prevent papers in other regions from running the story at about the same time. According to O'Hara, the core problem was the cooperative system:

> You were reliant on people who at the end of day worked for someone else—you couldn't command them to deliver the stories on time, only coax them. This was an inherent frustration in NZPA. There was a lot of suspicion and certainly not a lot of goodwill.

So the shared sense of purpose that was required between NZPA's member newspapers in order for the system to work was being eroded by the journalistic ethos to scoop the other papers.

Another indication of trouble ahead occurred in 1987 when news organization New Zealand Newspapers set about launching a new morning newspaper, *The Auckland Sun.* The *Sun* would thus be in direct competition with Wilson and Horton's Auckland newspaper, *The New Zealand Herald.* This was a rare case of a new newspaper planning to compete with another paper in the same geographical area. New Zealand Newspapers applied to obtain shared copy from NZPA for the *Sun.* NZPA agreed to do this, but only on the condition that no *Herald* material would be supplied to the *Sun,* and vice versa, presumably a demand made by both news groups (NZPA, 1987). This indicates how quickly the bonds that tied the member newspapers to NZPA could be broken once newspapers entered into direct compe-

tition with each other. In the event, the high cost of establishing the *Sun*, coupled with the sharemarket crash in 1987, soon saw its demise.

New Zealand Newspapers eventually disappeared from the media landscape, and there has been a gradual concentration of ownership of New Zealand newspapers. By the early 21st century, as mentioned previously, two ownership blocs had emerged, both Australian. Most New Zealand newspapers are owned by one or another of these two companies. The first is Fairfax, which owns *The Press* in Christchurch, *The Dominion Post*, *Sunday Star-Times*, *Sunday News*, and a host of regional and community newspapers. Fairfax, therefore, dominates the major Christchurch, Wellington, and national Sunday markets. The second is APN News & Media, owner of *The New Zealand Herald* and many regional and community newspapers. APN, therefore, dominates the major Auckland market. By 2003, the NZPA board comprised three Fairfax representatives, three APN representatives, and two representatives of independent newspapers.

These two Australian blocs, especially Fairfax, brought a new culture to New Zealand newspapers. NZPA's counterpart in Australia, Australian Associated Press (AAP) operates on a strictly commercial basis. Its reporters find and write their own stories and the copy is sold to whoever will buy it (AAP, 2006). Fairfax, a co-owner of AAP, found the NZPA copy-sharing cooperative model quite alien. Instead, Fairfax has been much more enthusiastic about sharing copy between its own newspapers, across both sides of the Tasman. In New Zealand, Fairfax has heavily promoted its Internet news service, "stuff" (www.stuff.co.nz), which runs copy sourced from the Fairfax stable of papers. In 2004, Fairfax even recruited NZPA's editor, John Crowley, to head its copy-sharing system, thereby drawing on NZPA's own expertise in the area (Anonymous, 2004).

Given these developments, it was fortunate for NZPA that it was well positioned to change with the times, following the 2002 appointment of Lincoln Gould as its chief executive. Gould had considerable experience in introducing market reforms. When he was general manager and joint chief executive of the New Zealand Futures and Options Exchange in the early 1990s, Gould helped change it from a cooperative to a commercial model. He also played a leading role in the creation of the wholesale electricity market in New Zealand, heading M-co, the company set up by the industry to administer the market. "I love marketplaces," Gould said.

When Gould first came to NZPA he began advocating for change. He could see that the developments in the industry were leaving NZPA dangerously exposed. As a journalist in his younger days he had witnessed the petty withholding of copy. But initially, the NZPA board was happy with the status quo. In much the same way as a power crisis in the 1990s had led to the establishment of the wholesale electricity market in New Zealand, Gould realized it would take a crisis to bring change at NZPA.

The crisis came in 2004 when APN decided to launch a new Sunday paper, *Herald on Sunday*. As a national paper, *Herald on Sunday* would compete head-to-head with Fairfax's two national Sundays. Fairfax had long been anticipating APN's move, and when in September APN asked NZPA's board for access to shared copy for the *Herald on Sunday* the Fairfax representatives refused. A letter from O'Hara, now a Fairfax representative on the board, to NZPA explained the reason for the refusal (NZPA, 2004):

> [I]t is the view of Fairfax that the NZPA structure was put in place on the basis of regional newspapers which supplied news to a central pool for distribution to each other. That no longer reflects the structure of the industry in New Zealand. (p. 2)

Fairfax regarded APN's move as aggressive. O'Hara said: "Fairfax saw itself as coming under some degree of attack. Why would we wish to cooperate with them? . . . We could have stopped all copy sharing, but we just stopped copy sharing on the Saturday to make the point that this was about the *Herald on Sunday*."

But APN painted Fairfax as the aggressor. Rick Neville, an APN representative on the NZPA board, said Fairfax was "incensed" that APN had lured top Fairfax editorial staff to work at the *Herald on Sunday*. APN also saw Fairfax's refusal as inequitable:

> Fairfax unilaterally advised they would no longer supply material from their papers that could be used in the *Herald on Sunday*, despite the fact the *Sunday Star-Times* and *Sunday News* were still able to access and use APN-generated copy. This put them in breach of the news agreement with NZPA.

This situation was clearly reminiscent of the *Auckland Sun* and *New Zealand Herald* episode: As soon as a newspaper proposes to enter another newspaper's market, the incumbent refuses to share copy with the would-be competitor.

The Fairfax representatives did not attend the board meeting where a was decision was to be made on the matter, and in their absence board members, who viewed copy sharing as the role of the NZPA, resolved to supply copy to the *Herald on Sunday*. Annoyed, Fairfax seriously began to consider withdrawing from NZPA entirely. The withdrawal of such a large player would have probably signaled the end of NZPA, so it was clear NZPA had to find a new business model fast.

In November 2004, Gould presented his proposal to the board. NZPA would become a conventional firm, owned by the major newspapers, and would cease copy sharing. Instead, NZPA's journalists would gather news

for a national newswire that NZPA would sell to whoever wished to be its clients. NZPA also would offer new services, such as supplying photographs to clients. In August 2005, the NZPA board adopted the plan, and copy sharing ceased in January 2006.

Today, Fairfax and APN each own about 47% of NZPA, with the remainder owned by the independent newspapers. Each organization continues to have three representatives on the NZPA board, and the independents have two. NZPA is now a for-profit conventional news agency. Whereas previously 100% of NZPA's revenue was from its member newspapers, NZPA has reduced the fees paid by the newspapers that take its copy—these fees now account for 35% to 45% of NZPA's revenue—and is seeking to make up the shortfall by selling its services to other clients.

The number of staff at NZPA's Wellington newsroom remains at about 50, but its Auckland office has been expanded from 2 to 5 journalists, a small Christchurch office has opened, and a national network of stringers and correspondents has been established. Some local independent newspapers supply NZPA with copy, paid for by the agency. NZPA now produces about 110 stories per day, somewhat less than what was produced at the end of the copy-sharing days. NZPA supplies a newswire to television and radio stations, as well as to corporate clients. It also has established a photographic news service, and is planning to offer electronic news services, such as news that can be read on mobile phones.

Fairfax and APN do source overseas news from their overseas newspapers, but also continue to obtain international wire services from NZPA. That is because NZPA remains the most efficient way to obtain feeds from organizations such as Reuters: NZPA staff filters the hundreds of stories that come down the international feeds, only sending out the stories most relevant to New Zealand papers. The newspapers prefer to pay NZPA for this service, rather than spend the time filtering the material themselves.

Fairfax is very happy with the new system and believes change was inevitable. O'Hara said, "The catalyst of the *Herald on Sunday* has got us there a bit quicker than otherwise would have been the case."

For its part, APN would rather the cooperative system had not ended, and Neville put the blame squarely at Fairfax's feet: "Fairfax precipitated the demise of the NZPA copy-sharing model. APN [was] content with the status quo, but has got on with life and made the new system work."

THE IMPACT OF THE CHANGES
ON THE NATURE OF NZPA'S NEWS

It is clear that the rise of two competitive ownership blocs in the New Zealand newspaper scene was a major contributing factor to the demise of

the old NZPA. Fairfax regarded the NZPA copy-sharing model as antiquated, something more suited to the bygone age of individually owned newspapers. Owning a stable of papers situated throughout most of the country and overseas, Fairfax was able to—and wished to—share copy in-house, rather than with its archrival APN. As O'Hara said:

> We have achieved the broad objective, the overriding strategy: We retain exclusive use of our content to leverage in any way we can, including into new markets. We use this content online, or whatever. It is our content: We haven't given it away to our competition.

Of course, in-house sharing is only as good as the coverage of a conglomerate's newspapers. Although Fairfax's coverage throughout New Zealand is good (with the notable exception of Auckland), APN's coverage is more limited. It seems likely that this is the reason why Fairfax was able to force change on NZPA and why APN remains skeptical that change was desirable. As Neville noted, APN has had to adapt the most:

> This has been achieved by strengthening the APN content network, being reasonably well served by NZPA, who are devoting more resources to regional coverage, and by setting up a stronger network of contributors.

Neville added that NZPA itself had to invest in new staff to ensure good national coverage, and to some extent has needed to reinvent the wheel:

> The cooperative approach worked pretty well for a long time, and Fairfax's decision has no doubt created duplication of effort in a number of areas. For instance, NZPA has had to install two journalists in Christchurch to supply APN's mostly North Island titles, when they used to get South Island copy from the Fairfax papers down south.

It seems likely both ownership blocs will remain with NZPA. Neither is in a position to go it alone, as neither has a truly national network of reporters, and neither company has plans to invest in such a network, which implies they will continue to need NZPA for at least some of the national news.

Although Fairfax and, to a lesser extent, APN have been able to use their conglomeration of papers to share copy in-house and adapt to the new world, the remaining small independent newspapers were not so well placed. At the time of the NZPA changes, concern was expressed that independent regional New Zealand newspapers would no longer gain access to national news. For instance, the small, independently owned *The News* in Westport,

on the west coast of the South Island, expressed considerable alarm. In 2005, editor Colin Warren queried publicly whether NZPA would be able to continue to supply his newspaper with the same level of service at an affordable price. Warren speculated that *The News* may have to stop publishing 5 days a week if the new-look NZPA could not operate as it had before (Anonymous, 2005a, 2005b).

Warren said that, as it turned out, the change in NZPA's pricing structure means *The News* is now paying less for NZPA copy. Nevertheless, Warren remains unhappy about the change, saying that his paper receives less copy from NZPA now and what copy they do receive is less diverse: "The volumes are not what they used to be. Choice is not what it used to be." Warren said the amount of news from nearby regions has been reduced:

> We see little from [Fairfax papers] *The Nelson Mail* or *The Marlborough Express*. We used to run lots of their copy because they are neighbors. Those papers do not file anymore—they have to file with Fairfax.

This is symptomatic of a larger issue, Warren said:

> There is no longer coverage up and down the country. In the past, a cub reporter might get a good Gore [South Island town] story and it would go into the system. That doesn't happen so much now—it only happens if it's a really big story.

As a result, *The News* must now run more NZPA stories sourced from the main centers.

Warren would like to see NZPA return to the old way of doing things. As a matter of principle, *The News* continues to send NZPA copy free of charge, as if nothing had changed.

The changes in NZPA's coverage identified by Warren are confirmed by NZPA itself. NZPA editor Nick Brown said that the agency has had to retrench in some areas, including reducing the number and range of stories. This is simply because NZPA must now rely on its own resources:

> The choice of stories is now not so big. It's a numbers thing—we don't have the volumes we had previously. . . . In the past we had hundreds of reporters around the country.

In particular, NZPA no longer provides as much regional news:

> Now we use freelancers, but only obtain the coverage when it's hard news of national interest. We used to do regional stories that might only be picked up by a neighboring newspaper.

Allied to that, NZPA has had to cut back on rural stories. "We still have the same amount of farming business stories," Brown said, "but we have lost contributions for soft features from newspapers."

Brown said one positive outcome of the changes is the improved timeliness of NZPA's news: "We get a lot of news out faster because we are covering news ourselves." For instance, in the past, newspapers may not have filed their court stories with NZPA until hours after the court closed because it would take them that long to write the material and then file it with NZPA. "Now we get court stories from our reporters and stringers within an hour of the court closing. We also file during the day."

Brown was adamant that commercialization has not led NZPA to change the tone of its reportage: "We don't jazz up stories to make them more attractive in the competitive environment. We tell staff to stay objective and keep an even tone: We are an agency of record." None of the other interviewees suggested the tone of NZPA's news coverage had changed following the end of copy sharing.

But what NZPA does do is report material already reported by others. As the newspapers are now able to keep exclusives to themselves, Brown said, NZPA will report what the newspapers are reporting—making sure the source of the material is attributed:

> Early in the morning we look at news sites and copy exclusives for use by others. We always clearly attribute these stories—other media are not always so careful to attribute. These are then quick matchers for Web sites, radio, and evening papers. For example, we may pick up a *Dominion Post* story, which will go to other Fairfax newspapers, and we might quickly rewrite it to go to APN.

This strategy, Brown said, "was always part of our plan."

CONCLUSION

Whereas the news media can have an important democratic function, taking part in national debates and informing the public on matters of public interest, many commentators have argued that the rise of concentrated news media ownership has led to two undemocratic outcomes: trivial, sensationalized news and a reduction in the diversity of voices in the news media. This chapter examined this argument with regard to the commercialization of NZPA.

Clearly, the rise of two ownership blocs was a major contributory factor in the conversion of NZPA from a copy-sharing cooperative to a commercial news agency. But none of the major players in the change has sug-

gested NZPA has sensationalized its news in order to command a market. Indeed, given neither Fairfax nor APN has total coverage throughout New Zealand, NZPA remains a valuable additional source of news for both companies, without NZPA apparently having to change the tone of its news to attract customers.

But the changes at NZPA have seen a reduction in the diversity of NZPA's news. Previously, reporters from all the regions filed stories with the agency, many of which may only have been picked up by neighboring regional papers. NZPA now uses its own reporters and regional stringers to gather news. As a result, coverage is focussed on events in the main centers, with regional news confined to major events. This is not conformist news in the sense that the news serves the business barons in the newspaper industry, but it does represent to some extent the silencing of regional voices.

REFERENCES

Alger, D. (1997). Megamedia, the state of journalism, and democracy. *The Harvard International Journal of Press/Politics, 3*(1), 126-133.

Anonymous. (2004). *Fairfax appoints NZPA chief to new position of group editor.* Retrieved November 17, 2006, from http://www.southland.co.nz/news/index.html.

Anonymous. (2005a, March 24). Provincial papers face change to NZPA supply. *Radio New Zealand Newswire.*

Anonymous. (2005b, April 7). Small papers unsure of effect of NZPA shakeup. *Radio New Zealand Newswire.*

Australian Associated Press. (2006). *Who we are and what we stand for.* Retrieved November 17, 2006 from http://aap.com.au/aboutaap.asp.

Bagdikian, B. (2004). *The new media monopoly.* Boston: Beacon Press.

Baker, R. (1998). Murdoch's mean machine. *Columbia Journalism Review, 37*(1), 51-56.

Bernstein, C. (1992, June 8). The idiot culture: Reflections of post-Watergate journalism. *New Republic*, pp. 22-28.

Borjesson, K. (Ed.). (2004). *Into the buzzsaw: Leading journalists expose the myth of a free press.* Amherst, NY: Prometheus Books.

Child, J., Faulkner, D., & Tallman, S. (2005). *Cooperative strategy.* New York: Oxford University Press.

Clarke, B. (2004). *From Grub Street to Fleet Street: An illustrated history of English newspapers to 1899.* Aldershot: Ashgate.

Cobia, D. (Ed.). (1989). *Cooperatives in agriculture.* Englewood Cliffs, NJ: Prentice-Hall.

Deiter, R. (1997). Cooperatives. In F. Magill (Ed.), *International encyclopedia of economics* (1st ed., Vol. 1, pp. 274-276). Chicago: Fitzroy Dearborn.

Djankov, S., McLiesh, C., Nenova, T., & Shleifer, A. (2003). Who owns the media? *Journal of Law and Economics, 46*(2), 341-381.

Doyle, G. (2002). *The economics and politics of convergence and concentration in the UK and European media*. London: Sage.

Fulton, M. (1995). The future of Canadian agricultural cooperatives: A property rights approach. *American Journal of Agricultural Economics, 77*, 1144-1152.

Joohan, K., Wyatt, R., & Katz, E. (1999). News, talk, opinion, participation: The part played by conversation in deliberative democracy. *Political Communication, 14*(4), 361-385.

Lemert, J. (1981). *Does mass communication change public opinion after all? A new approach to effects analysis*. Chicago: Nelson-Hall.

McChesney, R. (1999). *Rich media, poor democracy: Communication politics in dubious times*. Urbana: University of Illinois Press.

McChesney, R. (2001). *Global media, neoliberalism and imperialism*. Retrieved February 13, 2007, from http://www.thirdworldtraveler.com/McChesney/Global/Media_Neoliberalism.html.

McNair, B. (2000). *Journalism and democracy: An evaluation of the political public sphere*. London: Routledge.

Merrett, C., & Walzer, N. (Eds.). (2001). *A cooperative approach to local economic development*. Westport, CT: Quorum Books.

Moy, P., McCluskey, M., McCoy, K., & Spratt, M. (2004). Political correlates of local news media use. *Journal of Communication, 54*, 532-546.

Myers, J. (2003). *Influences on interpersonal political conversation during the 2000 election*. Retrieved September 18, 2004, from http://www.politicsandgovernment.ilstu.edu/conference/confinalupl/Myers8317.doc.

New Zealand Press Association. (1987). *Auckland Sun*. Unpublished manuscript, NZPA board minutes, Wellington, NZ.

New Zealand Press Association. (2004). *Minutes of a meeting of the NZPA board of directors held by teleconference on Thursday 14 September 2004, commencing at 4.02 pm*. Unpublished manuscript, NZPA board minutes, Wellington, NZ.

Norris, P. (2002). News media ownership in New Zealand. In M. Comrie & J. McGregor (Eds.), *What's news? Reclaiming journalism in New Zealand* (pp. 33-55). Palmerston North: Dunmore Press.

Rosenberg, B. (2007). *News media ownership in New Zealand*. Retrieved September 15, 2007, from http://canterbury.cyberplace.org.nz/community/CAFCA/publications/Miscellaneous/mediaown.pdf.

Sanders, J. (1980). *Dateline-NZPA*. Auckland: Wilson & Horton.

Scholefield, G. (1958). *Newspapers in New Zealand*. Wellington: A.H. & A.W. Reed.

Skudder, A. (2006). *Media consolidation in New Zealand*. Retrieved February 12, 2007, from http://www.radioheritage.net/ColumnAS1.asp.

Stephens, M. (2007). *A history of news* (3rd ed.). New York: Oxford University Press.

Tuchman, G. (1980). *Making news: A study in the construction of reality*. New York: The Free Press.

6

TRADITIONAL AND INNOVATIVE TRENDS IN JOURNALISM REPORTING PRACTICES IN CROSS-MEDIA ENVIRONMENTS

Ebbe Grunwald

University of Southern Denmark

What happens to the reporting practices of journalism when the environments of producing and publishing news and background articles change? In 2003, one of the first fusions of different media organizations took place in Denmark when the regional paper *Nordjyske Stiftstidende* merged with a local television station and two radio stations. At the same time, a new Internet site was opened under the URL www.nordjyske.dk. A fusion of different media in a shared *media house*, in this case named *Nordjyske Medier*, involves changes at several levels. Its economy will change along with the whole organization, its ideology, architecture, media techniques and, of course, its editorial and journalistic practices.

The focus of this study is on journalism practice expressed in the choice of news genres and language used when news stories are communicated on different platforms—newspaper, television, radio, and the Internet—in the same media house. A news story from March 2006 has been selected, which elicited relatively high activity in terms of number of daily hits on the Internet over a period of 14 days. The story is about a young local high school girl stabbed and killed by a former boyfriend, who committed suicide a few hours after the murder. This news story developed from breaking news into a news story about the tragedy, and then to a story about dealing with grief.

The task of this research is to describe and discuss how the news genres and the language of the "story told" as opposed to "real story"[1] are managed

[1]What here is called the "real story" has to be understood as a construction consisting of all accessible information based on sources collected and used by the journalist. The "told story" is a construction based on editorial selection and rhetorical salience meant to inform actual media users. For a further discussion of this see Grunwald and Rupar (2009).

and perhaps changed, when this story is activated on several different platforms: Is journalism able to match these developments? If not, what are the challenges of the new situation, and how will it be possible to cope with them in the future?

During the past 10 to 15 years, digital media have invaded our lives: personal computers, the Internet, mobile phones, and portable media players (PMPs; e.g., iPod). This technological revolution has had remarkable consequences for developments in the traditional print and broadcast media (DAB-radio, free daily newspapers, HDTV recorders, on-demand TV, etc.). At a higher level, this development can be seen as an ongoing concentration of ownership, ideology, organization, technique and architecture in a newly established media space. We call this form of organization the *media house*, to distinguish it from the *media conglomerate* (which usually involves the production of other media forms, such as videos or books, and not only news media) and from the model of the *media organization* (which involves far closer links between the constitutive elements).

The structures in a media house converge continuously, and the physical, technical, and organizational developments seem to lead to multiple platforms covering all current and historical functions of daily newspapers, radio, and television (Petersen, 2006). But at other, lower levels, the various media seem to diverge. Besides the old media—newspapers, radio, and television—the news is coming from the Internet, blogs, short-messaging services (SMS), and podcasting services. Gradually, as consumers, we free ourselves from the agendas of the old media and build up stories and gather information by collecting stuff based on our own interests as the most important background. When receiving content by reading, viewing, or listening, we principally choose an independent moment of reception by ourselves.

Because of the structure of the new media houses, the working processes and contents are integrated, coordinated, and communicated through several media platforms each with its specific technological and organizational environments. In this way, it becomes possible to fulfill different types of needs and interests by new and growing audiences.

The Media General Group in the southeastern United States, for example, currently owns 75 online enterprises, 30 television stations, 25 daily and more than 100 weekly newspapers, and other publications. In 2000, one of its daily newspapers, *The Tampa Tribune* (Florida) moved into the buildings of a "News Center" together with the TV-station *WFLA* and the Internet service *Tampa Bay Online*. Its purpose was to become "the information powerhouse" in the Tampa area, covering 1.5 million households. Interest in the "laboratory in Florida" was great. The event was followed by media professionals from all over the world (Jacobsen, 2001). Such a significant and relatively quick development of convergence and divergence in the media landscape will continue in the near future.

The impact of the convergence in the News Center experiment in Tampa has been explored closely in a case study by Garrison and Dupagne (2003). They investigated a three-level model of convergence: technical, economic, and regulated convergence. For *technical* convergence, developments in hardware and software make it possible to handle all sorts of information, whether it is text, data, voice, or video; *economic* convergence establishes the basis of new services and new ways of doing business within society; in *regulated* convergence, legal possibilities for converging separate media are prepared. Garrison and Dupagne conducted a series of in-depth interviews with 12 selected staff members (news directors, editors, producers, reporters, and technical personnel). They found that convergence has an impact on the newsroom. Gradually, additional resources, common facilities, and new organizational structures change the jobs and roles of the staff. Some of the respondents felt that they improved their multimedia thinking about storytelling because they had to learn more about the specifics of work on other media platforms.

In a case study of *The Tampa Tribune* news stories, Huang, Rademakers et al. (2006) conducted a "content analysis" to see whether converged "journalism has jeopardized journalistic quality" (p. 1). To evaluate the quality of the news stories, five constituting factors were used: enterprise, significance, fairness and balance, authoritativeness, and localization. These were determined on the basis of interviews with professionals. Huang et al. (2006) compared the quality factors shown in the *Tribune* stories before, at the beginning of, and 3 years into, the convergence. They concluded that by and large "media convergence [had] overall sustained the quality of news reporting" (p. 1).

As a result, the impact of the convergence movements up to the present have been studied without bringing the reporting practices of journalism into focus. The following study addresses this point. The focus is on choice of genres, and the language used, when reports and background stories are communicated to different types of news media users.

This study deals with constructional and functional principles of news texts produced by journalists, and is based on different reporting practices. The units of analysis in the study are texts covering the same event (the murder at the school ball), developing almost simultaneously in different newsrooms of the *Nordjyske Medier*. The common purpose of these news texts is, as always, to inform the readers, viewers, and listeners. However, the construction principles behind each text seem different. News-gathering technique, the choice of genre, and the depth of reporting seem to reflect different conditions and possibilities of each media platform on which the text is intended to function.

In order to gain deeper insight into these aspects—the conditions and possibilities of different platforms—the study looks at the news texts (journalistic outputs) to investigate the following points: the speed of news deliv-

ery, the text frames, the precision of their linguistic expression, and their varying comprehensibility. All these qualities are embedded in the tools that editors and journalists use to communicate stories to readers. Editors and journalists make choices at each stage of the communication process. By investigating their texts it becomes possible to describe, discuss and, to a certain degree, explain why actual choices are performed with different linguistic results.

The daily newspaper *Nordjyske Stiftstidende* moved into a white, brand-new building, which looked like a modern palace with columns, spires, and glass fronts. The convergence at this economic, organizational, and architectural level took place in 2003 with the idea of developing new modern journalism on multiple platforms. The *Nordjyske Medier* incorporates the following:

- *Nordjyske Stiftstidende*, a morning newspaper, distributed 7 days a week.
- *24 Nordjyske*, a television station that broadcasts programs 24 hours a day.
- *ANR Hit* and *ANR Gold*, two radio channels with identical news transmissions.
- *www.nordjyske.dk*, a Web site with news, updates, articles that are also published in the morning paper, and where the house publishes.
- *10minutter*, a free daily newspaper that is distributed 5 days a week and is financed by advertising. In August 2006, this part of the house was restructured and renamed: *CentrumMorgen* is the morning edition of the free newspaper, and *CentrumAften* is the evening edition.
- An *SMS service* that especially serves sports enthusiasts.
- *Nordjyske Ugeaviser*, free local weekly newspapers financed by advertising.
- A *blog* based on the Internet, connected to the website.[2]

EXPLORING JOURNALISTIC ACTS ON MULTIPLE PLATFORMS

The purpose of this study is to examine the genres and language of the news as determined by reporting practices at different platforms. How does the

[2]It also has a new Web site http://Ditcentrum.dk established in September 2006 with news, discussion boards, and blogs as the key services, but this new platform has not been included in this study.

environment in a new media house such as *Nordjyske Medier* influence traditional methods of writing, expressing, and communicating information? These methods were developed more than 100 years ago within the framework of the print media, and it is worth exploring how they are used in this new environment.

I look at the news text as a journalistic *output*, which is influenced by two forces: the *potentials* hidden in the new environment and the *competence* represented by the actual staff of media workers. The output depends on whether the human competence within the media company is able to encompass and *use* the potentials afforded by the technological and organizational structures in the house. In a hypothetical work scenario, the output expresses the choices every journalist makes in terms of genre and language, when stories are told and communicated. At the same time, these choices reflect the potentials within the media house, as well as journalistic and editorial competence, which is handed down and mastered by virtue of the learned traditions of the journalistic craft.

This is the result of a complex interaction between producer, product, and contextual factors within the environment. Some of the environmental potentialities are realized within this interaction, others are not. The result of the ongoing process is sometimes described by means of the concept *affordance* (Engebretsen, 2006). The concept was introduced by the psychologist James J. Gibson (1979) and refers to the result of a mutual interplay between physical possibilities in an environment and the mental and motor competences of the individual:

> I mean by it [affordance] something that refers to both the environment and the animal in a way that no existing term does. It implies the complementarity of the animal and the environment. (p. 127)

The concept deals with the possibilities of action, which are used in a closely described interplay between an individual and a particular environment. Navigation in a kayak serves as an example: Moving across a surface by means of a kayak *not only* depends on the conditions of weather and water, but also on details of construction by which the kayak is supplied as a manmade object and tool. The series of possible actions that are actualized at the same time depend on the competence of the kayaker, which can be mobilized when using the object and encountering the surrounding nature. The beginner does not have as many possibilities for actualizing the hidden potentials of a kayak. The same applies for other types of individuals: children at a crawling stage, dogs, cats, or canaries. The degree of utilization here—and thereby the output of actions in these hypothetical situations—is zero. The trained and competent oarsman, on the other hand, is able to demonstrate a far more differentiated output. He or she will be able to use

more of the potentialities, when the kayak fulfills its purpose and serves as a means of transportation across the water.

In short, affordance is the quality of actions, performed with *complementarity* as a background; that is, a fundamentally bigger or smaller contrast between environment and individual. Additionally, affordance builds on *interdependence* and a coordinated utilization, partly of the potentials in the environment, partly of learned and inborn competences.

In the same way, a media house can be regarded as a unity of technical potentials and highly and quickly developed organizational potentials on the one hand, *and* a collection of editorial, journalistic, and administrative competences on the other. The affordance of the media house will appear as qualities in terms of editing, reporting, developing genres, and specific style. When I describe the communicative qualities of this combined output, I speak indirectly of the affordance of the media house. The output of kayak navigation, and the affordance of the navigator, can be described and evaluated in relation to a purpose, which basically is to survive and reach a destination. The output of the modern media house, and the affordance of the staff of the house, can be evaluated in relation to a purpose, which is also about surviving, but in this case based on an informative contact with users in order to fulfill their communication needs.

CHOOSING A CASE

The case study for this investigation has been selected carefully, to clearly record the impact of different platforms on the use of genres and language. In order to expose similarities, differences, and a possible interplay between the ways the language on the platforms function, I looked for a journalistic story that satisfied the following requirements:

- causes high activity on the platforms;
- triggers the use of different news genres;
- is simple in its essential structure; and
- runs at least a whole week .

I compared the number of *hits* recorded on the Web site www.nordjyske.dk. The period of observation was March 2006. The statistics during this period showed some significant deviations from the average daily number of hits, which had been established during a period of 6 months. These deviations offered the reasons for the choice. The curve regularly reaches its maximum every Wednesday and its minimum every weekend, especially on Saturdays.

When comparing the average numbers with the actual number of hits within the period February 25 to March 19, 2006, the deviations in a time space of more than 1 week are significant. The biggest difference observed is on Saturday, March 4, 2006. On this date, 111,113 hits were recorded against an average on Saturdays of 35,063. This corresponds to an increase of 217%.

This significant deviation from the average reflects that a need for information among users has occurred. On this date—as well as the date before and the dates after—the users of the Web site searched for information about a certain, much discussed event, that has caught their attention and increased their need for more information.

When we look for stories that underlie these above-average numbers during this period, there is no doubt that the front-page story of the Saturday edition of *Nordjyske Stiftstidende* accounts for some of the high activity: "One was killed and two wounded, when a ball turned into a drama last night at the Hasseris High School in Aalborg."

The first sentence of the text in the article introduces a crime story about the event, which is covered closely, often with several articles per day in the main newspaper during the monitoring period. The story is about a young girl who, on her way to a fancy-dress ball at the high school, is assaulted and stabbed by her former 23-year-old boyfriend. The assault began about 8.30 p.m. outside the high school, and continued inside the foyer of the building, where the participants of the ball were assembled. Those who were present at the event thought the assault was a spectacular part of the ball, but the young girl died shortly after from her stab wounds. Two of her friends had tried to rescue her. One of them was badly wounded, but partly recovered after a few days. The police arrived in less than 1 hour. After a few hours, the case was considered solved when the police found the body of the killer, who had committed suicide.

The story is not selected because of its violent development, but exclusively because it caused high editorial and journalistic activity. Additionally, by engaging the users, it made them fellow players of the media house when the story dominated the news agenda. The story developed from breaking news, which shocked the audience, to a tragedy, and further to a story about tackling collective mourning, which affected many people in the community. Within this field of suspense, the daily productions of journalism unfolded on all platforms using different genres and styles.

DELIMITATION OF THE INVESTIGATION OBJECT

When analyzing a journalistic story, I distinguish between the *real* and the *told* story (Grunwald, 2004). This distinction, often rigorously attacked by postmodernists, seems reasonable from a journalistic point of view: You can,

as in the present case, act and kill with a real knife, but not with the corresponding word. The real knife is part of an event, and this event belongs to a domain of "art factual," actionable and textual sources on which journalists are committed to act and research before they are able to tell and communicate stories. A conception of an extratextual reality seems to be a logical necessity in the domain of journalism, in order to demonstrate and keep hold of the dimensions of truth that seem to be integrated and necessary parts of the credibility of journalistic texts, and that separate journalists from poets.

Matheson (2004), in a comparison of traditional news and weblogs, similarly operated with a clear-cut distinction between text and event:

> . . . the reshaping of news material in the text around a news angle and in a descending hierarchy of importance is made to appear to be the natural shape of the news event itself. . . . The weblog, by contrast, is a much more "raw," less "cooked," source of information, allowing users to participate more in constructing knowledge about events in the world. (p. 455)

This distinction, a precondition for the authority and credibility of the profession, is described in many journalism textbooks. For instance, Phillips (2007) noted:

> [The] story is a sequence of events in which some form of action takes place. In journalism, as opposed to fiction, that sequence of events has actually taken place or is likely to take place. A narrative, in the literary sense, would be the telling of that story in printed form. (p. 7)

Phillips' distinction between *story* and *narrative* corresponds to my distinction between *real* and *told* story. Accordingly, the basis of the present journalistic treatment is claimed to be a real story, an event, which at a given date took place at a certain location between certain agents (players), who were acting from more or less transparent motives. The main event in this case was an assault, which resulted in murder and suicide. When the main event was communicated as *told* news, it was because it represented a drastic deviation from everyday normality (Grunwald, 2004), from what merely should have been another happy night in town. Taken as such a deviation, the *told* event was by definition a "good journalistic story," which confronted the public with the unexplainable, a shocking loss of meaning.

So the object of investigation here is not the real story, nor all that it depended on or what it caused. After all, this is a task for the police, psychologists and, in the long-term, authors. What is examined is the story as

told by *Nordjyske Medier*. This story built on selected and framed facts, and had a certain sequential structure and linguistic expression. I examine and compare how different themes are simultaneously weighed and expressed in different media platforms in the selected week of coverage.

FRAME OF ANALYSIS

How does the journalistic story begin and develop? How quickly did each platform react? Which parts of the story were foregrounded and which were backgrounded? How much space did they receive? How was the flow of information coordinated? Which style and which genres were used? Which potentials on the platforms were activated and which were not?

The potentials of platforms change. The historical transition from spoken to written language is a good example. During this transition, people had a technical opportunity to write down, preserve, and move texts. Analogously, it is a central technical condition for the Web that the audience can dissociate the saving of texts and the presentation of texts: Data intended for Web communication are saved as the digits 0 and 1 on an independent device. This paves the way for a high degree of user control with respect to presentation. We can say that presentation and reception are based on combinations and constructions made by the users themselves.

Where the paper-based text carries a message, which the sender has determined (i.e., has begun, documented, and ended), the Web-based text is principally the result of choices made by the user. The user of the Web provides an overview of the story and is able to look into its parts and their interrelations by choosing between possibilities and *links*, which are offered on a user interface and in a menu.

As Engebretsen (2005) said, we can say that the units of content on the Web that demand the full awareness of the user during a long period of time, are experienced as units behaving like strangers. With this in mind, it seems clear that an investigation of the relationship between the paper-based texts of *Nordjyske Medier*, and the texts on www.nordjyske.dk, is warranted.

In the same way, but from a different perspective, I investigate selected, parallel units of content, which can shed light on the relationship between written communications in the newspapers and on the Internet, the spoken language on the radio, and the communication on television (which uses animated pictures and sound together with spoken language). What are the consequences of the changes in content, focus, and linguistic expression in the news texts?

METHOD

In order to examine the different elements of the output, I focus on different journalistic features. Initially, the investigation is carried out through a comparative reading of texts published on the murder case. I examine (a) *comprehensibility*, based on syntactic and semantic choices and different image-evoking techniques; (b) *precision*, based on abstraction and degree of specification; (c) *exposure* of the plot, based on more or less complete descriptions of the agents of the story as well as scenes, actions, motives, means and targets, and (d) *documentation*, based on references to time, place, and involved persons and sources.

The different treatments of the story have been collected from the various platforms, which were activated during the progress of the case. The material from *Nordjyske Tidende, 10minutter* and www.nordjyske.dk is nearly complete, whereas the collection of material from the news radio *ANR* and the television station *24 Nordjyske*, for technical reasons, has been difficult to determine in detail. Nevertheless, the accessible material (about the story) is used as a basis for analyzing and discussing what happened on these platforms in terms of genre and language.

Table 6.1 shows how many media texts (articles and programs) from the case have been collected.

TABLE 6.1
Number of Texts Distributed on Observed Platforms

Nordjyske Stiftstidende (main newspaper)	32
www.nordjyske.dk (Web site) Preprints to the main newspaper; preceding versions not included.	26
ANR Hit and *Guld* (radio)	26
24 Nordjyske (television)	12
www.nordjyske.dk (Web site) Web stories only (not brought in the main paper); preceding versions are excluded.	11
10minutter (free daily paper)	10
Total number of media texts	**117**

FINDINGS 1

Television is the fastest and most precise in initially reporting the event. About 30 minutes after the event took place, the first news about it was on television. Later, I show that this medium is overtaken by messages communicated over private SMS networks. We expect that the television station has enough resources to dispatch journalists "on the spot" to gather information and provide background reports. This means that most of their information is based on interviews with witnesses, as well as journalists' own observations, supported by television pictures.

The *Web* as a medium is almost as fast as television, but not nearly as precise in the formulation of the information provided. The Web medium refers to the Danish news agency Ritzau, whose base of sources has not been explored. I expect that information gained via the television at some time during the night is going to become part of updates on the Internet.

At this introductory stage, both media are purely informative, offering messages formulated in a simple syntax. The choice of words is governed by the *consequences* frame—the fatal consequences of the killing are in focus, exposed in as much detail as possible. In some places, subordinate clauses are put ahead of the main clause. However, such a syntactical structure is common when sources are referred to. On the *radio* and *television*, careful reading can compensate for this. On the *Web*, which, broadly speaking, uses a stiff, written style of language in combination with photos, the reporters would possibly get a more functional textual interface if they were willing to use a more personal style free from the influence of the formalities in the language of administration. The contents of the messages are documented by short quotations from authorities (in particular, the police) as soon as they were willing to be interviewed.

The main *daily newspaper's* coverage was incomplete at the introductory stage of coverage. The references to authorities are detailed, but information regarding the event itself is not precise. The newspaper had a photographer on the spot, but the news–gathering seems to have been generated by telephone and based on Ritzau's reports, with cautious police as the main source. Cooperation with the reporters from television (*24 Nordjyske*), who were at the location right up to the deadline of the newspaper, might, in terms of precision, have improved the product of *Nordjyske Tidende*.[3]

[3]There is a question here about the cooperation. I asked them why they didn't cooperate. They said that there was a problem, but they could neither diagnose it precisely nor solve it. My hypothesis is that the different sections of the newsroom on this level of development have their own practices and norms, which prevent smooth cooperation. Instead, they function as parallel and relatively independent subgroups in the editorial news domain of the organization. But this has to be investigated and tested in a separate study.

The first morning report on the *radio* occurred nearly 10 hours after the event, and was short and very precise. The radio was able to make use of the earlier versions of the story from the other media. These journalists had the latest information about the case at their disposal, close to the time when messages went to air. The radio is usually a very quick medium. In this case, the slow reaction seemed to concern resources: The program controller explained the relatively slow delivery of the radio message resulted from the organization and governing concepts of the local station, which prevents news transmissions on Fridays after 6 p.m. He said that if something happens in the 12-hour period after this time, listeners would not get to hear about it until 6 a.m. on the following day.

All platforms of *Nordjyske Medier* have access to the constant flow of news from the news agency Ritzau (which was also covering the case). However, only television has the resources to practice investigative reporting, to supplement the general information from Ritzau with more concrete information about the event and the agents involved, and to show details. This supplemental information is provided by their reporters on location. Ritzau typically depends on information received from police officials on duty. Initially, police were withholding information while they carried out their investigations, and this limitation could be observed in the texts from the platforms depending on Ritzau—the Web, and the next day's edition of the main newspaper.

BACKGROUND AND INTERVIEW

On Saturday morning, news of the event was published in the main newspaper and broadcast on radio. The focus of the story changed from news to background. The main questions at this stage were *how* the event took place and *why* it happened. Also the *consequences* for the involved parties— students, teachers, parents, and the responsible authorities from the local administration—were discussed.

In the next 24 hours, four *background* or *focus themes* dominated all three media. When the main newspaper was published on Sunday morning all themes were gathered and covered:

1. Security and counseling.
2. Shock and mourning.
3. The behavior of the killer.
4. The killer's possible motive.

Additionally, there were a couple of smaller elements that portrayed the victim and illustrated the relationship between victim and killer.

The treatment of the case in the genres of the newspaper involved mixing follow-up news, background, interview, and reportage. At this stage, this meant that the repertoire of genres was extended: The short introductory news items with few quotations and photos were replaced by articles that summarize the already communicated main points of the event. Simultaneously, the media gradually tried to expose the details of the drama when these were available. Interest was greatest in the reconstructions of the most decisive and dramatic seconds: There was a noticeable need to explain how the killer acted and what the victim and the victim's helpers were exposed to. The main sources of information were the police, the medicolegal experts, and the headmaster of the high school. At this point, the information from the authorities was supplemented with information from an interview with one of the closest involved helpers.

FINDINGS 2

The Sunday edition of *Nordjyske Stiftstidende* contained seven background articles about the case, based primarily on interviews and journalists' observations. The first three themes were treated, and the newspaper demonstrated its ability to present a broad and thorough coverage. The killer's motive was the most mysterious and challenging point of the story and, as such, an important driving force in the narration, which took place during that weekend and the following days. One can conclude that the newspaper wanted to leave the mystery unsolved rather than publish material that was speculative or inadequate. The newspaper came close to a cautious and discreet description of the man's social background, and noted that the man was known to the police.

Some advantages and disadvantages of the *Web* are evident at this stage. This medium has the advantage of being able to act quickly and cover broadly. Moreover, information is accumulated so that the user can quickly find earlier versions and fragments of the story through a menu of links. The disadvantage from the Web users' point of view is that most of these are planned as newspaper articles which, by virtue of their length, seem strange in that specific context. The Web site functions as a platform for the distribution and archiving of newspaper articles that are being developed, or are ready for print. In this way, the interplay with the user is reduced to a minimum. There is no integration of video on the user interface and the integration of audio is limited: The studio texts are available in print attended by a short documentary sound quotation. Hypertext links from an actual presentation of a story to written or audiovisual sources are not available.

The television makes use of its mobility and ability to communicate from the location where the story begins. It brings the user close to the var-

ious people interviewed. Reporting and interviews are the strengths of television news. The people interviewed are not only voices who answer questions, but faces that (in this case) express feelings behind the official appearance of authority.

The strength of the *radio* (after the initial debacle on the Friday night) is its ability to present short and quickly updated messages. At this stage, elements of background information were brought together with quotations providing additional information.

On Monday morning, *10minutter* was on the street for the first time during the case. The front page was covered with four articles in the form of news reports, follow-up news, and a background report. They were extracts from articles that had already been on the Internet or in the main newspaper, or shortened versions of the articles in the same day's main newspaper, but with a different headline (*10minutter*: "Silence in the Street"; *Nordjyske Stiftstidende*: "Stabbed Girl Remembered With Silence in the Street." *10minutter*: "Psychologist: Killer Possibly Momentarily Insane"; *Nordjyske Stiftstidende*: "Psychologist: Killer With Low Self-esteem." *10minutter*: "Considers Bouncers at High Schools Balls"; *Nordjyske Stiftstidende*: "Tightening Up on Security After the Killing.") This indicates that the sources of the articles in the free newspaper are stories from the other media, especially the main newspaper. Although the articles in the free newspaper were short, they actualized, in a restricted space, different genres by which they functioned according to the intentions of the media house: as a kind of appetizer for the in-depth articles in the main newspaper.

Finally, the "accounting" or "explanatory" journalism contained complex subjects related to Themes 3 and 4, the behavior and the motives of the killer. These themes were first of all treated in the traditional *daily newspaper* (especially *Nordjyske Stiftstidende*, but also, slightly edited, in the *free daily newspaper*). Neither *radio* nor *television* followed these parts of the story. Radio and television made short and condensed reports on the event and described the subsequent mourning. These were interview-based reports, which in sound and pictures exposed the sources while at the same time discussed security or counseling for those who were stricken by the event. Compared with radio and television, the main newspaper stood back in that sense, but on the other hand covered all—both with respect to the contents of the story and the diversity of the genres in use.

CONCLUSION

Some details still remain to be dealt with here: the heroes of the story, who played their roles despite the tragic perspective; the slightly exposed victim's funeral, the anonymous mention of the killer's funeral, as well as the side

story concerning young people's SMS networking during the event, which caused a rapid, detailed, and precise distribution of the main story during the very first hours of the event.

These parts confirm observations made about earlier stages of the story distributed on multiple platforms, and can be summarized as presented here.

Speed

The investigations demonstrated that—not counting the first 10 hours—the *radio* is a rapid medium, which traditionally integrates the results of journalistic research by the other media into its own independent productions, which are quickly sent to air. Accordingly, the radio depends on events being reported in the other media.

Principally the *Internet* is as rapid a medium, but it has not developed its own style and genres. Articles in the archives of the Net are the earlier versions of the texts published in the newspaper. Thus, the contents of the Internet depend on material produced for the newspaper, which comes from the news agency Ritzau, the television, or the radio. This becomes quite clear when the media begin to tell the follow-up story: The Internet uses hours to find a precise formulation for the essence of the story.

At this stage, *television* wins in speed, presumably because it possesses the resources and readiness for practicing investigative journalism, and not only retailoring already-made news texts.

Precision

Television also wins in terms of precision. Television relies on pictures and being on location is mandatory for reporters. In the version that follows shortly after the event, television did not depend on the police as a source as much as the newspaper. Television succeeded in identifying and presenting the central details of the story in its very first reports, obviously because it made use of all the witnesses near the crime scene.

The *daily newspaper* is slow in the beginning, and initially not particularly precise. The victim was, in the first article on Saturday morning for instance, described as a "student," who was "presumably a woman," whereas television, and later the Internet, for hours had been reporting that the deceased person most certainly was a female. However, the newspaper is deeply rooted in traditions of precision in terms of journalistic research and communication. This means that, time and again, it comes up with a more complex and thorough product. It is in the newspaper that the audience finds the most comprehensive treatment of the case and the widest *diversity* in terms of used genres. Clarity and care with references to named sources

take priority. The newspaper is also able to capture the complex elements of the case. Moreover, it is in the newspaper that the story gets its frame and perspective overall. It is also the newspaper that finds a way of ending the story. The newspaper has a slower cycle of publication, but in this case it was the newspaper that established the frames, decided how comprehensive the communication needed to be, and which course it had to follow.

Cooperation

When following the parallel times of publication on the different platforms, the study shows that cooperation around updating the story does not always occur. This is a problem that may be investigated further with methods other than comparative text analysis. The study could involve producers and writers, for example. The investigative television medium has advantages by being on location. They might be used by the other media without spoiling the items made by television.

Lack of precision in the first versions on the Internet was evident. Also, in its first version of the story, the main newspaper could have taken advantage of the information obtained by television when it had passed its publication deadline on Friday at 10:15 p.m. One can suppose that a certain work routine, and perhaps a latent culture of competition prevented this from happening. Obviously, the radio is more open to using the results from other media, without having to plagiarize their work. The items from the radio are expressed in an independent format and an audibly adjusted language, even if the information on the item derives from the other media. It seems as if the radio works as a part of the organization under the assumption that there is open cooperation in the sharing of stories.

Quality

Let us for a moment return to the concept of *affordance*, which expresses how the amount of local competences play together with the potentials in the surrounding, quickly developing technological environment. *Affordance* is a general expression of the qualities of the output that the media house is able to deliver to its users.

If affordance has to be changed and perhaps improved, changes are necessary in the culture of cooperation regulating the concrete processes of communication for each of the different platforms. The innovation that takes place economically, ideologically, technically, and organizationally in a media house such as *Nordjyske* seems at some levels to be met with resistance, which is deeply rooted in solid traditions of journalistic research and writing. This puts the brakes on the use of all the technical potentials avail-

able in each of the multiple platforms. The spontaneous utilization of the private SMS network is, in this context, thought-provoking, because young people seemed to outdistance the professional media both with respect to speed, precision, and identification.

The Web is expected to be the place that, in the future, will gather and coordinate the services delivered by the separate media platforms. At present, Web output seems to be affected by the fact that the medium has not yet developed an independent form of journalism that immediately matches the potentials of the medium.

Journalism, the craft of storytelling, and the linguistic expression of the Internet are especially rooted in the traditions of the daily newspaper. The sort of convergence that is carried through at other levels of the media house has not been carried through to the user interface for the Web. The possibilities of integration with radio and television have only been used to a limited degree. The possibilities of developing true hypertext are not yet present, nor are the possibilities for the user to construct his or her version of the story via visual, auditory, and linguistic details, offered by the medium.

The results of this study support the hypothesis that tradition in terms of genres and language is stronger than innovation. The *affordance* (Gibson, 1979) is weaker than it should be, not because of a technological lack of *potentials* in the cross-media environment, but because of a lack of *communication competence* matching the new technological possibilities of the media house.

ACKNOWLEDGMENTS

Thanks to editor-in-chief Bruno Ingemann for kind assistance and useful information during my visits to *Nordjyske Medier*. Thanks to the Department of Political Science, University of Southern Denmark, and to UPDATE—The Danish Journalism Development Institute, for financial support to the project.

REFERENCES

Engebretsen, M. (2005). *Konvergens i tekst. En studie av et tekstformat som kombinerer skrift og video* [Convergency of text. A study of a textformat, which combines writing and video]. Kristiansand: Høyskoleforlaget i samarbeid med Høgskolen i Agder.

Engebretsen, M. (2006). Shallow and static or deep and dynamic? *Nordicom Review,* 27(1), 3-16.

Garrison, B., & Dupagne, M. (2003, November). *A case study of media convergence at Media General's Tampa News Center*. Paper presented at Expanding Convergence: Media Use in a Changing Information Environment, University of South Carolina, Columbia.

Gibson, J. (1979). *The ecological approach to visual perception*. Boston: Houghton.

Grunwald, E. (2004). *Artiklen* [The article]. Odense: Syddansk Universitetsforlag.

Grunwald, E., & Rupar, V. (2009). Journalism curiosity and story telling frame: A comparative study of Australian and Danish newspapers. *Journalism Practice, 3*(4).

Huang, E., Rademakers, L. Fayemiwo, M., & Dunlap, L. (2006). Uncovering the quality of converged journalism — A case study of *The Tampa Tribune* news stories. Retrieved October 5, 2006, from http://www.poynter.org/resource/69008/ USF_study1.pdf#search=%22%E2%80%9DUncovering%20the%20Quality %20of%20Converged%20Journalism%E2%80%9D%20%3F%22.

Jacobsen, P. (2001). *Laboratoriet i Tampa, Florida* [The laboratory in Tampa, Florida]. Århus: CFJE.

Matheson, D. (2004). Weblogs and the epistemology of the news: Some trends in online journalism. *New Media and Society, 6*(4), 443-468.

Petersen, A. (2006). Medielandskabets voksende flermedialitet, tvaermedialitet og nye mediekoncepter? [The growth of multiple platforms, Cross-mediality and and new concepts of the media?]. *Samson, 16*(3), 15-17.

Phillips, A. (2007). *Good writing for journalists*. London: Sage.

7

TABLOIDIZATION

Form, Style, and Sociocultural Change

David Rowe

University of Western Sydney

This chapter is concerned with change of various kinds: in newspapers, the media sphere in general, and in wider culture and society. It engages in particular with the important and influential "tabloidization thesis" and its proposition that all media (including broadcast) have moved toward more direct, simplified, succinct, and spectacular modes of news and entertainment, and, not uncommonly, that this specific media phenomenon represents a more thoroughgoing tabloidization of society (Lumby, 1999; Sparks & Tulloch, 2000). The consequences for the theory and practice of journalism of such tabloidization are profound, implicating journalists in a process that would universally shape their labor and its product, and prescribing for newspapers a cultural blueprint that constrains their form, style, relations with readers, and cultural political role.

Newspapers are, as in previous eras, challenged by shifts in the media landscape, but they remain influential in relation both to other, newer media and to the sociocultural relations and structures that they represent—not least because they can themselves be acutely responsive to change. In this sense, changes in newspaper form and style may be regarded as indices and accommodations of wider sociocultural change, rather than as futile strategies of a moribund medium. This chapter, in drawing on a study incorporating quantitative content analysis and qualitative interview method, reflects on changes to two Australian newspapers (one broadsheet, one tabloid) that suggest an often underacknowledged responsiveness to the shifting circum-

stances within which they operate.[1] These considerations raise difficult questions of causality, in particular the extent to which changes in the media (here newspapers and journalism) reflect or precipitate sociocultural change. Dialectical processes, whereby shifts in one sociocultural domain resonate and sometimes collide with others, producing, in various measures reinforcement, resistance, uncertainty and unpredictability, are related to mutations in the form and style of contemporary newspapers; to the labor practices and practical consciousness of the journalists who produce them; and to the implied relationships with readers that are implicated in them.

Examining continuities and discontinuities in newspapers can be seen, therefore, to offer a variety of opportunities to enhance the social scientific understanding of the ways in which the media "render reality," and the manner in which prevailing sociocultural conditions register within media structures, textual relations, and newspaper forms and styles. The speed of change in media and culture—the gathering sociotechnical transformative trends of "accelerated culture" described in the influential work of Virilio (Der Derian, 1998; Redhead, 2004a, 2004b), may mask some persistent or recurrent phenomena that indicate that contemporary societies are not as dramatically different from historically preceding societies as they might appear. Interrogating the concept of tabloidization, then, can assist meaningfully in the task of analyzing sociocultural change, especially in the still-important domain of the daily newspaper, and in understanding the forces that are brought to bear on the practice of contemporary journalism.

In surveying the critical literature on tabloidization, a range of often disparate qualities can be presented as characterizing the tabloid (Turner, 1999), encapsulated through consistently ascribed general characteristics (perhaps, commandments) of the tabloid that might constitute an "ideal type" in the Weberian sense (Weber, 1949). Among these trend characteristics are "the decline of 'hard news' (including orthodox, official or formal institutional politics) in favor of 'soft news' (gossip, lifestyle, consumer advice)" and "sensationalization and spectacularization of news, accompanied by the accelerated ephemerality of news stories" (Rowe, 2000, p. 82). Although these characteristics of the tabloid may be commonly ascribed, especially among critical analysts, they constitute only a diffuse framework of structures, processes and trends that does not convincingly establish or explain tabloidization as a sociocultural phenomenon. The lack of "a consensual

[1]This chapter draws on "Disposing of the Tabloid? A Critical Analysis of Contemporary Developments in the Print Media," a project funded by an Australian Research Council Discovery Grant. Alongside the content, discursive and textual analysis, and use of audit bureau statistics, senior editorial staff and journalists from these and other newspapers in Australia, Britain and the United States were interviewed. Of course, national variations in newspaper industrial and professional contexts must be taken into account. Research ethics protocols required that no interviewees could be identified, and in some instances details of interviewees' employment have been disguised in order to protect their anonymity.

definition of tabloidization" and the suggestion that "tabloidization should not be considered as a static concept" (Uribe & Gunter, 2004, p. 400) make the process especially difficult to track, both in theoretical and empirical terms. Uribe and Gunter, following McLachlan and Golding (2000), see changes in newspaper range, form, and style as definitive of tabloidization, while also noting the instability and variability of their "operationalization." In turn, they share with Winston (2002) the perspective that, although tabloidization "cannot be easily defined," it is possible to trace commonly proposed tabloid trends (as summarized by Sparks & Tulloch, 2000) in British television and print news, such as the decline of political news and the rise of human interest stories. In my own study, the most common and persuasive tabloid characteristics emerging in the research literature, as opposed to their rhetorical deployments, were weighed and distilled into a set of common attributes that could be measured and analyzed. Although such a "typology" is inevitably (and desirably) contestable, it seeks to supplement the "limited" data "on changing tabloid newspaper news profiles" (Uribe & Gunter, 2004, p. 389) that can inform debates on contemporary media culture. In particular, it is concerned with the ways in which newspaper formats and the practices of journalists may be adjusted according to changing circumstances in the media and in wider sociocultural spheres.

TESTS OF TABLOIDIZATION: JOURNALISM AND THE NEWS SPACE BUDGET

The study on which this chapter is based sought in the first instance to examine developments in the format, content, and style of the principal news pages of selected newspapers in Australia. Two newspapers from the same publisher, the Rupert Murdoch family-controlled News Limited (part of the aforementioned News Corporation), are appraised here: the *Australian*, Australia's only daily national broadsheet (first published in 1964), and the *Daily Telegraph*, Sydney's only daily tabloid and the city's largest selling newspaper. The content-analysis[2] component of the research

[2]The limits of the content-analysis method are recognized here, but the categories used were revealed to be reasonably robust, through such techniques as requesting a researcher from another field with no contact with the research to "test" them. There was a high level of agreement (approximately 90%) in the application of the proposed categories, but other data were used in analysing trends in contemporary newspapers, including previous empirical studies, interviews with media personnel, and trade data. No ultimate claim is made of the unassailability of the findings and conclusions here—for example, the data set in most cases was not suitable for the application of tests of significance—but the combination of quantitative and qualitative data gathering, theoretical analysis, and critical conceptual investigation enabled some effective new insights into the subject of the research.

was designed to discover whether there were detectable differences between these newspapers and also, by tracking them (using sampling techniques) in the period from 1992 to 2002, to establish whether clear, consistent tabloid trends could be found, irrespective of whether they were technically tabloid—in other words, whether there had been a more general tabloidization of newspapers (and perhaps, by implication, all media).[3]

In this context, I only can select elements of the study for analysis in order to highlight its main concerns, picking out "sample" elements of the quantitative and qualitative data in order to tease out the ways in which tabloidization, if detected, might be seen as a response by newspapers and their journalists to the pressures to be livelier, more "digestible" and user-friendly, thereby eliciting conflicting interpretations of consequences for the quality of news. One key test of the tabloidization thesis is the change to the space budget of the newspaper. There is, as noted earlier, no agreed international standard as to what constitutes the tabloid, but there are many characteristics that are routinely attached to it. In moving beyond the technical definition relating to newspaper size, various features are posited as encapsulating the tabloid. A space budget analysis was, therefore, conducted of what journalists call the "front end of the book" in which the main news pages are to be found.[4] In this context the focus is on tabloid form—the proportions of text, image, headline, and advertising on the main news pages. However, although these individual story elements are useful in tracking a tabloidizing trend (the reduction of text and the expansion of visuals and headlines), as a unit (defined as "all text") they also constitute news material in a way that contrasts with advertising, masthead, index, and other non-news items. For this reason, it is necessary to examine, both separately and collectively, the compositional units of newspaper form.

In tracking the main news pages (pages 1–3) of the *Australian* from the early 1990s to the new millennium, in terms of the space budget a tabloidization trend would be consistent with a reduction in article text, larger mastheads, images and headlines, and more space devoted to advertising and non-news copy. Tables 7.1 and 7.2 indicate that there was a decrease in the amount of space devoted to the text of articles (–6.8%) and an increase in that given to the index (+2.8%) in the sample period, while images were more prominent (+5%) and headlines and advertisements have remained

[3]Many broadsheet newspapers, especially weekend editions, have tabloid inserts. A newspaper, however, is regarded as a broadsheet here if its key news pages are in that format.

[4]The full study deals with three different publications (two broadsheets and one tabloid—only two of which are discussed in this chapter). A comparative section of equivalent print space across all three newspapers was taken as the sample size in the initial year of analysis (1992) and replicated in the 1997 and 2002 sample years, regardless of any potential structural changes in news presentation format. Six issues per annum of the first three pages of the broadsheet newspapers and the first six pages of the tabloid newspaper were sampled. The six issues per annum were sampled on a rolling week basis to account for both weekly as well as seasonal variations.

fairly consistent when comparing the 1992 and 2002 samples. The uneven-
ness of some trends also is apparent, however, with a sharp "spike" in space
devoted to advertising (+8.9%) in 1997 and a concomitant reduction in news
text (−9.3%), but by 2002 the advertising component had dropped to below
1992 levels, and the proportion of news text had risen (+2.5%) since 1997,
although not to 1992 levels.

TABLE 7.1
Components of Pages 1–3 of the *Australian*
in square meters, 1992–2002 Sampled at 5-Year Intervals

COMPONENTS	1992	1997	2002
Article text	14,580.56	11,735.70	12,441.66
Article image	6,360.05	6,826.37	8,025.67
Article headline	3,073.20	3,227.39	2,835.65
Publication title	1,816.00	1,616.50	1,899.25
Advertisements	5,423.00	8,419.00	5,229.75
Index	695.75	726.00	1622.50
Other copy	340.01	161.75	384.00
Total	32,288.57	32,712.71	32,438.48

TABLE 7.2
Components of Pages 1–3 of the *Australian* as a Percentage
of Total News Space Budget, 1992–2002 Sampled at 5-Year Intervals

COMPONENTS	1992	1997	2002
Article text	45.2%	35.9%	38.4%
Article image	19.7%	20.9%	24.7%
Article headline	9.5%	9.9%	8.7%
Publication title	5.6%	4.9%	5.9%
Advertisements	16.8%	25.7%	16.1%
Index	2.1%	2.2%	5%
Other Copy	1.1%	0.5%	1.2%
Total	100%	100%	100%

It should be noted, however, that any reduction in space devoted to advertising might not have arisen out of the wishes of the newspaper, but might instead reflect market conditions at the time. For example, in the 2002 annual report of News Corporation it was stated that "The *Australian* maintained its circulation while it battled a downturn in Australian national newspaper advertising" (News Corporation, 2002a, p. 28), and its chairman, Rupert Murdoch, told shareholders at the 2002 News Corporation annual meeting that:

> Our newspapers also faced very difficult operating environments during the year and, I think, performed well under the circumstances. The severe ad recession in Australia and the UK were particular drags on our newspaper operations, although the quality and strength of those businesses enabled us to generally retain our leadership positions in extremely competitive markets. Circulation at our Australian papers was healthy, but revenues were hit by falling ad spending. (News Corporation, 2002b, n.p.)

It is important, therefore, when positing the broad tabloidization thesis, not to overestimate the degree of control that individual media companies and their personnel exercise in any given context (Curran, 1998). Overall, in the case of the *Australian* in the sample period, space devoted to the total article as a unit (text, image and headline) in the main news pages fell from 74.4% in 1992 to 66.7% in 1997, but rose in 2002 to 71.8% (although still remaining below 1992 levels). Within this news item framework, however, as noted earlier, there was not a clear and consistent move toward what is commonly taken to be the tabloid "formula": shorter articles, bigger headlines and photographs, and a higher advertising to editorial ratio.

The patterns and trends evidenced by an actual tabloid newspaper, as opposed to a broadsheet that might be taking on aspects of the tabloid, require to be considered next. In turning to the *Daily Telegraph* and its "news" space budget (pages 1–6 due to its tabloid format) between 1992 and 2002, there is a general trend (despite some fluctuations) toward proportionately more image space (+15.9%) and article text (+5.1%), and a concomitant (although also fluctuating) decrease in the space devoted to advertising (–9.3%). The proportion of space devoted to headlines (–6.1%) and the index (–11.6%) fell, and of the publication title rose (+4.5%), although again the trend was not constant throughout the sampled period. Similarly, the space devoted to total article space of text, image, and headline in the principal news pages of the *Daily Telegraph* fluctuated over the sample period, from a base of 58.8% in 1992, rising to 73.2% in 1997 and falling in 2002 to 67.2% of the space budget for pages 1–6, a nonetheless marked increase over the decade (see Tables 7.3 and 7.4).

TABLE 7.3
Components of Pages 1–6 of the *Daily Telegraph*
in square meters, 1992–2002 Sampled at 5-Year Intervals

COMPONENTS	1992	1997	2002
Article text	6,907.92	8,769.81	7,263.28
Article image	8,360.17	9,793.00	9,687.45
Article headline	4,248.34	3,859.77	3,988.02
Publication title	1,471.50	1,726.65	1,537.25
Advertisements	11,165.38	5,175.25	7,580.05
Index	818.90	622.75	724.15
Other Copy	250.80	712.20	416.05
Total	33,223.01	30,659.43	31,196.25

TABLE 7.4
Components of Pages 1–6 of the *Daily Telegraph* as a Percentage
of Total News Space Budget, 1992–2002 Sampled at 5-Year intervals

COMPONENTS	1992	1997	2002
Article Text	20.8%	28.6%	23.3%
Article Image	25.2%	32.0%	31.1%
Article Headline	12.8%	12.6%	12.8%
Publication Title	4.4%	5.6%	4.9%
Advertisements	33.6%	16.9%	24.3%
Index	2.5%	2.0%	2.3%
Other Copy	0.7%	2.3%	1.3%
Total	100.0%	100.0%	100.0%

Once again, therefore, there is no consistent evidence of the tabloidization trend by these measures, even in a tabloid newspaper that might be expected to be getting more "tabloid" according to the formal measures presented here. By some measures, such as the *Australian's* decreased proportion of news text, the broadsheet newspaper may be said to have exhibited a more pronounced tabloid trend than the tabloid itself (perhaps, this could be regarded as the broadsheet "catching up" the tabloid). The tabloid *Daily Telegraph*, in fact, reversed (if unevenly) some elements of tabloidization,

with proportionately more text and less advertising, although, of course, the smaller page size of the tabloid provides less room for large advertisements on the main news pages, especially the key front page.

There are many other measures of the tabloid trend not addressed here, such as the newspaper's mode of address or its news subjects, but these indicative findings challenge some of the more absolutist pronouncements of a consistent, irresistible tabloidization process in contemporary journalism. The shifts within the principal news pages space budgets of both the broadsheet and tabloid newspaper were, across the period surveyed, much less consistent and dramatic than is suggested in what Langer (1998) described, in specific reference to critiques of television culture, but as part of broader critiques of media culture, as the tabloid "lament." However, even if there could be a clear empirical measure of tabloidization and its trends, it is still necessary to go beyond statistics and category coding to engage with the meaning of the tabloid among the human subjects, and within the organizations, responsible for the production of news texts. This task means that it is necessary to interrogate the ways in which journalists negotiate the tabloid, with its many connotations and ramifications, as it impinges on their professional practice.

JOURNALISTS AND THE DISCURSIVE MANAGEMENT OF TABLOIDIZATION

Newspapers are, like all cultural products, outcomes of cultural labor. They are produced in a macro environment (broadly, the social world and the public sphere) under particular institutional and organizational conditions (the media sphere and its constituent parts), and operated by personnel located in organizations with a complex division of labor and with variable levels of control over what is produced (Hesmondhalgh, 2005). Newspaper editors and journalists work under historical circumstances where there is a hierarchy of occupational prestige (Rowe, 2005). The established journals of record (such as the London *Times*, *The New York Times* and the *Sydney Morning Herald*) have, at least until recently, mostly been broadsheets ("broadly" defined) that are generally placed, both within and outside the profession of journalism, above the tabloids (such as the London *Sun*, the *New York Post*, and the Sydney *Daily Telegraph*). This is not an entirely inflexible hierarchy—broadsheet journalists (as is demonstrated later) may distinguish between "good" and "bad" tabloids, and tabloid journalists may claim parity with their broadsheet colleagues. There also is some movement of personnel between the two, and even parallel hierarchies—for example, the sports round on a broadsheet may be regarded as inferior to the politi-

cal round on a "quality" tabloid. Nonetheless, there is little doubt that broadsheets are more prestigious than tabloids within the media sphere and beyond (Sparks & Tulloch, 2000).

In order to learn more about and to explain these tensions, the study also involved interviewing editors and journalists from both broadsheet and tabloid newspapers. It sought to understand how they interpreted and discursively managed the concept of tabloidization, and was especially interested in whether the tabloid was seen as a purely technical term or one that was value-laden. A small sample of the interviews is discussed here in teasing out what the tabloid means to working journalists, and the range of connotations that arise from what might seem, denotatively, as simply a matter of newspaper format variation. In particular, an attempt was made to tease out journalists' responses to the formal and stylistic changes that are commonly held, both in and outside the profession of journalism, to signify tabloidization.

All journalists interviewed recognized a broadsheet–tabloid distinction, but exhibited differing views on its implications and on whether a gathering process of tabloidization was in train. One Australian tabloid sports editor[5] who had previously worked for a broadsheet and on other news rounds took an unapologetic view of the difference between broadsheets and tabloids:

DR: When I use the word tabloid what immediately springs to mind for you?

Roland: Compact. Easy. Disposable. Understandable. Provocative. Argumentative. And also the basic rule in journalism too, information. In a compressed form a lot of the time, too.

DR: So would you see a tabloid newspaper as being very different from a broadsheet newspaper in that sense?

Roland: In a literal sense, the size, or content?

DR: Both.

Roland: Well a tabloid obviously is easy to read, easily accessible for people. A broadsheet is a much bigger newspaper and it's a good parallel that it's a bigger newspaper, too, because people, uneducated maybe, would believe it's a much more dif-

[5]More than 50 journalists, including several editors and some in the broadcast media, were interviewed for the project in Australia, the United Kingdom, and the United States. In this chapter, given its Australian empirical focus, only interviews with some Australian journalists are presented. The anonymity of all interviewees is maintained here by using fictitious names and omitting other information that might identify them. Phatic utterances ("um," "er," etc.) and excessive repetitions ("you know") have been omitted. Ellipsis (. . .) is used to screen out extraneous information, repetition, and potential interviewee identification. Interpolation [. . .] is used for clarification purposes, such as when words are clearly implied but unspoken.

ficult newspaper to get through. Tabloid I think is, as I said, more disposable, more argumentative, more provocative, more issue-based, where a broadsheet has a lot more structure to it. There's analysis, in-depth reporting, investigative reporting, and generally very good writing. In the tabloids you get very good writers too but it's a more compressed state. Less copy. More display. That's the basics of it, I think. There's more [of an] avenue for readership in the broadsheet and in-depth analysis, whereas the tabloid is more day-to-day, at a glance.

This journalist sees a clear formal and stylistic distinction between tabloid and broadsheet newspapers, but with regard to readership and function rather than in any straightforward hierarchical terms. When presented with common pejorative judgments associated with tabloid newspapers, including its reliance on sports and the lack of depth of news coverage, he enlisted equally familiar arguments about reader preferences:

Roland: My response to that is that I put out a paper that people want to buy, and that's what we're talking about, so that's the market we're going toward. I think an obligation of all journalism is information. . . . Like if there's going to be a street march or something. But I'm not going to write forty centimetres on a boring street march, I'll try and dress it up. And make "Why are we having this?" an issue. More sport? If that's what people want to read and our sales figures show that they do, I'll keep doing that.

Here, value-laden terms were exchanged and reversed, with the journalist invoking the kind of populist discourse that contrasts elite assumptions of what (at least the target) readership desires with what is actually sought in newspaper texts (see, e.g., Flint, 2003). Both the journalist's personal occupational history and the discursive and organizational location of the interviewee often corresponded with the manner in which the broadsheet–tabloid split was represented. For example, one senior Australian broadsheet journalist responded to the same opening question as follows:

Ken: Well it's a sort of sensationalism, it's a sort of personality-driven journalism, or celebrity-driven rather than issues driven. Sometimes celebrity issues and sports are a bit hard to separate. But it's a shallowness, I suppose. That's the main thing.

DR: So you see tabloid as a negative term?

> Ken: Well I do, but [from where] I work I think there is good
> tabloid journalism [laughs, trails off] . . .

This journalist, who had also worked on tabloid newspapers and was a
union representative "serving" both broadsheet and tabloid newspapers,
deployed the common negative descriptors of the tabloid ("sensationalist,"
"personality- and celebrity-driven," and "shallow"), but also mitigated this
unfavorable judgment by acknowledging the possibility of "good tabloid
journalism." This position, however, appeared to be more a matter of indus-
trial solidarity than of genuine professional respect for "good tabloid jour-
nalism," with few examples given (despite prompting) in a lengthy interview
of what might constitute it, but many examples provided of "bad tabloid
journalism." Indeed, for Ken (who has since retired after a long career), the
future of the broadsheet is not to resemble the tabloid in larger format, but
to re-instantiate a sociocultural separation of readerships:

> Ken: I just think it's (the *Daily Telegraph*) a crap paper, and I
> think it sort of runs an agenda, agenda journalism, which I
> hate and that's what it does to try to survive. And they're
> just racing to the bottom, to try and be the most, you
> know, they'll end up like the *National Enquirer*.
>
> DR: So you're not troubled by say an accusation of elitism? You
> know, only looking after the big end of town, the affluent
> region?
>
> Ken: That should be our only badge, elitism. You know, we
> should be elite, to make people want to be elite. I don't
> think we should try and be all things to all people. It's just,
> there's nothing wrong with being . . . [trails off], I mean
> elitism causes amusement. Apparently I'm a member of the
> elite. I always thought the elite had power. I haven't got the
> government on side, I get abused in the papers every day
> by people. I mean, I think in terms of elitism in terms of,
> you know, this is the people who we want, are sort of the
> top 20% of the society, of the demographic.

For this journalist, at least, broadsheet newspapers can survive threats to
their existence through sociocultural "distinction" (Bourdieu, 1984) from
the tabloid and its popular readership, rather than by imitation of tabloid
style and extension of the broadsheet newspaper readership to encompass
what several journalists (including Roland) described as the "tabloid demo-
graphic." Some interviewees, however, emphasized differences in the condi-
tions of news production of broadsheets and tabloids as much as those in
form, style, content, and ideology. For example, Gordon, a broadsheet jour-

nalist who had also worked for a tabloid took, initially, a less critical and more technical view of the tabloid when asked to describe it:

Gordon: A different size of newspapers for a start. Tabloid newspa-
 pers in what sort of definition or label you seek to apply to
 them I think differs from jurisdiction to jurisdiction. So a
 European or a London tabloid or even an American tabloid,
 in the English-speaking world, would differ from what I
 would say is the Australian version of the tabloid. . . . The
 one that I'm most conversant with, obviously, is the *Daily
 Telegraph*, because of my time on the paper and observing
 it daily. It doesn't seek to be an exhaustive chronicler of the
 day's events, nor does it necessarily at times seek to sensa-
 tionalize, although that is an aspect of its work. The lead
 story in the paper is not necessarily the most important
 story of the day, but sometimes one that the bosses would
 claim would elicit the most response the next day. And
 tabloids, like broadsheets increasingly, love their stories to
 be followed up or talked about during the next day's news
 cycle, to afford them prominence and currency, and hope-
 fully translate into extra sales and reputation.

When asked about general views of tabloid newspapers, and especially those of broadsheet newspaper journalists, Gordon sought to avoid a standard cri-
tique of the tabloids, arguing that their direct approach to news may be an advantage, but that, especially because of understaffing when compared to broadsheets, there is less attention to "quality control." Thus, conditions of journalistic labor are seen to differentiate broadsheets and tabloids, to the disadvantage of the latter:

Gordon: I suppose I have a gentler view of tabloids than some of my
 colleagues, not least because I was born there in a career
 sense. I have nothing but good thoughts about the greater
 rigour that training in a tabloid newspaper had for me. It's
 a much more, you can sort of descend into clichés, but
 they're far more hungry and rapacious in their desire for
 collecting news than the broadsheet, which can drift into
 ponderous tendencies on occasions. . . . The negative char-
 acteristics of tabloid newspapers are that they are massive-
 ly under resourced in terms of the people, human
 resources, than any broadsheet I've seen.

Here Gordon offers a qualified endorsement of tabloid newspapers, which are seen as less "ponderous" and more "news hungry" than broadsheets.

However, he also observes a lesser degree of cultivation of human journalistic resources and a lower level of overall quality control. Gordon's consciousness of his tabloid origins and training—as revealed in the stigmatized self-description of a "tabloid refugee"—is seen to be accompanied by a perception of a more general shift toward tabloid style in broadsheet newspapers. This trend is not necessarily or exclusively regarded as negative. Most of the journalists interviewed from both newspaper formats saw that elements of tabloidization were increasingly evident within broadsheet newspapers. There were, however, disagreements about the desirability and consequences of this trend. In interviews with editors and journalists, it was consistently made clear that the future of newspapers was threatened by a variety of social forces (such as "time poverty" and generational change) that produced intensifying competition within the media sector, especially from broadcast and online media. Broadsheet journalists of longer standing (many close to retirement) abhorred the increasing reliance on reader research and its matching with journalistic practice, whereas others took a "survivalist" approach that was more accommodating to tabloidizing trends in newspaper journalism prompted by competition from other media and ageing, gender-skewed newspaper readership.

Most of the editors and journalists interviewed, whether broadsheet or tabloid, shared a romantic attachment to what one described as "ink on the fingers," but there was also a frequent feeling of professional vulnerability, even among relatively young journalists, that newspapers of all kinds were losing sight of their "mission." As Julie, currently a journalist working for a tabloid newspaper who had also spent considerable time on a broadsheet, said:

Julie: I think all newspapers are becoming more about market-
 ing. It's becoming much more important. . . . Maybe that's
 what tabloidization is, the marketing of news, and it's
 about entertainment and it's about selling papers as
 opposed to what is the news, and it seemed to me that
 when I started in my career it was all about the news.
 What's the news. And they seem to have lost sight of that,
 it's become about selling papers and what's going to sell.
 It's the marketing of the products.

DR: So marketing's the problem, rather than tabloidization?

Julie: Maybe it's one and the same. Maybe marketing is responsi-
 ble for tabloidization. I mean, the old tabloids were always
 still all about news . . .

DR: So you think the news function perhaps has diminished?

Julie: Yeah. It's still there, it's not that it's not important, it's just
 that in the final judgment as to what story should have

> prominence, it seems to be now more about what's going to
> sell as opposed to what's the best story. Maybe the [hesita-
> tion] I can't say that the best news story is the one that sells,
> I can't say that's the case, it's the main difference that struck
> me moving from a broadsheet to a tabloid.

Thus, for Julie and for several other journalists interviewed, tabloidization
was more a matter of accentuation of a trend than a clear division between
broadsheets and tabloids. The careful targeting of reader demographics and
marketing strategies, and their receptiveness to "the editorial line that is
taken . . . reflecting the views of their readers," meant that she felt that "to a
certain extent they [the readership] get the papers they deserve." In seeking
to get to know the readership better (many of the interviewed journalists
complained about having to attend briefings on reader demographics and
marketing strategies), newspapers have sought to counter competition from
more "interactive" media forms as expressed in the efflorescence of "citizen
journalism" (Allan, 2006; Hewitt, 2005). This finding reflects Barnhurst's
(2002) observation that

> When sociologists and anthropologists do field work in the newsroom,
> they find the relationship of journalists with the audience oddly para-
> doxical. Reporters and especially editors have a hunger to know who is
> out there reading and viewing, but resist knowing the answer. They
> reject most all of the available information, except what they can gather
> from a few proximate stand-ins they know personally. (p. 11)

In the interviews with journalists, moves to encourage them to be closer to
their readers as representatives of the "people" in the interests of sophisti-
cated marketing to audiences that was also often conceptually linked to
tabloidization, seemed to constitute the erosion of the professional status of
the journalist as having a superior mastery of the specific skill set that
reflects its shift from craft to profession (Allan, 2004, 2005, 2006; Barnhurst,
2002).

 However, the direct linkage of the printed newspaper to its online ver-
sion, and consequent incorporation of "blogging," audiovisual streaming,
reader feedback, and forums, encouragement of user-generated content, and
so on, cannot be easily and simply classified as tabloidization. More plausi-
bly, what has been typified as the tabloid in the newspaper sector might be
seen as part of a more generalized move toward media organizations seek-
ing to know, speak to, speak for, engage with, capitalize on, and accommo-
date current and potential audiences. This process is occurring under condi-
tions of intensifying media competition and (across many Western societies
at least) a decline in the authority of the formal news media (Bennett, 2003;

Franklin, 1997), in relation to which tabloidization, whether celebrated and critiqued, may be regarded as both symptom and cause. Newspapers, then, are both the agents and subjects of the sociocultural changes to which they, voluntarily and by compulsion, are a significant party.

CONCLUSION: JOURNALISTS DELIVERING "THE PAPERS THEY DESERVE"?

The tabloidization process, at the very least in the strict technical terms of newspaper dimensions, has accelerated in the 21st century. Since 2003, as previously mentioned, leading British broadsheet newspapers have gone progressively tabloid, the *Independent* first going dual format (initially on a regional basis) and then wholly tabloid, and the *Times*, having noted the sales and circulation benefit to its rival, did likewise (Greenslade, 2004b). In partial concession to this trend, the *Guardian* "downsized" to the "Berliner" or "midi" format in 2006 (following France's *Le Monde*, Spain's *La Vanguardia* and Italy's *La Repubblica*, while the journalists of the *Berliner Zeitung* mounted a campaign to resist its relaunch as a tabloid). In April 2007, the *Sydney Morning Herald* and the *(Melbourne) Age* announced that they were to be reduced in size by the width of a column. The tabloid stigma is generally sought to be countered by emphasising qualities of "impact" and "compact," or by underplaying the difference to the old newspaper. Indeed, commercial rivals yet to make the change have made sport with this positioning, the U.K. *Daily Telegraph*, for example, using the advertising slogan "Impact, Not Compact" in seeking to retain its existing readers and recruit disgruntled broadsheet readers whose chosen newspaper had become smaller.

In a pattern of market imitation, more than 100 broadsheets have made this shift since 2001, constituting what one commentator in the *Chicago Tribune* described as "The Next Brit Invasion: Tabloidization" (cited in Preston, 2004, n.p.). According to Greenslade's (2004a, n.p.) analysis of an edition of the *Times* not long after it went tabloid, the format change involves more than newspaper resizing:

> A detailed study comparing the broadsheet and compact editions reveals a pattern in which the editorial content of the former is vastly superior to that of the latter, although, of course, readers of the compact have no idea what they are missing in their version, or what has changed. Although the *Times* did not promise (as the *Independent* did) to carry all its broadsheet material in its compact version, the differences between the two editions are so conspicuous that they merit close examination.

First, there are substantial cuts in major stories . . . the important news stories were much shorter in last week's compact editions. That is only a sample: in fact, scores of stories were far shorter in the tabloid. Many stories were cut back to news-in-briefs.

Second, there are omissions. Several stories carried in the broadsheet did not appear in the tabloid. . . .

Third—and the most alarming to a serious newspaper—is the change of editorial agenda adopted by the tabloid. It was noticeable that serious policy stories were the main casualties of the cuts, while human interest and entertainment stories were promoted.

Even here, however, the cuts to the sports pages and the greater amount of foreign news also recorded by Greenslade (of course, it is not possible to extrapolate too far from a sample of a single newspaper on a single news day) are not entirely consonant with the conventional tabloidization thesis.

In conclusion, it can be stated that both the content analysis and interview data, and the secondary material discussed, reveal that changes have occurred that can be said to constitute tabloidization, but unevenly and under circumstances wherein what constitutes the tabloid, and its desirability or otherwise, are in various ways contested. The changes that have occurred to newspapers are not insubstantial, and to some degree have been resisted by journalists, and may be regarded as responses to the pressures of maintaining profitability and retaining readerships in an era when progressive digitization is loosening the grip of formal media organizations on media content and delivery, and when media audiences are correspondingly fragmenting and shifting to new media forms (such as gaming) and genres (such as blogging).

The broadsheet and tabloid journalists interviewed, many of whom had moved between newspaper forms (although generally starting out in tabloids and moving to broadsheets, rather than the reverse), were required to engage self-reflexively in the discursive management of the broadsheet–tabloid binary, the negative cultural connotations of the tabloid, and widespread acceptance of the "reality" of tabloidization. Thus, irrespective of precise empirically measurable trends, tabloidization is a sociocultural phenomenon with which journalists are compelled to deal. Media corporations have been repositioning their existing media outlets and purchasing new ones in order to take advantage of, or to prevent damage by, the new modes of interaction between producer, text, and audience. Tabloidization might, therefore, be interpreted not so much as the remodeling of media texts in a consistent direction according to coherent strategies, as the negotiation, often provisional and difficult, of new relationships between regimes of news gathering, information, and entertainment (Hartley, 1996; Wolf, 1999),

the journalistic labor practices that they entail, and the interactions with readers (sometimes conceived as "fellow producers") on which they rely. Tabloidization is, then, a much more complex and uneven process than the "lament" so loudly or plaintively expressed will allow—not least by professional journalists.

ACKNOWLEDGMENTS

I thank Drs. Peter Wejbora and Ruth Sibson for their expert, dedicated research assistance, and Professor Colin Sparks for his valuable research advice, and I express my gratitude to the journalists who generously gave up their time to be interviewed for this chapter.

REFERENCES

Allan, S. (2004). *News culture* (2nd ed.). Maidenhead, UK & New York: Open University.

Allan, S. (Ed.). (2005). *Journalism: Critical issues.* Maidenhead, UK & New York: Open University.

Allan, S. (2006). *Online news: Television and the Internet.* Maidenhead, UK: Open University.

Barnhurst, K. G. (2002). Who: People in the news. In *The New Long Journalism*. Retrieved April 29, 2007 from, http://tigger.uic.edu/~kgbcomm/longnews/html /barnljch2.htm.

Bennett, L.A. (2003). *News: The politics of illusion.* New York: Longman.

Bourdieu, P. (1984). *Distinction: A social critique of the judgement of taste.* London: Routledge

Curran, J. (1998). Newspapers: Beyond political economy. In A. Briggs & P. Cobley (Eds.), *The media: An introduction* (pp. 81-96). Harlow: Longman.

Der Derian, J. (Ed). (1998). *The Virilio reader.* Oxford, UK: Blackwell.

Flint, D. (2003). *The twilight of the elites.* Melbourne: Freedom Publishing.

Franklin, B. (1997). *Newszak and news media.* London: Arnold.

Greenslade, R. (2004a). Little echo: Are readers of the compact *Times* getting everything the broadsheet has to offer? *The Guardian.* Retrieved December 3, 2006, from http://media.guardian.co.uk/mediaguardian/story/0,1125898,00.html.

Greenslade, R. (2004b). *Press gang: How newspapers make profits from propaganda.* London: Macmillan.

Hartley, J. (1996). *Popular reality: Journalism, modernity, popular culture.* London: Arnold.

Hesmondhalgh, D. (Ed.). (2005). *Media production.* Maidenhead, UK: Open University.

Hewitt, H. (2005). *Blog: Understanding the information reformation that's changing your world*. Nashville, TN: Nelson Business.

Langer, J. (1998). *Tabloid television: Popular journalism and the "other news."* New York: Routledge.

Lumby, C. (1999). *Gotcha: Life in a tabloid world*. Sydney: Allen & Unwin.

McLachlan, S., & Golding, P. (2000). Tabloidization in the British press: A quantitative investigation into changes in British newspapers, 1952-1997. In C. Sparks & J. Tulloch (Eds.), *Tabloid tales: Global perspectives on the popular media* (pp. 76-90). Boulder, CO: Rowman & Littlefield.

News Corporation. (2002a). *Annual report*. Retrieved December 3, 2006, from http://www.newscorp.com/report 2002/2002_annual_report.pdf.

News Corporation. (2002b). Chairman's speech to shareholders at News Corporation limited annual meeting 2002. http://www.newscorp.com.au/news/news_175.html (no longer accessible).

Preston, P. (2004). Are newspapers burnt out?, *The Observer*. Retrieved December 3, 2006, from http://media.guardian.co.uk/columnists/story/0,7550,1356015,00.html.

Redhead, S. (2004a). *Paul Virilio: Theorist for an accelerated culture*. Edinburgh: Edinburgh University Press.

Redhead, S. (2004b). *The Paul Virilio reader*. New York: Columbia University Press.

Rowe, D. (2000). On going tabloid: A preliminary analysis. *Metro, 121/122*, 78-85.

Rowe, D. (2005). Working knowledge encounters: Academics, journalists and the conditions of cultural labour. *Social Semiotics, 15*(3), 269-288.

Sparks, C., & Tulloch, J. (Eds.). (2000). *Tabloid tales: Global perspectives on the popular media*. Boulder, CO: Rowman & Littlefield.

Turner, G. (1999). Tabloidization, journalism and the possibility of critique. *International Journal of Cultural Studies, 2*(1), 59-76.

Uribe, R., & Gunter, B. (2004). Research note: The tabloidization of British tabloids. *European Journal of Communication, 19*(3), 387-402.

Weber, M. (1949). *The methodology of the social sciences* (E. Shils & H. Finch, Eds.). Glencoe, IL: The Free Press.

Winston, B. (2002). Towards tabloidization? Glasgow revisited, 1975-2001. *Journalism Studies, 3*(1), 5-20.

Wolf, M.J. (1999). *The entertainment economy: How mega-media forces are re-shaping our lives*. New York: Penguin Putnam.

PART III

MEDIATION OF REALITY

The need for critical reflection on journalism has never been more urgent than it is today. The striking contrast between the power of journalism to tell the "truth" about reality, and the growing apathy of its audience, raises the question of how journalism can legitimately mediate reality for us. Has the old notion of helping readers to understand the world beyond their own experience disappeared under the pressures of the organizational, political, technological, and economic milieu within which journalism operates? If so, and if the glorious days of journalism have passed, what remains? What do we actually read and expect to read when we buy a newspaper (once called a portion of the early morning prayer)?

The next four chapters look at the new forms of mediation of reality that have developed in newspaper journalism over the last few decades.

Libby Lester (Chap. 8) investigates how celebrities are portrayed in the news, and how this representation influences the representation of politics. The history and trends in celebrity journalism illustrate the dynamics of the news media and the expanding promotional industries. Celebrity journalism has spread with unsurprising ease from the entertainment sphere to other spheres such as sports, science, law, and politics; celebrities are called on to (and do) carry meaning in situations far beyond what might reasonably be seen to be their professional expertise. Lester argues that new access is not only about getting into news; it is also about the delicate negotiation that surrounds meaning-making.

In Chapter 9, Annona Pearse reflects on newspapers' coverage of the Port Arthur massacre in 1996, and the Thredbo landslide in 1997, to examine the ways in which public grief and mourning are conducted through the media and how the shock of significant loss of life is ameliorated by the reinforcement of national characteristics. Her study demonstrates how the positive actions of victims, survivors, and rescuers are reinforced though the media as being representative of "Australianness," thereby further entrenching the mythology of national characteristics within a wider discourse.

Dorothy Economiu, in Chapter 10, looks at news features on issues of current concern, and explores how headline, image, write off, and quotes—she calls this part of the news story "standout"—contribute to the creation of meaning in the news. Her analysis is linguistic by nature, but the findings are far-reaching for journalism studies. Economiu argues that standout has to be seen not just as a promotion of the story but as an independent text. She demonstrates how the mismatch between two elements of the front-page standout and the actual story, function in the feature story "Wait in Fright" (*The Sydney Morning Herald*), a story that explores the Australian government"s response to asylum seekers.

In Chapter 11, Helen Caple traces the evolution of the use of press photographs in newspapers, and points out that it is not only technology that sets up the conditions for the use of photographs in newspapers, but the set of cultural and political circumstances that establish the patterns for the visual culture of journalism. She interrogates the role of the image in multimodal text. Like Economiu, who introduces standout text, Caple distinguishes a new news genre that she calls "image nuclear news story." It is photography and the headline that work together to form a nucleus from which meaning is produced. The word-play in image nuclear news stories, Caple warns, requires a high level of reader literacy, where the reader is expected to display his or her cultural capital and engage with the text at several levels. This new form of news text raises the question of the creation of cultural capital in (postmodern) journalism.

8

JOURNALISM
AND CELEBRITY POLITICS

Libby Lester

University of Tasmania, Australia

When Australian celebrities sign on with a new agent, they are commonly asked two questions: which designer will dress them, and which cause will they represent. Explicit in the first question is the understanding that image for the modern celebrity is vital. It also is explicit in the second. What is less clear is how this exchange between celebrities, their audiences, and their chosen cause—or, indeed, a cause, the public, and its chosen celebrity—interacts with news journalism and, more specifically, impacts on journalistic representation of politics. This interaction is important to understand. News access and representation are limited resources for which various elite and non-elite political contenders vie. Protest movements seek to harness the power of celebrities to increase their visibility and the saliency of their messages in the news media, whereas celebrities, in representing non-elite political groups, can extend their credibility and representativeness beyond their established audiences. What has made this transaction increasingly possible is the transformation that has occurred in recent years to news content and journalistic practice.

Although the increased presence of celebrities in the news pages has been the subject of more recent scholarly research (Turner, Bonner, & Marshall, 2000) and the relationship between celebrity and politics has long been of interest (see, e.g., Boorstin, 1961/1972; Gamson, 1994; Marshall, 1997; Turner, 2004; West & Ormon, 2003), the power struggle that takes place at the news interface of celebrity and movement politics remains largely unexplored. This chapter seeks to highlight several key features of this

interface. It also asks how changes to journalism form and style in regard to celebrity impact on news representation of politics. To begin, it briefly outlines how a consideration of the role celebrities play in movement politics can help unravel the interplay between the fields of journalism, politics, and the promotional industries. It then examines the history of and recent trends in celebrity journalism, and the integration of the promotional industries with the news media, before questioning how celebrity functions in politics, particularly in terms of representation. The focus then shifts to celebrities and social movements, especially environmental conflict where symbols are the weapon of choice. Analysis of newspaper coverage of the 40-year-long Tasmanian wilderness conflict shows how changing dynamics of news media and expanding promotional industries have impacted on the representation of this important debate. The chapter then isolates a number of specific dynamics of the celebrity–politics–journalism nexus as they emerge through interviews with key actors, concluding by considering the potential impact of changes in this interplay of fields on public debate over environmental conflict.

FIELD INTERPLAY AND SOURCE STRATEGY

The Tasmanian wilderness conflict has played out over 40 years, in a relatively stable media, political, and social landscape; the impact of change in one field and at a particular time can, therefore, be highlighted and examined against other fields and times, essential to understanding journalism dynamics and their bonds to broader social change.

The value of such an analysis—one that looks across not only fields but time and engages with history—is increasingly recognized in journalism studies. As Benson and Neveu noted (2005): "Fields cannot be understood apart from their historical genesis and trajectory" (p. 18). Yet, many studies of news media are largely atemporal, leaving them poorly equipped to consider changing dynamics both within the journalistic field and in terms of its interplay with other fields. It is in the studies that look across time and those that place news content and journalism practice in broader context that contemporary debates about media roles and responsibilities are sharpened. Gitlin (1980), in his classic study of the rise and fall of the Students for a Democratic Society, noted the value of paying attention to "precise historical experience" (p. 22), whereas in his study of the coverage over 10 years of the Stephen Lawrence case, Cottle (2004) wrote that studies of media events often:

> decontextualise such moments from preceding and surrounding social dynamics, and they thereby fail to properly theorise their determinants.

> A longer-term frame of reference can help to better ground media phe-
> nomena within society and can also sharpen our understanding of the
> complex cultural dynamics and determinations involved. (p. 190)

The concept of field interplay also encourages journalism studies to move
away from *media-centrism*, a term coined by Schlesinger (1990) in his influ-
ential Bourdieu-inspired analysis of journalism sociology and, in particular,
the primary definers model. Here, source strategies become central to
understanding media power.

> The key issue at the heart of the study of sources is that of the relations
> between the media and the exercise of political and ideological power,
> especially, but not exclusively, by central social institutions which seek
> to define and manage the flow of information in a contested field of dis-
> course. (Schlesinger, 1990, p. 62)

Power inequities between sources are also paramount.

> [I]t is necessary that sources be conceived as occupying fields in which
> *competition for access* to the media takes place, but in which material and
> symbolic advantages are unequally distributed. But the most advantaged
> do not secure a primary definition in virtue of their positions alone.
> Rather, if they do so, it is because of successful *strategic action* in an
> imperfectly competitive field. (Schlesinger, 1990, p. 77)

Therefore, by focusing on the role of celebrity spokespeople for non-elite
political groups over time, this chapter begins to unravel the changing rela-
tionship and interplay among three important fields: journalism, politics,
and promotional industries. In doing so, the impacts of actions in one field
emerge, as do questions that go to the heart of concerns about media power
and contemporary democratic functioning. How has changing form and
style in journalism impacted on political debate? How have elite and non-
elite political contenders contributed to and/or exploited these changes?
How may these important debates be influenced in the future?

JOURNALISM AND CELEBRITY

The relationship between celebrity and news journalism emerged in 19th-
century Britain and the United States, where newspapers expanded their
content to cater for a newly literate populace and potential mass market

readership. The trend accelerated from the 1880s onward, with a shift away from parliamentary and political reporting to gossip, sports, crime, and sex (Conboy, 2006). Profiles of celebrities were one form of early celebrity journalism, with the reporting as news of scandal and personal detail concerning high-profile individuals another. The two forms could not be separated clearly; the process by which celebrity gossip was picked up and re-reported by newspapers as news has been creatively described as "trumours" (Haigh, 2004). In celebrity news, the focus is on the individual. Prominence is the defining news value, although as with other news genres, newsworthiness is enhanced by the presence of additional news values such as conflict, proximity, and currency.

Over the last two decades, the presence of celebrity news in Australian newspapers has grown significantly. Turner et al. (2000) have collected comparative data that allows the transformation in newspaper content related to celebrity to be quantified. They found that between 1977 and 1997, there was a dramatic increase in the number of stories devoted to celebrities in the daily press. In the quality Fairfax-owned broadsheet, the *Sydney Morning Herald*, for example, the number of celebrity stories more than doubled during this period. The change was of a comparable magnitude to that occurring in other media forms, including women's magazines and television news bulletins. Importantly, the study also found that a large portion of this increase was the result of a greater presence of Australian celebrities, and this was being driven by an Australian publicity and promotional industry emerging primarily since the mid-1980s (Turner et al., 2000).

A number of factors were behind the parallel transformations in the publicity and promotions industries and to Australian media and cultural production, including a demand for local stars to help sell the emerging Australian film industry; increasing advertising and a need for personalities to sell products for these advertisers; and a growing celebrity management industry (Turner et al., 2000). Increased editorial space, a large portion of it in glossy insert form and linked to additional advertising and competition from lifestyle television and magazines, ensured celebrity journalism featured more heavily in the print media.

The following is an illustration of how celebrity journalism typically features in the news pages of contemporary Australian newspapers: A single edition (November 19, 2006) of Tasmania's highest selling Sunday newspaper, the *Sunday Tasmanian*, included news stories on celebrities as fashion model ("Bana's Fashion Fit," p. 4), celebrity divorce ("Rocker Files to Divorce Hudson," p. 4), a crisis meeting among reality TV contestants ("Talk Tames Tensions in Idol House," p. 5), a celebrity wedding ("Stars' Nuptials Under Wraps," p. 8), and a model "victim" of a tell-all book ("Betrayed by Corby," p. 15). Apart from the focus on celebrities, the inverted pyramid structure and hard news lead are common features of these

stories. These traditional elements of news, combined with the prominence news value, operate here to signify the newsworthiness of the celebrity items. This is "real" news. With its steady incursion into the news pages, celebrity journalism has spread with unsurprising ease from the entertainment sphere to others spheres, including those of sports, science, law, and politics. Four political stories in the same edition of the Sunday newspaper had a celebrity angle, including a political leader's gaffe over a celebrity death ("Rudd in Wait as Beazley Falters," p. 4), Bono's meeting with Federal Treasurer Peter Costello ("Howard Hits Pop Culture Leaders," p. 4), the announcement of a benefit concert by a former rock star to help protect the wedge-tailed eagle ("Anthem With a Soaring Spirit," p. 11), and a plea by a musician for more musicians to speak out on Iraq and environmental issues ("Time to "get 'vocal,'" p. 14).

These stories, on both mainstream and activist politics, blur the lines between celebrity and political journalism to such an extent that separation becomes impossible. They, too, are defined by an inverted pyramid structure, a hard news lead and, despite their political content, a focus on prominence, in this case of celebrity individuals. They are becoming an increasingly common form of political news representation. For Marshall (2005), both journalism and celebrity "articulate a changing public sphere and a different constitution of engagement and significance" (p. 19).

> Journalism has been instrumental in proselytising a new public sphere and celebrities have been a foundational means and method for the expansion of key elements of that new public sphere. In that convergence, journalism has expanded its "coverage" of entertainment and sports by developing features on personalities. It has also used techniques developed in writing about entertainment stars for its coverage of the famed and notorious in politics and many other domains. . . . With the celebrity reporting that has accompanied this expansion of coverage, there has been a naturalization and normalization of the close connection between the sources of information and journalistic practice; in other words, celebrity journalism is one of the key locations for the convergence of publicity, promotion and journalism in terms of the generated editorial content. (Marshall, 2005, p. 28)

To understand how the increasing presence of celebrity news in newspapers —still a primary and credible source of political news for Australians (Pusey, 2003)—impacts on the creation of meaning about environmental/political conflict, it is important to consider more fully how celebrity functions specifically within the political field.

CELEBRITY AND POLITICS

In his diaries published in 2005, former Australian Labor Party leader Mark Latham described his first meeting to woo Midnight Oil frontman and environmental campaigner Peter Garrett to the party:

> I had lunch with the legend at his Mittagong home the day before Australia Day. My conclusion? Simply outstanding: charismatic, humane, full of ideas, dedicated to his gorgeous family. . . . Our target is Cunningham. It's close to Peter's home, and we'll out green the Greens to win back the seat. Sharon Bird has the preselection at the moment, but after her bruising loss in the by-election she can't be too keen. A simple plan: Carr will talk to Roozendaal, Bird will get the vacancy for the NSW Upper House, Garrett will get Cunningham, and my environmental credentials will be secure. A fine night's work. (p. 272)

For Latham, Garrett is a relatively straightforward representation of environmental values, and linking Garrett's fame with the Australian Labor Party provides the party with clear environmental credibility. Of course, symbolic power is a complex affair, as Latham discovered in the final days of the October 2004 federal election campaign when the detail of Prime Minister John Howard's forests policy was covered in Australian newspapers accompanied by images of Howard surrounded by magnificent tall forests or addressing a large crowd of "underdog" forestry workers and, importantly, their "struggling" families. Nevertheless, this diary excerpt is indicative of one way in which celebrity and politics co-exist.

Meyrowitz (1985) reminded us "that *all* politicians must be concerned with style and image" (p. 277); Gamson (1994) noted that celebrity logic is clearly a part of the political realm and "there is no question of turning back" (p. 192); and Schlesinger (2006) wrote that the "extraordinary growth of the celebrity culture" has "leached into our understanding of politics" (p. 301). Nevertheless, for Turner (2004) celebrity in Australia and the United Kingdom is surrounded by a discourse of inauthenticity that both constrains a celebrity from running for political office or a politician who "subordinates the representation of the political issues to the celebritized persona of the politician" and thus is perceived to diminish the capacity for public debate (p. 134).

Celebrity functions with politics on multiple levels. It is expected to provide the solution to the problems of contemporary life, thus "celebrities are called on to (and do) carry meaning in situations far beyond what might reasonably be seen to be their professional expertise and to audiences far exceeding those who might be supposed to be interested in the products they represent" (Turner et al., 2000, p. 164).

A defining characteristic of contemporary times is what is popularly called "information overload," and celebrities can be seen as one way in which to short-circuit this. As advertisers all know, the individual celebrity persona provides a powerful condensation of meaning which can be attached to commodities and issues; similarly, celebrities can act as prisms through which social complexity is brought back to the human level. (Turner et al., 2000, p. 166)

Celebrities can crystalize issues, create meanings, and humanize institutions (Marshall, 1997; Turner, 2004), but to what extent do they actually impact public debate? A study of the influence of celebrity political endorsements on the attitudes of young Canadians found celebrities strengthen support among those already predisposed toward a position and "make unpopular causes, candidates or ideas slightly more palatable" (Jackson & Darrow, 2005, p. 94). As such, "causes and candidates would be advised to use celebrities to strengthen support among their followers, mobilize voters and raise funds" (Jackson & Darrow, 2005, p. 94). The study also found that a complex process of meaning-making was involved, which relied on the "appropriate interaction among celebrity, product and audience" and that celebrity endorsement would not work if any of these elements were out of harmony (p. 94).

A celebrity's political legitimacy can be measured in part by media focus on his or her politics as opposed to art/career/personal life; political attention, such as the willingness of political leaders to meet with the celebrity to discuss his or her political concerns; and audience support, which can be measured by a willingness to act beyond the normal requirements of a fan, such as by donating money (Street, 2004). Street noted:

The capacity to claim to speak politically as a celebrity is determined by a number of conditions and structures, as well as by the affective bond which is created by the relationship between the celebrity and their admirers. In certain contexts and under particular conditions, performers can lay claim to represent those who admire them. They give political voice to those who follow them, both by virtue of the political conditions and by means of their art. . . . This is not a matter of mimetics but of aesthetics, of creatively constituting a political community and representing it. (p. 449)

But this ability to represent is clearly negotiated by more than the artist and his or her audience. As Street pointed out, Bob Geldof could not have represented concerns about starvation in Africa without the willingness on the part of the BBC to broadcast the Live Aid concerts. Celebrity representation—within the realm of politics broadly—is complex, even contradictory at times, and it is vital to understand how such representation works and

what impacts it may have. In particular, it is important to understand how it works within the news media, because here is both an arena on which elite and, significantly, non-elite political groups, causes, and issues can fight and be fought, and a site where journalistic practice and form are determined.

CELEBRITY AND SOCIAL MOVEMENTS

In environmental politics, the search for powerful symbols is ongoing. Symbols are often the only resource available to movements seeking news access; shared understandings and meanings create a cultural resonance on which the battle for social change is fought. Symbols open the possibility of non-elite challenges to the "strategic power and routinized media interventions of dominant institutions" (Cottle, 2004, p. 41). Celebrity politics functions symbolically; a celebrity is able to stand for a concerned citizenry and a threatened ecosystem, replicating in some ways the symbolic power of a protester chained to a bulldozer or the image of a dying seal or threatened tree. Yet, the mobilization of symbolic power is not simple. Symbols shift. Sometimes movements create the shift, sometimes they simply monitor and adapt, but they must always treat symbols with care as misuse or overuse can see potentially powerful symbols dissipate into meaningless images, negative rhetoric (Hilgartner & Bosk, 1988).

Celebrity, however, also has unique elements, functioning differently from other forms of symbolic power. It can impact on the internal logics of social movements (Gitlin, 1980; Meyer & Gamson, 1995). By gaining access to the news media, movements are able to mobilize, validate, and enlarge their scope (Gamson & Wolfsfeld, 1993), but celebrities also can bring movements access to political leaders, and to other elite individuals, including more celebrities. Celebrity-inspired media coverage also can have negative impacts for social movements, ones that may affect a movement's long-term ability to engage in and influence public debate. Gitlin (1980) observed how the news media's focus on conflict and deviance changed the nature of the 1960's student movement by encouraging those members comfortable with radical rhetoric into leadership positions. These leaders, although able to fulfill the needs of the media, were unable to fulfill the needs of the membership. Alternatively, movement leaders may become less visible as celebrities, unrestrained by a movement's views and practices, take over the roles of activists. According to Meyer and Gamson (1995), "The story of social protest then becomes a celebrity story, and not one that includes politics, policy, or space for grass roots action" (p. 187).

Celebrities also will seek to be involved in causes in which they will have some kind of credibility. "Celebrities bring with them significant incentives to shift movement frames, and in particular to depoliticize or

deradicalize movement claims. Participation by celebrities then can speed the process of institutionalizing and domesticating dissent" (Meyer & Gamson, 1995, p. 188). This "softening effect," as Meyer and Gamson described it, is important to isolate and understand. If news access is vital to a social movement's ability to participate actively in the public sphere, and celebrity involvement becomes a key determiner of social movement news access, then there is cause for anxiety about recent change in news production and journalistic practice in relation to celebrity. As Schlesinger (1990) contended, "the conditions of survival of alternatives are crucial to the survival of any public sphere at all" (p. 82).

CELEBRITY AND ENVIRONMENTAL CONFLICT IN TASMANIA

The newspaper coverage of the Tasmanian wilderness conflict provides much insight into the changing relationship between journalism and celebrity politics.[1] Here, the impact of celebrity involvement and recent changes to news content and journalistic practice are examined across time. For nearly four decades, Tasmania has been the site of a bitter dispute over land use and the environment. The battle to prevent the damming of Lake Pedder in Tasmania's remote southwest was a seminal moment in Australian environmental history (Doyle, 2000; Hutton, 1987), while a decade later, in 1982-1983, the campaign to save the Franklin River was the first environmental campaign to "attain global stature," attracting international media, identities and organizations (Hay, 1991). Throughout the 1980s, logging in various National Estate forests around the island prompted bitter, sometimes violent, protests, as did plans for the Wesley Vale pulp mill. The mid-1990s focused on the Tarkine, in the state's northwest, whereas recent debate has centered on the clearfelling and woodchipping of old-growth forests and associated forestry practices. A proposed $1.9 billion pulp mill on the Tamar River and logging of the site of early French exploration, Recherche Bay, have been the focus of recent conflict.

During the Lake Pedder and Franklin campaigns, the involvement of entertainers created only minor media interest. The news media remained more interested in the actions and occasional arrests of prominent businessmen Dick Smith and Claudio Alcorso, elite artists Guy Boyd and Lloyd

[1]This chapter builds on an earlier paper, which focused on newspaper texts and campaign strategy (Lester, 2006), with additional interviews with journalists, celebrities, public relations specialists, and celebrity agents. Overall, it draws on both quantitative and qualitative analysis of local, interstate, and national newspaper texts—including the *Hobart Mercury* and the *Melbourne Age*; 30 semistructured interviews with main actors; and direct observation of protest and celebrity events.

Rees, writers Manning Clark and Xavier Herbert, and politicians John Button and Don Chipp, than soap star Lorraine Bayly, TV detective Leonard Teale, or even comedian Spike Milligan. The involvement of these prominent citizens was framed as independent, informed, and thus legitimate. News media access was withdrawn when these figures were perceived to cross from informed well-known citizenry into entertainers performing on behalf of the environment movement. For example, news stories reported U.K. celebrity television botanist David Bellamy's involvement in the Franklin campaign initially as denoting the significance of the debate. Before his arrival in Australia, *The Mercury* quoted the "world-famous botanist" Bellamy as saying:

> "It is vital that we save this valley, and I am quite prepared to go to prison," Prof Bellamy said . . . "We should say now that this piece of Tasmania, which is incredibly rich in flora and fauna, is sacrosanct from industrial development." ("Experts to turn 50," 1983, p. 1)

Here, Bellamy's commitment, expertise, and legitimacy are to the fore. However, on arrival, Bellamy announced that he was in Australia for a "pure public relations job," that he planned to attract "worldwide attention," and "I'm here to do what I'm told for once in my life. Whatever Bob Brown tells me to do, I'll do it" (Guilliatt, 1983, p. 1). By cheerfully valuing his "well-knowness" above his scientific credentials and dismissing his independence, Bellamy had overtly drawn attention to his role as strategy for news access. Reframing quickly followed. This is a small part of a particularly direct but substantively typical response from *The Age's* Michael Barnard:

> The "on-site" entry of English television botanist Dr David Bellamy into the Gordon-below-Franklin debate on behalf of anti-dam protesters—or as he would have us believe, on behalf of humanity—illustrates the extent to which the campaign against the dam has been engineered into a media event. (Barnard, 1983, p. 11)

Bellamy's involvement is dismissed as a blatant grab for news access, and the link is made between celebrity, publicity, and thus unauthorized control of the news agenda.

Two decades later, this link is not made. The Global Rescue Station action over summer 2003-2004 in the Styx Valley centered around a group of international protesters living on a tree-top platform 65 meters above ground in a massive tree and communicating their actions via a campaign Web site, which also acted as conduit to mainstream media outlets. Celebrity involvement provided important parallel action, and, here, the strategy clearly involved entertainers, including singers Olivia Newton-John, John

Butler, and Jimmy Barnes, and actors Sam Neill, Toni Collette, David Wenham, and Sophie Lee. In March 2004, London-based actor and former Tasmanian, Essie Davis was given the prime last speaker's spot over movement leaders, including Sen. Bob Brown, at a massive forests rally in Hobart. In local news coverage of the event, Davis was the focus of a break-out story whereas Brown was not quoted at all ("Massive forest rally," 2004, p. 5). Significantly, Davis' right to comment on the Tasmanian forestry issue is not questioned in the coverage, despite a heavy presence of critical industry/government responses. In fact, throughout the campaign, the right of celebrities to be involved is rarely questioned. This divergence from earlier campaigns is indicative of the significant shift in the news media's relationship to celebrity. The environmental movement has been able to capitalize on this shift by using an increasing number and range of celebrities to carry meanings and messages to the public via a wider number and range of media forms. On their part, the news media have allowed celebrities to become legitimate participants in the public debate about the Tasmanian environment. A story on a recent field of battle, Recherche Bay, clearly illustrates the change; here, the journalist does not distinguish between the involvement of powerful political figures of the past who had direct investment in the conflict and a current well-known actor, David Wenham:

> Greens leader Senator Bob Brown took Wenham to Recherche Bay after using the same see-it-for-yourself tactic with Labor numbers man Graeme Richardson in the 1980s and former Labor leader Mark Latham before the last federal election. The strategy was again effective. (Bevilacqua, 2005, pp. 10-11)

However, although coverage of celebrity involvement in a campaign may have expanded to legitimize the participation of entertainers, it can come at a price for not only the protest organizers, but for the celebrities themselves. Jimmy Barnes, for example, was confronted with forest industry workers when he visited the Styx on January 16, 2004. The following day, *The Mercury* ran a heading "Jimmy Barnes: hero or traitor," a play on the title of Barnes's hit "Working Class Man." "Working Class Man Jimmy Barnes came face to face with the workers in the Styx Forest yesterday . . . and proved to be less than a hero to them. As one union chief put it: 'As far as we're concerned, he's a working class traitor'" ("Jimmy Barnes," 2004, pp. 1-2). Seen to become legitimate participants in public debate, celebrity entertainers also are seen to become legitimate political targets. Their participation may be legitimized, but so too are the comments of their critics. This may impact on movement access to the celebrities, who with their managers may pause for thought before linking their carefully constructed identities with certain social movements. In turn, movements may soften and deradicalize in order to attract celebrities to their campaigns.

CELEBRITY POLITICS IN THE NEWS:
A SOFTENING EFFECT?

To explore more fully the possible impacts of the changing interaction among celebrity, politics, and journalism identified in the Tasmanian conflict, it is necessary to look beyond the textual outcomes to the behind-the-scenes dynamics of the interaction. Interviews with celebrities, celebrity agents, professional movement activists, and journalists, all of whom have been involved in the recent Tasmanian conflict, highlight many of the key features behind the interaction, and illuminate possible future impacts on the representation of political debate.

First, it is important to note that journalists see the increased celebrity presence in news as simply "part of the job nowadays." Although journalists are generally unwilling to articulate what makes a story newsworthy, "names make news" is a commonly understood and repeated aphorism. Journalists also are in daily competition for space, both in terms of quantity and quality, and there is a shared understanding that a celebrity angle will improve the possibility of gaining more space and better placement for copy. Nevertheless, journalists have a heightened awareness of being manipulated by the environmental movement through its deployment of celebrities, and claim to only run with a story after a careful consideration of the issue beyond celebrity involvement and/or the level of celebrity prominence.

Second, within the environmental movement, celebrities are seen as an important addition to their symbolic toolbox to gain journalistic interest and news access, but no more than an addition. They are perceived to provide a symbolic "clarity," whereas direct action protest can "muddy the waters," raising such concerns as trespass, blocking machinery, arrests, appearance of protesters, and stopping workers from earning a living. Celebrities' relationship to their fans is an important factor in this. A senior Wilderness Society campaigner interviewed for this study said, "If you've got someone who they respect in another field that expresses an opinion, then that can help sway the person one way or another." The link to mainstream political activism is seen as less direct but nevertheless powerful:

> I don't believe that a politician makes that connection, but I do think the people on the street who look up to Jimmy Barnes or Olivia Newton-John or connect with her—and whether it's a realistic connection or a Hollywood one—those people may become more sympathetic, more accepting of the issue, and that's when it starts to affect politicians and political policies because once they know that there's a critical mass of support for keeping the forests or saving the whales or stopping nuclear energy, that's when we start to see policy shifts.

It is, however, a symbolic resource that should be used sparingly and in combination with other protest "tools." As one Greenpeace communications manager noted during an interview:

> We wouldn't ever replace real creation of constructive environmental conflict with, you know, image-based campaigning because that would be futile and it would be weak. It wouldn't work. It would run out. You would need to refuel the images and the propositions with activism continually.

Third, the celebrities who campaigned in the Tasmanian conflict claimed to have done so to use their celebrity status to gain news access and thus "make a difference." When referring to their celebrity status, they used terms such as *exploit, make the most of it,* and *value-add.* Indeed, clear strategizing appeared to be common. For example, one actor described using the temporary revival of her character in the soap *Neighbours* to campaign, appearing in protests and encouraging other younger soap stars to join protest action. She described the opportunity as "fleeting." There are a number of routes by which celebrities came to be involved. Celebrities with known environmental sympathies were approached directly by an organization such as the Wilderness Society, or indirectly via another celebrity. Alternatively, they contacted an environmental organization themselves, offering their services, which they commonly noted included the ability to speak at rallies and to sell a message. These offers were not automatically accepted—one well-known actor from *Blue Heelers* described making four phone calls before the Wilderness Society found a role for her in an upcoming rally.

Fourth, from a movement perspective, a clear hierarchy of celebrity credibility exists, with some entertainers considered more powerful both in terms of gaining news access, particularly in terms of gaining access to more than their own media organization, and "selling the message." They also are less likely to seek approval from their media employers. Thus, the ability to attract these more "powerful" celebrities is important as it allows, in some ways, the environmental organization to maintain a more radical agenda. During an interview, one senior Wilderness Society campaigner noted the following:

> There are two types of celebrities. There are those celebrities that are so big they can get away with pretty much saying anything. Jack Thompson can get away with saying that logging old growth forests is a bigger threat than terrorism. Now that's a huge statement to make. Very few Australians can make that statement without getting broad condemnation. . . . So there are those celebrities now who are so big or so consolidated in their place in Australian society they're almost—not

bullet proof—but they can afford to take risks. Then there are those celebrities who for coming out on issues is much more dangerous. They're not as big or they're forming their place, their career, and therefore they have to be much more cautious and selective about the issue they choose to align themselves with and then what they say once they do align themselves. So there's those kind of two groups of people and they need to be managed quite differently.

Overall, in relation to potential deradicalizing of movement politics, the celebrities interviewed did not perceive that their involvement could have a softening effect on environmental campaigns, yet described incidents where they had deliberately softened their description of their involvement in the Tasmanian campaign to ease the anxieties of their employers. For example, one actor avoided the word *rally* when informing Channel Ten about the activity in which she and six young cast members of *Neighbours* were involved. They were acutely aware of the level of conflict and potential "danger" that surrounds the Tasmanian conflict, and celebrities did not see themselves as immune from criticism from pro-logging industry and government groups. There was also no acknowledgment within the movement that the involvement of celebrities would deradicalize or make superficial movement issues. Rather than "dumbing down," the use of celebrities to gain media coverage was discussed in terms of becoming less "arrogant" or "snobby" and a sign that the movement was prepared to look beyond the urban educated for support.

There was, however, acknowledgment from within the movement that "safety" was a concern when celebrities selected campaigns and organizations. This, from one Wilderness Society campaigner, who liaises with a number of celebrity supporters, was a typical comment: "I don't think most celebrities would say we're the safest. We're not as safe as fundraising for breast cancer or for MS." The importance of "image" and "branding" was noted, but in relation to credibility and the maintenance of the celebrity–audience relationship. "Celebrities don't attach themselves to an issue lightly and they're informed about an issue when they do," the Wilderness Society campaigner noted. Celebrities described knowing of "others" who became involved with causes to raise their profiles but rarely in the case of the environment, where "people are genuinely interested in it because they loved nature." An agent who represents several celebrities involved in the Tasmanian conflict described as "very dangerous ground" the process by which a celebrity takes on a cause only to improve his or her image. The audience relationship can be damaged:

They discovered you in one light and all of a sudden you want to switch channels and you want to become a great spokesman for a cause, you have to be very careful how far you actually go because you've got a fan

base as well that you need to respect. . . . It's a hard one. I know some
people who have done it successfully. I know other people who have
tried and let me tell you they looked pretty silly.

Finally, there is a perceived safety in numbers. All interviewees claimed that
as more celebrities spoke out on the Tasmanian conflict, more were willing
to join the campaign. A typical comment from a celebrity noted that "the
water has been tested, no one's lost their job, no one's been particularly rep-
rimanded." Words like *safety*, *danger*, and *credibility* feature heavily in the
discourse around celebrity involvement with movement campaigns.
Although the celebrity–politics–journalism interaction may not be used
strategically by celebrities to widen their appeal or improve their "image," it
is nevertheless a strategic interaction on the part of movements and the
celebrity/promotional industry, with clear and articulated paths, goals, and
hindrances. This has important ramifications when considered beside
changes in the journalism field and, in particular, the news media's relation-
ship to celebrity.

CONCLUSION

As social movements increasingly deploy celebrities in order to gain news
media access, capitalizing on the opportunity provided by changing journal-
ism practice and promotional industry logics, there is good reason to ques-
tion more fully the impact of this strategy on the representation of political
issues beyond the mainstream and, more generally, the role celebrities are
increasingly playing in political conflict. This chapter has hoped to con-
tribute to that task by considering outcomes and dynamics behind the
celebrity–politics–journalism interaction and how these are changing over
time. What emerges is that although the environmental movement has been
able to capitalize on the increased presence of celebrity news to gain greater
news media access, it is a complex transaction, one that involves changing
journalistic practice, news forms, and representation, a growing promotion-
al industry, and sensitive relations with media audiences.

News access is about more than getting into the news. It is also about
the delicate negotiation that surrounds meaning-making. Celebrities can
help with basic news access and they are able to represent environmental
concerns to a wider audience. Although these concerns may become second-
ary to the main news angle—involvement of the celebrity—this is not
unique in symbolic politics. As with a photograph of threatened wilderness,
symbolic power is created via a complex mix of denotation and connotation,
of the real and the imagined. In non-elite movement politics, it is often more
effective—and affective—to keep the contested issue as secondary. Thus,

celebrities can play an important role in environmental debate, a role that in some ways levels the uneven arena on which movement politics is so often fought.

However, there is also cause for concern. Celebrities have power and influence unlike other forms of symbolic protest, and although they may use that power and influence to send movement messages to wider audiences, they must also protect their own images, their brands. More concerning is the potential influence of others who have commercial interest in those brands, and thus interest in the celebrity–politics–journalism interaction. In Australia, the celebrity system has been deliberately constructed by media companies to market their wares, and is maintained by a promotional industry that continues to grow. Even with the best of intentions, celebrities cannot escape this system. If allowing celebrities to become an essential voice of dissent in our public debate, a development aided by significant changes to journalism form, style, and practice, we need to be aware of the limitations to and marketing strategies behind their dissent.

REFERENCES

Barnard, M. (1983, January 18). March of the media martyrs. *The Age,* p. 11.

Benson, R., & Neveu, E. (2005). Introduction: Field theory as a work in progress. In R. Benson & E. Neveu (Eds.), *Bourdieu and the journalistic field* (pp. 1-28). Cambridge, UK: Polity Press.

Bevilacqua, S. (2005, May 1). Show-stopper scene in a tense drama. *Sunday Tasmanian,* pp. 10-11.

Boorstin, D. (1972). *The image: A guide to pseudo-events in America.* New York: Atheneum. (Original work published 1961)

Conboy, M. (2006). *Tabloid Britain: Constructing a community through language.* Abingdon, UK: Routledge.

Cottle, S. (2004). *The racist murder of Stephen Lawrence: Media performance and public transformation.* Westport, CT: Praeger.

Doyle, T. (2000). *Green power: The environment movement in Australia.* Sydney: UNSW Press.

Expects to Turn 50 in State Jail. (1983, January 10). *The Mercury,* p. 1.

Gamson, J. (1994). *Claims to fame: Celebrity in contemporary America.* Berkeley: University of California Press.

Gamson, W., & Wolfsfeld, G. (1993). Movements and media as interacting systems. *Annals of the American Academy of Political and Social Science, 528,* 114-125.

Gitlin, T. (1980). *The whole world is watching.* Berkeley: University of California Press.

Guilliatt, R. (1983, January 15). Bellamy to the barricades. *The Age,* p. 1.

Haigh, G. (2004). No one to blame. In J. Schultz (Ed.), *Griffith review 5: Addicted to celebrity* (pp. 37-52). Sydney: ABC Books.

Hay, P. (1991). Destabilising Tasmanian politics: The key role of the Greens. *Bulletin of the Centre for Tasmanian Historical Studies, 3*(2), 60-70.

Hilgartner, S., & Bosk, C. (1988). The rise and fall of social problems: A public arenas model. *American Journal of Sociology, 94*(1), 53-78.

Hutton, D. (Ed.). (1987). *Green politics in Australia: Working towards a peaceful, sustainable and achievable future.* North Ryde: Angus & Robertson.

Jackson, D.J., & Darrow, T.I.A. (2005). The influence of celebrity endorsements on young adults' political opinions. *Press/Politics, 10*(3), 80-98.

Jimmy Barnes: Hero or Traitor. (2004, January 17). *The Mercury,* pp. 1-2.

Latham, M. (2005). *The Latham diaries.* Melbourne: Melbourne University Press.

Lester, L. (2006). Lost in the wilderness? Celebrity, protest and the news. *Journalism Studies, 7*(6), 907-921.

Marshall, P.D. (1997). *Celebrity and power: Fame in contemporary culture.* Minneapolis: University of Minnesota Press.

Marshall, P.D. (2005). Intimately intertwined in the most public way: Celebrity and journalism. In S. Allan (Ed.), *Journalism: Critical issues* (pp. 19-29). Maidenhead, UK: Open University Press

Massive forest rally. (2004, March 14). *Sunday Tasmanian,* p. 5

Meyer, D.S., & Gamson, J. (1995). The challenge of cultural elites: Celebrities and social movements. *Sociological Inquiry, 65*(2), 181-206.

Meyrowitz, J. (1985). *No sense of place: The impact of electronic media on social behavior.* New York: Oxford University Press.

Pusey, M. (2003). *The experience of middle Australia: The dark side of economic reform.* Cambridge, UK: Cambridge University Press.

Schlesinger, P. (1990). Rethinking the sociology of journalism: Source strategies and the limits of media-centrism. In M. Ferguson (Ed.), *Public communication: The new imperatives* (pp. 61-83). London: Sage.

Schlesinger, P. (2006). Is there a crisis in British journalism? *Media, Culture & Society, 28*(2), 299-307.

Street, J. (2004). Celebrity politicians: Popular culture and political representation. *British Journal of Politics & International Relations, 6*(4), 435-452.

Turner, G. (2004). *Understanding celebrity,* London: Sage.

Turner, G., Bonner, F., & Marshall, D.P. (2000). *Fame games: The production of celebrity in Australia.* Cambridge, UK: Cambridge University Press.

West, D.M., & Ormon, J. (2003). *Celebrity politics.* Upper Saddle River, NJ: Prentice Hall.

9

DEATH IN THE MEDIA—
REPRESENTATIONS OF TRAGEDY
AND TRAUMA

*The Port Arthur Massacre and the Thredbo
Landslide*

Annona Pearse

University of Newcastle

The question of what may constitute the "Australian national character" has been extensively explored in both academic and popular literature since European settlement of Australia. Writers such as Ward (1966), Blainey (1966), White (1981), Turner (1994), and Hughes (1996), among others, have articulated and analyzed the concept of an Australian national identity through historical, cultural, and sociological frameworks. Feminist writers such as Schaffer (1988), Lake (1993), and Dixson (1999) have contributed to the debate through their contestation of male paradigms within Australian history. Narratives of such topics as exploration, settlement, migration, and war service have been examined in terms of what they have contributed to the exegesis of an Australian cultural tradition and of a shared national identity. Turner (1993) argued that narratives are ultimately produced by the culture out of which they emerge, and that they generate meanings, take on significances, and assume forms that are articulations of the values, beliefs, and ideologies of their cultural context.

In keeping with Turner's conceptualization of narratives, this chapter examines discourses of Australian characteristics, and the narratives of the mythology of a shared national identity within print media representations of two traumatic events in recent Australian history—the 1996 Port Arthur massacre and the 1997 Thredbo landslide. In April 1996, at the tourist site of Port Arthur in Tasmania, a lone gunman killed 35 people. The gunman entered the heritage penal area, ate lunch, then produced guns from his bag and proceeded to shoot indiscriminately those around him. In terms of

death tolls, the Port Arthur massacre was, and remains, the highest of any Australian shootings. In July 1997, 19 people died in the alpine resort town of Thredbo, New South Wales, when, as the result of land slippage, two ski lodges fell into one another. Tons of concrete and mud covered the lodges and impeded the rescue efforts. At the time of the landslide, the winter ski season was at its peak and the Thredbo resort was busy with tourists. In contrast to the Port Arthur site, which closed for 1 month following the massacre, the Thredbo resort continued operating by isolating the area surrounding the landslide. Media reporting of both the massacre and the landslide continued intensively for more than 5 days, with Port Arthur and Thredbo developing into dominant news events. The initial reactions were, understandably, shock and disbelief. By the commencement of memorial services, conducted between 5 and 7 days following each incident, the media represented the public mood as united by and through the events. This chapter argues that, through particular news stories, the media (re)created myths that informed certain ideological criteria and reinforced hegemonic discourses of a mythological Australian masculine identity through the promotion of bravery, heroism, and sacrifice as Australian national characteristics.

NEWS MEDIA AND THE CONSTRUCTION OF NATIONAL IDENTITIES

As Couldry (2001) noted, any theorization of the media's social impacts must start from their privileged role in framing our experiences of the social, and thereby defining the "reality" of our society. The "social" experience of Port Arthur and Thredbo was garnered through a sense of sharing the reality of the events, made possible through the news media, filtered through national cultural myths. Journalism, according to Hartley (1996), is a gigantic archive of textuality, unself-consciously generated by documenting the social, personal, cultural, and political interactions of contemporary life, while at the same time displaying its own particular properties, and characteristics, patterns, histories, quirks, and accidents. In terms of news media, Hartley (1982) also argued that news comes to audiences as the pre-existing discourse of an impersonal social institution that is also an industry. As audiences become familiar with the codes and conventions of news, they become "news-literate"—not only able to follow news and recognize its familiar cast of characters and events, but also able to interpret spontaneously the world in terms partly derived from classifications made familiar in the news.

National characteristics, such as bravery and heroism, are classifications familiar to news audiences from news events, defined through the historical reporting of situations such as bush fires and sea rescues. Bravery and heroism are identified as familiar characteristics in such news broadcasts, evolving

into mythological traits that can be held up as emblematic of a perceived national character, and reified as a result. Any media analysis of Port Arthur and Thredbo must examine the social and historical conditions of the production of discourses, because, as Hartley (1982, p. 6) argued, these "determinants" will shape what it says, the way it develops, and the people who use it.

The news media play a major role in shaping public opinion and, as such, the tendency of journalists to confirm their own opinions, while citing objectivity through their presentations, is characteristic of their profession and the news industry. The distinction between news, where objectivity is thought possible and desirable, and opinion, where objectivity is thought impossible, is deeply entrenched in journalistic culture (Lichtenberg, 1993). Hudson (1992) argued that there is consonance in the depiction of media material, particularly violent material in news, in the ways in which journalists exhibit uniformity and similarity in reporting as detailed in the work of Galtung and Ruge (1973). Schudson (1989) argued that journalists "personify" the news stories, that is, they write of persons, not structures, and of individuals, not social forces. Such an approach, suggested Schudson, is cultural idealism—the Western view that individuals are masters of their own destinies, and responsible for their acts through the free will that they exercise. By reporting on the individual's actions, however, journalists cannot help but reflect on, and so include, society as a whole. Journalists, through their stories, draw the boundaries of society, where they distinguish between those who are members of the society, and those who fall outside.

REPRESENTING GRIEF
AND MOURNING IN THE MEDIA

This chapter explores two issues regarding the role of journalists and the news media in the processes of grief and mourning. The first is that the media can act as a collective site for societal involvement in death through the representation of events such as Port Arthur and Thredbo. Incidents such as these become media events through which the disparate mixtures of shock, denial, and anger are channeled into the rituals of grief and mourning. Second, any emphasis on heroic victims that occurs in the media following public deaths can serve the purpose of "extending" the life of the victims. The actions of the Port Arthur victims, in protecting their families or friends at the expense of their own lives, are examples of such a process. Mediated death not only highlights the ways in which the deceased actually dies, but reinforces the heroic manner in which it occurred. The heroic victim, then, "lives on" through his or her act of bravery in the face of death. The circumstances of the deaths of several victims of the Port Arthur massacre were reported in the media, emphasizing the heroic and sacrificial

manner in which they occurred. It can be argued, then, that it is the function of journalism (and news media) to interpret death for their audience by providing "ways of understanding" through which grief and mourning can be directed.

In the examples of Port Arthur and Thredbo, the violent deaths followed by funeral and memorial services (most particularly after Port Arthur) invite the public to celebrate the heroic actions of the deceased and mourn with the living victims. Dayan and Katz (1992) argued that events such as funerals remind societies of their cultural heritage and provide reassurance of social and cultural continuity, and it can be argued that a reaffirmation of values was sought through the mediated discourses of bravery and heroism during and following the Port Arthur and Thredbo events.

Although there are national and cultural variations to the ways in which journalism represents death and grief, reactions to public deaths can be regarded as socially shared events. Through journalism, death, grief, and mourning enter the public sphere. If, for example, the event is witnessed in a live broadcast, then it can be argued that media audiences "experience death" in the most public of ways. Such an experience can generate reactions of grief and mourning that constitute the mediated performance of death. Established mourning practices, such as those of religious services, may give way to public mourning where the shared community grief can be openly expressed. In terms of news reporting, it can be argued that tragedy has been an obsessive staple of journalistic discourses. Tragedy can be examined in terms of Galtung and Ruge's (1973) model of news values. News values, they argued, tend to favor events about elite people, elite nations, and negative happenings. Such values are believed to produce most audience interest, and are consistent with several organizational and genre-related selection requirements (McQuail, 1994). Organizational factors are the most universal. Genre-related factors concern a preference for events that fit advance audience expectation—that is, they have consonance with past news, and there is a bias toward what is unexpected and novel within the limits of what is familiar.

The events at Port Arthur and Thredbo meet these selection requirements. The Port Arthur massacre was both unexpected and novel, but was reported within the familiar routine of crime reporting. It had consonance with past news because journalism practices associated the massacre with other mass shootings, although none had previously resulted in such a high death toll. The Thredbo landslide was reported within the familiarity of "natural disaster" stories, such as bush fires, even though the coroner's report later identified contributory human error. Popular imagery and discourses of "victims" and "helpers" in the media during natural disasters has been well documented in Australia (Short, 1979; West, 2000; West & Smith, 1996), and the reporting of Thredbo repeats and reinforces such discourses. More recent events such as the World Trade Center and Pentagon attacks

(2001), the Bali bombings (2002), the Asian tsunami (2004), and Hurricane Katrina (2005) ensure that tragedy and fear pervade news media and popular culture. News reports, then, as a feature of popular culture, become intertwined in everyday life.

The mediated events of Port Arthur and Thredbo can be examined with regard to collective experience and the notion of commemoration within the Australian context. Acts of commemoration can serve to reaffirm social morality and unity in the face of risk, trauma, and unexpected or inexplicable tragedy. Memorial services and permanent monuments to events can be regarded as representing the moments when the personal experience also becomes a collective experience. In terms of the Australian experience, it can be argued that an aggregate of individuals transforms itself into a community bound together through common experience during events such as Anzac Day and Remembrance Day where the mythical and historical memory of events is commemorated. The commemoration of Port Arthur and Thredbo is intrinsically bound to the collective experiences shared through the media representations of both events.

WHAT IT IS TO BE AUSTRALIAN

Apart from daily conversation, there is probably no other discursive practice that is engaged in so frequently by people as reading newspapers or watching television. Discourse analysis, then, allows for accounts of the relations between structures of text and talk, and of their cognitive, social, cultural, or historical "contexts" (Van Dijk, 1991). This chapter examines news and news journalism as a point of contact between people and events. News is dependent on a culturally shared language and set of meanings within its audience, and through discourse analysis, the news events of Port Arthur and Thredbo reveal reproduced and reinforced shared mythologies of an Australian national character.

Discourses change over time and struggle to compete for dominance. The discourses of bravery, heroism, and sacrifice that constitute the mythology of an Australian character have evolved and changed over time. Although the mythology of the bush and Anzac have remained dominant facets of an Australian identity, current mythology is also inclusive of sporting achievements where examples of risk-taking can be found. The changes reinforce the discourses and continue to determine dominant ways of thinking about what it is to "be Australian." The practices of media discourse reveal an attention to the historicity of discursive events by showing continuity with the past, and an involvement in making history (Fairclough, 1995). For example, media reports of Port Arthur engaged audiences with the convict past of Tasmania, thereby ensuring that the massacre reinforced

the mythology of penal colony violence already established, but not always acknowledged. At Thredbo, the bravery that was romanticized and mythologized in the historical literature of the high country again assumed status, through the media discourses of rescue workers, and, to a lesser extent, the survivor Stuart Diver.

Myth, in this chapter, is adapted from the work of Barthes (1972), where it is conceived as a system of communication and as a mode of signification. For Barthes, myths can be conveyed through verbal or visual means, examples of which in this chapter are print journalism. The concept of *myth* is interpreted not in the sense that is not "not true" but rather in the sense of a systematic organization of signifiers around a set of connotations or meanings (Barnard, 2001; Fiske, Hodge, & Turner, 1987; Stevenson, 1995). The cultural products in this chapter are the "texts" that are the media representations of the Port Arthur massacre and the Thredbo landslide. These representations have been "read," or decoded, to elicit meaning about the constructions of national character that are mythologized within Australian cultural practices.[1]

CONSTRUCTING PORT ARTHUR: PRINT MEDIA REPRESENTATIONS OF THE NATIONAL CHARACTER

Port Arthur and Thredbo have always been, in modern terms, tourist destinations. Although tourists seek different experiences from each site, promotion of both to potential visitors draws on particular historical and cultural claims. Port Arthur functioned as a penal settlement from 1827 to the late 1880s. The penal settlement at Port Arthur is Tasmania's most visited tourist site, with more than 250,000 visitors in 2004–2005 (*Port Arthur Historic Site Annual Report* 2004-2005). The site encompasses more than 247 acres of buildings, ruins, and restored period houses. Themes of isolation and remoteness are similarly constructed in the media discourses of both the massacre and the landslide. An autumn landscape, discussed in media narratives in terms of decay and seasonal decline, was used at Port Arthur to represent loss and death. Photographs of brown autumn leaves became the symbols of the Port Arthur massacre (Scott, 1996; Stephens, 1997), and later formed the basis of the permanent memorial design.

The massacre at Port Arthur occurred on an autumn Sunday afternoon in 1996. Geographically, Port Arthur is situated on an isolated Tasmanian

[1]This chapter is adapted from a larger study that is interdisciplinary in its methodological approach, incorporating the theoretical perspectives of leisure and tourism studies, the sociology of death, and media and cultural studies.

peninsula, southeast of the capital city, Hobart. Communication with the peninsula is difficult, with mobile phones unable to be used. There is only one road in, and out, of the area. The main banner headline of the April 29, 1996 *The Sydney Morning Herald* announced "Massacre at Port Arthur" and the reports covered four pages. Under the subheading "A Bloody History," the penal settlement and the historic discourses of fear were revisited:

> Established as a place for secondary punishment—that is, for offences committed after convicts arrived in Australia—its name was synonymous with fear for half a century, by which time 12,700 men had been through its gates. (Humphries, 1996, p. 2)

The article was written from the personal experience of the journalist who recalled his own past visits to the site. Such descriptions reinforced the mythological atmosphere of fear surrounding the settlement, seemingly further increased by the massacre:

> On a visit to Port Arthur a couple of years ago, friends and I were struck by the creepiness hanging over the site, known to nineteenth century Australia as the Earthly Hell or "abode of misery". It wasn't some paranormal experience but the legacy of having learned, like so many other Australians, just what evil had chilled this spot's beginnings. (p. 2)

Humphries likened his experience of walking through Port Arthur to that of crossing the fields of Flanders, or graves of allied soldiers in southeast Asia. It is not possible to walk around the Port Arthur site, wrote Humphries, without pausing to reflect and respect. Humphries' description and personal experience was one of several media articles to include and evoke Australia's war past and Anzac mythology within discourses of convict punishment. The acronym ANZAC stands for Australian and New Zealand Army Corps. Australian and New Zealand troops formed part of the Allied force during World War I. Anzac Day memorial services are held on April 25 each year, and the day is gazetted as a public holiday. Part of the process of explanation of the massacre, for journalists, was to place it within accepted historical contexts, such as the violent past of Port Arthur, a past already in circulation through tourism discourses, among others. References to Australia's war history ensured a place for both the deceased convicts and massacre victims within the mythology of Anzac. Already associated with crime and criminals from another century, Port Arthur was now associated with a substantial crime of the 20th century.

Given the scarcity of "real" information, mainland journalists engaged in an examination of the national historical context of the event:

> The Tasmanian massacre surpasses any other documented in Australia's history, and is believed to be one of the worst massacres of all time. And like the Hoddle Street and Queen Street massacres in Melbourne, the name Port Arthur will bear the mark of the killings indefinitely. (Costa, 1996, p. 2)

By placing the event within the context of other shootings, the media developed a framework within which the scale and gravity of Port Arthur could be located. The Hobart-based *Mercury*, as if voicing the reaction of the Tasmanian population, addressed readers with the headlines "Our Deepest Sympathy" on April 29. The opening paragraph was expressed in emotional language:

> Tasmania is in mourning. Tears. Grief. Fear. Shock. But most of all disbelief. And questions. This happens elsewhere. This happens in Sarajevo. In KwaZulu. In Lebanon. It doesn't happen in Tasmania. Just like it couldn't happen in Dunblane. (p. 2)

This paragraph from *The Mercury* reveals several of the discourses of Port Arthur, some already in circulation and some to appear in the following days and months. Discourses of the need for public grief would emerge, most notably at memorial services in Hobart. The concept of fear was raised by the media within discourses of violence as a regular feature of other places — not Tasmania. *The Mercury* placed Tasmania in an international position that included Dunblane, Scotland, but not the third-world trouble spots where death and massacres were represented as commonplace. The editorial, from which this paragraph was taken, confirmed that the tears, grief, and fear being openly displayed by Tasmanians were acceptable in terms of mourning practices and, furthermore, that such public demonstrations are acceptable in the circumstances.

Port Arthur continued to be a media event long after Martin Bryant, the perpetrator, pleaded guilty and was sentenced (in November 1996), and it was over the ensuing year, culminating in the first anniversary of the massacre, that the media narratives of heroism formed at Port Arthur were reinforced. Images such as those of Walter Mikac (whose wife and two children were killed at Port Arthur) leaving the Hobart memorial service to the victims again appeared in the press. Mikac signified, in grief, a component of the "Australian spirit" that the media promoted. Mikac's "sacrifice" was his wife and children, and his "bravery" in being "available to the media" signified Mikac as a hero through the media, to the wider public. The traits of the individual (Mikac) became those of the nation so that heroes and heroines in private then represented in public the mythological traits of national identity.

On the first anniversary of the massacre, April 26, 1997, *The Sydney Morning Herald* published a report entitled "Out of the Shadows." Of significance is the symbolism of the image of a wooden cross together with the caption "Lest We Forget." The tradition of Anzac Day is signified by the caption, and extends the symbolism of Anzac beyond its war mythology to the victims of the Port Arthur massacre. The date of the massacre had some significance also, occurring as it did 3 days after Anzac Day. A sense of national identity, already articulated by the Anzac remembrance, was then reinforced between past and present heroes of the nation through the sacrifices at Port Arthur. The references to Anzac provide a sense of spatial connection through recognized rituals and traditions and the memorializing of the Port Arthur massacre continues and reinforces such traditions.

In contrast to Port Arthur, there was only one survivor from the Thredbo landslide, and as details of the deaths of the victims were largely unknown, the media constructions of heroism were developed through the already culturally recognized signifiers of rescue workers. The endurance of the one survivor, Stuart Diver, is represented in the media with regard to the skills of those who rescued him. The following section discusses some of the media representations of Thredbo.

THE THREDBO LANDSLIDE AND MEDIA REPRESENTATIONS OF NATIONAL CHARACTER

The alpine village of Thredbo is located within the Kosciusko National Park in New South Wales. Tourism promotion at Thredbo is most heavily concentrated toward the short winter season from June to September. In contrast to Port Arthur, tourism promotion of Thredbo does not overtly emphasize the history of the area, however, imagery of the village draws on its European past, particularly those of German and Swiss heritage. Whereas the built environment dominates Port Arthur, landscape is the dominant theme of Thredbo. The landscape discourses of Thredbo were represented in the media in terms of winter, another season symbolizing death. Grief and mourning were framed within images of the winter season, and the cold and difficult climate was represented in opposition to the warm, close community of Thredbo.

Although the victims and survivors were the media heroes at Port Arthur, the emergency and rescue teams at the Thredbo landslide represented "working together as friends, mates and comrades under great adversity hoping to assist Australians in desperate circumstances" (Prime Minister Howard, Australian Parliamentary Hansard, 1997, p. 6686). The media-defined "human chain of rescue workers," removing rubble from the two destroyed ski lodges, remains as one of the enduring media images of the

landslide that killed 18 people. The difference of interpretation between the loss of life at Thredbo and at Port Arthur is associated with the initial reaction to the landslide as an act of nature, rather than the actions of man, as was the case at Port Arthur. Acts of nature feature prominently in Australian mythology, and the struggle against such forces can be identified in the media discourses of not only Thredbo, but also of disasters such as Cyclone Tracy (West, 2000) and more recently the bushfires of 2006 ("Sydney's hottest," 2006) and 2009 ("We faced the howling flames," 2009). Media representations of Thredbo were constructed as a battle between man and nature, with the selfless acts of rescuers the counter to the destruction caused by nature. The rescuers were, not surprisingly, predominantly male. The media narratives of Thredbo described "triumph over adversity" in the tradition of historical narratives of natural disasters concerning bush fires, droughts, and floods.

As a result of difficult site access, the rescue efforts were necessarily slow and laborious, and initially only led to the discovery of those who had died. Press headlines attempted to convey the shared sentiments of the rescue workers, families, and citizens in headlines such as "A Nation Waits" and "The Agonising Vigil." The journalist's response reflected an event that was slowly developing, rather than one where the impact was swift and the results immediate. Media resources, such as camera crews and reporters, were required to be on the site for an extended period of time.

The *Daily Telegraph*, a Sydney-based tabloid newspaper, used the services of Glenn Milne, also a political reporter for commercial television network Channel Seven, who was staying at Thredbo. Milne's report conveyed a sense of authenticity, suggesting a "witnessing of the Thredbo landslide." Milne's report was useful because it contained a considered account of how much danger the rescue workers encountered after the landslide. Furthermore, the photographs that accompanied Milne's report effectively conveyed the degree of devastation, with arrows pointing to the original position of the destroyed Carinya Lodge, and the ruins in the photograph almost unrecognizable as once being a building.

On the following pages, the *Daily Telegraph* pursued a theme of rescue response time. An article entitled "Rescue Effort Balance of Heroism and Realism" discussed the decisions made by the local area commander. Heroism was a dominant theme in the early media reports of Thredbo, and served to mask the risk-taking actions of those who sought to attempt unrealistic rescues. Rather than be representative of foolish and dangerous action, heroic risk-taking, as a signifier of the mythology of a national character, reinforces masculinist notions of dominance and self-reliance. An analysis of the representations of the Thredbo landslide indicates that heroism associated with self-reliance and bravery was the dominant media construction (see articles in *Daily Telegraph, The Sydney Morning Herald*, and *The Australian* from August 1–3, 1997).

The attempted mastery over a threatening landscape, exemplified in the actions of the rescue workers, allowed for a representation of unified identity (Schaffer, 1988). The landslide had caused the initial mastery, in the form of the village, to be shattered. The developers of the Thredbo Alpine Resort stand in relation to their exploitation of the fragile site. However the rescue workers, who also displayed characteristics of mastery, stand in relation to the site as heroes, evoking different responses within narratives of domination. What could be described as a regrouping of a unified identity took place within the narratives of a concerted rescue effort. With the aid of earth-moving equipment, rescue workers dug with their hands in the search for anyone alive. A photograph appeared on the front page of *The Australian* on August 1 of a "human chain" of rescuers in orange overalls, handing each other pieces of debris from the site. One of the enduring media images of Thredbo remains a "mountain" of rubble covered in orange overall-clad humans, mirroring the images of skiers on the snow-covered mountains behind the landslide. Small in comparison to the debris of the landslide, the workers represented human bravery and endurance, and symbolized the tradition of volunteerism, an action also involving sacrifice. On August 3, 1997, the *Sunday Telegraph* praised the "Army of Heroes":

> It is a disaster that has produced so many heroes. From the young cook who volunteered for three back-to-back shifts to cater for emergency personnel to fire brigade officer Steve Hirst who detected the first faint sound of human life amid the wreckage of Australia's worst ski-field disaster. (p. 4)

This reference recalls the mythology of an Australian egalitarian spirit. The natural disaster of the landslide symbolized past encounters with nature in the Australian tradition. Historically, the bush, argued Schaffer (1988), took on characteristics of danger, representing a force that drove the bushman to despair. The rescue workers at Thredbo came to symbolically share the historical challenge of the bushman, working in a dangerous landscape. Death at Thredbo, then, is represented within the masculinist constructions of mateship within the tradition of the Snowy Mountains. The media developed discourses of a sense of community (as they did at Port Arthur), but the community of Thredbo is seemingly "turned upon" by the very landscape from which it takes its living.

Public grief following the landslide appeared in the media in the form of grieving relatives of those trapped under the destroyed buildings. A report in *The Sydney Morning Herald* (August 2) detailed the response of one family:

> In the Mary McKillop Chapel on the edge of the Thredbo village, an
> elderly couple sobbed together. As they left, the woman cried aloud:
> "Where is my Steve, where is my Steve?" They are the parents of Steve
> Urosevic, 32, the front office manager at the Thredbo Alpine Hotel,
> who is believed to be trapped beneath the wreckage. Mrs. Maria
> Urosevic, and her husband Milan, arrived in Thredbo on Thursday to be
> told their son is believed to have been among the 20 who fell victim to
> Wednesday night's disaster. (p. 1)

In the accompanying photograph the Urosevics embrace and are visibly dis-
tressed. Their display of grief was open and expressive, in contrast to other,
more subdued media expressions of mourning, such as the services in the
Thredbo chapel.

The media-described despair of the rescue workers was punctuated with
the discovery of one survivor. With the discovery of Stuart Diver, the res-
cuers were praised in the media for their determination. Through the media,
the rescue of Diver, and the role of the emergency services, symbolized
dominant understandings of the Australian national characteristics of brav-
ery, heroism, and sacrifice. Diver's survival, as reported by the media, iden-
tified him as triumphant over the threat of nature and as embodying all three
foregrounded national characteristics. In turn, the actions of the rescue
workers embodied the mythology of risk-taking as a component of nation-
al character that was deemed acceptable with the recovery of Diver. In broad
Durkheimian terms, it could be argued that the survival of the individual
was achieved through the actions of society in the form of volunteers and
emergency services. Religious symbolism was evoked with the rescue of
Diver, referred to in the media as "Miracle on Thredbo Mountain" (*The
Sunday Telegraph*, August 3, 1997, p. 5).

Following Diver's rescue, no one else was found alive. The media
coverage of the final stages of the salvage and removal of rubble was lim-
ited. Any further public access through the media to Diver was curtailed
by his decision to employ agent Harry M. Miller to manage his media
commitments:

> When Thredbo survivor Stuart Diver hired celebrity agent Harry M.
> Miller to broker media deals, a palpable wave of disapproval rippled
> across Australia. One letter writer to the *Herald* snapped angrily: "A
> weekend columnist commented on the insensitivity of those skiing
> within sight of the rescue team at Thredbo. However, surely this pales
> with the news that Stuart Diver and his family have already signed up a
> top agent to negotiate sale of his story for as much as possible, while his
> volunteer rescuers, the real heroes, are still digging for bodies."
> (Freeman, 1997, p. 11)

This quote illustrates the ways in which the rescue workers, represented in the media as self-sacrificing and heroic, came to signify the national character rather than Stuart Diver. In contrast, Diver's actions in considering monetary returns for his story were regarded as "un-Australian." Diver's status as a hero was quickly undermined because he appeared to be gaining materially from the heroism of others. The reporting of the events at Thredbo amplified the actions of rescuers at the expense of Diver's survival skills. The media highlighted the social actions of the rescue workers and their achievements through sustained reference to their embodiment of the mythologies of the national character. The validity of the act of heroism was not in the act of survival, as symbolized by Diver, but rather in the humble, selfless act of "helping" demonstrated by the volunteer rescue workers, confirming such traits, defined through media representations, as typical of the Australian national character.

CONCLUSION

My research argues that the media representations of Port Arthur and Thredbo confined expressions of grief and mourning largely within established myths of nation. Preliminary research on the media representations of the 2002 Bali bombings reveals similar findings. Any sense of private loss was conducted through public emotions demonstrating heroic, self-sacrificing actions. The memorial services after Port Arthur engaged media audiences with a "model of grief" in victims such as Walter Mikac. Following the Thredbo landslide, mourning was, to some degree, displaced by the media attention given to the rescuers. The media texts demonstrate the continuing thematic of heroism, in particular, through the actions of victims, survivors, and rescuers. Expressions of grief are largely confined within established myths of nation. Wright (1995) argued that myths can use the setting of the past to tell us how to act in the present. For this chapter, the mythology of national character, as it is represented in the media following tragic events, presents a model of social action where bravery, heroism, and sacrifice can be reinforced as legitimate and "natural" responses. As Fulton (2005) argued, the ultimate consequence of narrativisation of the news is that audiences are often left feeling helpless and disempowered. The stories they read in newspapers seem to have no easy resolutions. Only the human interest stories, of triumph over disaster, for example, provide some "closure," which reassures audiences that "happy endings" are possible. Furthermore, news stories constantly reaffirm the ideology of randomness, of the inexplicability of events and the need for charismatic individuals—ordinary heroes—to restore order in an otherwise chaotic world. This chapter has

argued that the media representations of the events at Port Arthur and Thredbo, through the narratives of the mythologies of national identity provide such restoration.

REFERENCES

Barnard, M. (2001). *Approaches to understanding visual culture.* Houndmills: Palgrave.

Barthes, R. (1972). *Mythologies.* New York: Hill & Wang.

Blainey, G. (1966). *The tyranny of distance: How distance shaped Australia's history.* Melbourne: Sun Books.

Costa, G. (1996, April 29). Australia's worst killing. *Sydney Morning Herald,* p. 2.

Couldry, N. (2001). The hidden injuries of media power. *Journal of Consumer Culture, 1*(2), 155-177.

Dayan, D., & Katz, E. (1992). *Media events: The live broadcasting of history.* Boston: Harvard University Press.

Dixson, M. (1999). *The real Matilda.* Sydney: University of New South Wales Press.

Fairclough, N. (1995). *Critical discourse analysis: The critical study of language.* New York: Longman.

Fiske, J., Hodge, B., & Turner, G. (1987). *Myths of Oz: Reading Australian popular culture.* North Sydney: Allen & Unwin.

Freeman, J. (1997, August 14). The selling of heroes. *Sydney Morning Herald,* p. 11.

Fulton, H. (2005). Print news as narrative. In H. Fulton, R. Huisman, J. Murphet, & A. Dunn (Eds.), *Narrative and media* (pp. 218-244). Cambridge, UK: Cambridge University Press.

Galtung, J., & Ruge, M. (1973). Structuring and selecting news. In S. Cohen & J. Young (Eds.), *The manufacture of news: Social problems, deviance and the mass media* (pp. 63-72). London: Constable.

Hartley, J. (1982). *Understanding news.* London: Routledge.

Hartley, J. (1996). *Popular reality: Journalism, modernity, popular culture*: London: Arnold.

Hudson, T. (1992). Consonance in depiction of violent material in television news. *Journal of Broadcasting and electronic Media, 36*(4), 411-425.

Hughes, R. (1996). *The fatal shore.* London: Harvill Press.

Humphries, D. (1996, April 29). Victims join ghosts from an earthly hell. *Sydney Morning Herald,* p. 2.

Lake, M. (1993). The politics of respectability: Identifying the masculinist context. In S. Margarey, S. Rowley, & S. Sheridan (Eds.), *Debutante nation: Feminism contests the 1890s.* St. Leonards: Allen & Unwin.

Lichtenberg, J. (1993). In defense of objectivity. In J. Curran & M. Gurevitch (Eds.), *Mass media and society* (pp. 216-231). Sevenoaks: Edward Arnold.

McQuail, D. (1994). *Mass communication theory: An introduction.* London: Sage.

Schaffer, K. (1988). *Women and the bush: Forces of desire in the Australian cultural tradition.* Cambridge, UK: Cambridge University Press.

Schudson, M. (1989). The sociology of news production. *Media, Culture & Society,* *11,* 263-282.

Scott, M. (1996). We will come to terms with it. *40 Degrees South, 4,* 16-19.

Short, P. (1979). "Victims" and "helpers." In R.L. Heathcote & B.G. Thorn (Eds.), *Natural hazards in Australia.* Canberra: Australian Academy of Science.

Stephens, T. (1997, April 26). Out of the shadows. *Sydney Morning Herald,* p. 25.

Stevenson, N. (1995). *Understanding media cultures: Social theory and mass communication.* London: Sage.

Surviving celebrity: The media and Stuart Diver. (1997, July 28). *The Media Report.* Retrieved August 2, 2000, from <http//www.abc.net.au>.

Sydney's hottest New Year's Day on record. (2006, January 1). *Sydney Morning Herald.* Retrieved July 1, 2006, from <http//www.smh.com.au/news/national>.

Turner, G. (1993). *National fictions: Literature, film and the construction of Australian narrative* (2nd ed.). St. Leonards: Allen & Unwin.

Turner, G. (1994). *Making it national: Nationalism and Australian popular culture.* St. Leonards: Allen & Unwin.

Van Dijk, T. (1991). The interdisciplinary study of news as discourse. In K. Jensen & N. Janowski (Eds.), *A handbook of qualitative methodologies for mass communication research* (pp. 108-120). London: Routledge.

Ward, R. (1966). *The Australian legend* (2nd ed.). South Melbourne: Oxford University Press.

We faced the howling flames. (2009, February 15). *The Herald Sun.* Retrieved July 29, 2009, from http//www.news.com.au/heraldsun/story

West, B. (2000). Mythologising a natural disaster in post-industrial Australia: The incorporation of Cyclone Tracy within Australian national identity. *Journal of Australian Studies, 66,* 198-205.

West, B., & Smith, P. (1996). Drought, discourse and Durkheim: A research note. *ANZJS, 31*(1), 93-102.

White, R. (1981). *Inventing Australia.* St. Leonards: Allen & Unwin.

Wright, W. (1995). Myth and meaning. In O. Boyd-Barrett & C. Newbold (Eds.), *Approaches to media: A reader.* London: Arnold.

10

HAVING IT BOTH WAYS?
IMAGES AND TEXT FACE OFF IN THE
BROADSHEET FEATURE STORY

Dorothy Economou

University of Sydney

Large colorful pictures and "screamer" headlines introducing news stories were once associated only with the popular tabloid press and often criticized for sensationalizing the news. Now, such pictures with associated headlines and captions accompany the most serious of news analyses, even in the most sober of broadsheets. Although these prominent visual–verbal "displays" (Keeble, 2006) are not presently recognized as independent texts in the journalism literature, such as Hodgson (1998), Keeble (2006), and McKay (2006), it is argued here that they constitute an important and widely read news genre. And where they introduce the longest and front-page story in a weekly broadsheet news review, they are considered particularly significant as a site for fresh knowledge unavailable elsewhere in the society. The news review feature story genre, sometimes called a "news backgrounder" (McKay, 2006), often analyzes and interprets some social or political issue of current concern. It is held in high epistemic regard by both the profession and community and today is typically opened by a striking verbal–visual introductory "display." This chapter examines the display not just as an introductory stage to a serious story, but also as a "stand-alone" text that evaluatively positions readers in respect to significant contemporary social issues of the day. For many, perhaps most readers, the display *is* the story, standing in for the long news review feature that follows and for other readers, it sets the tone for the story they go on to read. In either case, the overall evaluative stance of such displays deserves close investigation. This chapter presents a case study that shows how one such display positions readers differently than the features story that follows it.

THE STANDOUT:
AN UNRECOGNIZED NEWS GENRE

In this chapter, I use the term *standout* to identify the verbal–visual displays introducing features stories as stand-alone texts. They are not recognized as such in the journalism literature and no audience research figures were found regarding the number of people who read the display, but not the written story. However, I argue here that these displays constitute the stand-out, a distinct news genre, with its own structure and typically comprising the five obligatory components:

1. large image or images (photo or other image type, such as illustration),
2. main bold headline,
3. image captions and credits,
4. by-line,
5. sub-headline referred to as *stand-first* or *write-off*.

There also may be additional optional components, such as a quote. A quote is included in the front-page standout in Fig. 10.1, which is analyzed in the case study. This standout introduces the top feature story of the weekly news review section in the Saturday issue of the highest circulation Australian broadsheet, *The Sydney Morning Herald* (*SMH*).

Most of the components listed above are discussed, in both the literature (Keeble, 2006) and in practice (*SMH* News Review editor, personal communication, 2006) in terms of being designed to pull large numbers of readers into the page, to "sell the story." Some of the standout components, like the headline and stand-first, are discussed in great detail in the literature (Hodgson, 1998), but no reference is made as to how all components interact. The only interaction discussed in both journalism studies and practice literature seems to be between the image and headline, and the image and caption. However, I argue that it is the interaction among all components that creates an overall evaluative stance. There are evaluative consequences to all editorial and design choices about which pictures and words to use, and about how to adjust, position and frame each in relation to the other.

Differences between the standout and the ensuing written story confirm its status as a distinct genre with a different authorship and social purpose as well as a wider readership. In terms of authorship, standouts are produced by broadsheet news editors and subeditors, often without access to the full written story. Editors now often work in collaboration with news designers and illustrators but still with some separation of responsibility for different

components. In terms of readership and social function (i.e., audience design; Bell, 1991), the large, attractive, brief, and easy-to-read standout may be designed to bring in more of the mass, and perhaps less engaged, readership. In contrast, more informed and already engaged readers seem to be targeted by the long, in-depth stories that usually include detailed analysis. The concern with hooking readers into the following story through different strategies in each component of the standout does not seem to take into account the overall stance created for those who only read the standout. In what follows, I raise questions about this and about how aware the professionals involved are of possible contradictions with the stance developed in the story. If they are aware of contradictions and not concerned, are they trying to have it both ways?

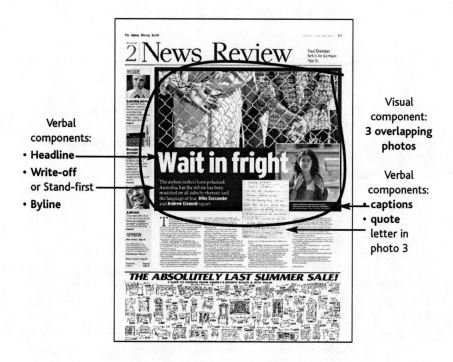

Figure 10.1. **Example of the standout genre (circled) from *SMH* news review (January 26, 2002). Story by M. Seccombe and A. McClennell.**

STANDOUT AND STORY FACE OFF:
A CASE STUDY

To explore the issues raised above, one front-page standout from Saturday's News Review in the *SMH* (see Fig. 10.1) is closely and critically examined and shows that the stance constructed by the standout on asylum seekers to Australia contradicts that developed and argued for in the written story that follows. The front-page story was chosen because it has the highest profile in the News Review and its standout the widest readership, making any evaluative mismatch between the two of the greatest social significance. "*Wait in Fright*" by Mike Seccombe and Andrew McClenell (which appeared on January 26-27, 2001) explores the Australian government response to asylum seekers after a year during which Australia took one of the most extreme stands taken anywhere in the world against such people entering territorial waters.

METHOD AND THEORY

An evaluative mismatch between standout and story is demonstrated by an analysis of both implicit evaluative meanings, also referred to as *ideological* and explicit evaluative meanings. Each verbal and visual component is analyzed for its evaluative meanings, as is the interaction between the components. In this standout, the verbal components are the main headline, the stand-first and byline (called write-off at *SMH*), which includes the byline, the image captions, and a quote included in the visual component, here three, separate but overlapping news photographs. Evaluative meanings identified are systematically compared with those of the full written story, analyzed elsewhere (Economou, 2009).

The deconstruction of ideological meanings in the standout follows the influential work on written news texts of the early critical linguists in the United Kingdom (Fowler, Hodge, Kress, & Trew, 1979; Hodge & Kress, 1979; Trew, 1979). This revealed bias and ideological positioning in seemingly objective news reports of events through application of a functional grammatical analysis. Their use of systemic functional linguistics (SFL; Halliday, 1978; Halliday & Matthiessen, 2004) showed how a consistent pattern of seemingly innocent grammatical choices in a text can be shown to be consistent with the set of commonsense assumptions or presuppositions associated with a particular ideological stance. They demonstrated how such patterns in a supposedly "factual" text can strongly attitudinally position compliant readers. This methodology, using the grammatical tools

of SFL, has been successfully taken up by many media analysts from within the SFL tradition (Iedema, Feez, & White, 1994; Martin & White, 2005; van Leeuwen, 1998; White, 1998, 2000, 2003a, 2003b, 2004a, 2004b), from those sympathetic to it (Chouliaraki & Fairclough, 1999; Fairclough, 1989, 1992, 1995, 2003) and from others outside it (van Dijk, 1991, 1998; Wodak, 1989; Wodak & Reisgl, 2001).

The analysis of more explicit evaluative meanings is carried out here using the recently developed SFL appraisal framework, which comprehensively maps evaluative or attitudinal meanings available in verbal language (Martin & White, 2005). Appraisal analysis has been successfully applied to various news media genres (see earlier references) and this chapter, following Macken-Horarik (2003a, 2003b), extends its application to visual as well as verbal text. The use of appraisal also extends the existing SFL-based description of visual meaning (Kress & van Leuween, 1996/2006), which has been applied to media texts (Fulton, 2005) but does not incorporate appraisal.

THE NEWS TEXT IN CONTEXT

The standout analyzed introduces the feature story entitled "Wait in Fright," one of four top news review feature stories in the *SMH* on the topic of "illegal" immigration published over a 1-year period from January 2001 to January 2002 (see Fig. 10.2). "Wait in Fright" deals with the broader social and political ramifications of a specific incident discussed in the other three stories concerning "boat people" picked up by a Norwegian freighter, the Tampa, off the coast of north Australia. The incident led to much coverage in the daily news, of the government's tough border protection and detention policy, and spearheaded the high-profile and successful election campaign that year. "Wait in Fright" was published after a media scandal erupted based on revelations of the inaccuracy of government statements and media reports on "the Tampa affair," also referred to as "the children overboard affair" (discussed in Macken-Horarik, 2003a, 2003b).

September 1, 2001 October 20, 2001

November 10, 2001 January 26, 2002 Case study text

Figure 10.2. **Four top news review stories on 'illegal' immigration (standouts circled).**

The focus of the story written by Seccombe and McClennell is the Australian government's response to asylum seekers—both the government's verbal response, what it said about asylum seekers, and its material response, its immigration and detention policy. The evaluative stance clearly taken and argued for by the authors of the story is one of condemnation of the government on both counts and sympathy for the asylum seekers. On the other hand, in the standout there is no explicit reference to the government; the focus is on asylum seekers only and this analysis shows that the way its verbal–visual meanings interact creates a negative evaluation of asylum seekers.

INTRODUCING THE FEATURE STORY:
THE ORBITAL STANDOUT

The standout of "Wait in Fright" has been analyzed and displayed in Fig. 10.3 as an instance of an "orbital" verbal–visual genre with a central nucleus and surrounding satellites (following descriptions of hard news stories as orbitally structured in Iedema et al. 1994; White, 1998). The initial, obligatory "nucleus" of the standout is identified here as the headline-images unit. The aim of the nucleus is to attract and engage readers regarding the issue featured in the story, hopefully pulling them into reading the story. Thus, the term *Lure*[1] is used to label this initial stage of the genre, which is always big and colorful, with arresting and attention-grabbing content. The Lure thus functions simultaneously as the first stage for two texts, the orbital standout and the long feature story, and lures readers into either or both. The Lure in this standout is shown to be one bimodal (verbal–visual) meaning unit in which three images and a headline act as one utterance to be read and viewed simultaneously at a glance.

The other stages in a standout are satellites able to be read in any order, and each elaborate on the Lure. Two of the three satellites here are always present in a standout. The smallest satellite, labeled functionally as *Image anchor* in this study, is thought to be the satellite most often read first, although its verbal component is the least salient (a caption strip on the right here). Besides providing the names of photographer, illustrator, or image bank, the caption identifies people, place, and actions in photos, thus verbally specifying (as does the stand-first) the less determinate content of pictures.

The most salient satellite identified functionally as the *Point*, is the component of the standout that elaborates most fully on the Lure, and its verbal component is here positioned below the headline and main image. The Point includes the sentence in the stand-first that gives readers the point of the

[1]Upper case is used in SFL descriptions to indicate a functional element of a genre.

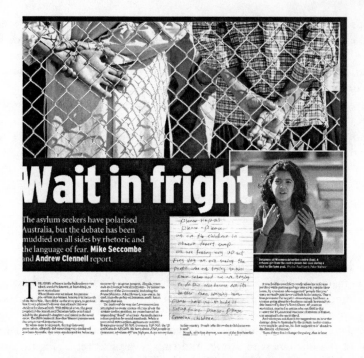

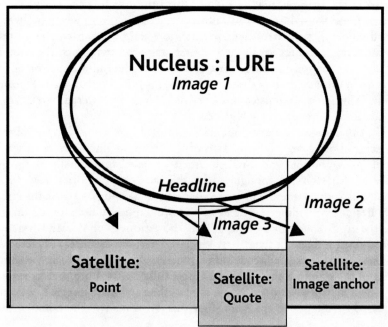

Figure 10.3. Orbital structure of "Wait in Fright" standout.

story in summary—what it is about, and why it is significant. Below the Point is the byline (often positioned elsewhere), which provides the names of writers.

The verbal component of the third satellite here is identified as an attributed *quote*, an optional satellite rarely included in the top story standout of the *SMH* News Review. The handwritten signed letter displayed in the only photo that overlaps the written story comprises eight legible clauses. The quote is attributed to detained asylum seekers—a key "social actor" (van Leuween, 1996) in the issue explored by the story. As an overlapping image in the Lure, the letter may be briefly and initially viewed by readers in close relation to other images and headline. However, it also can be re-viewed and read as a satellite after the Lure is read.

TELLING READERS THE "POINT" OF THE STORY: THE STAND-FIRST–IMAGES SATELLITE

The Point is the most salient of the satellites, with its verbal component, the stand-first, in bold white font on a black background. Readers expect to find out what the feature story is about from the stand-first, particularly from its opening clause, presented here.

"The asylum seekers have polarised Australia"

The Point in this standout provides the most striking evidence of how the standout stance on the issue is different from that taken in the feature story. This dissonance is demonstrated by lexical, grammatical and appraisal analyses comparing the stand-first with the written story. This comparative focus is taken precisely because editors aim for, and readers expect the Point to provide an "abstract" of the written story. Only a verbal component of the standout comprising a sentence can definitively specify the main point and/or thrust of the story and this is seen as the function of the stand-first, not the headline or captions. The abstract of the story as given in the Point is expected to be based on serious reflection and analysis of the issue, unlike the more "attention-grabbing" orientation to the issue expected of the Lure. Thus, the Point, in the authoritative voice of the editor, has a more encompassing purpose than other satellites. And importantly, for those readers who do not read the full story, the Point does not just *stand-first*, it stands *in* for the story. In other words, the Point *is* the story in the standout, one that is shown, in this case, to be at odds with the written feature story.

Lexis and Grammar

Of the two clauses in the Point, the focus of analysis here is on the shorter, more salient and accessible opening clause (Table 10.1). This is the thematic, opening clause for this stage and grammatically the more straightforward. This prominent clause also is, significantly, the first complete and unambiguous verbal proposition on the page.

The first three words of the Point provide the first striking contrast with the written story. They label a key social actor in the story as *"the asylum seekers,"* in large, easy-to-read words directly beneath the arresting lead image. This identification not only begins the Point but is also in traditional picture-labeling position, thus verbally identifying the people in the pictures. This identification strongly contrasts with the written story, where this same social group is never referred to lexically by what they *do*, as in "seek asylum," but most often, by what has been *done to them*, as in "detention." The most frequent expression the writers use to refer to them in the story is *"people in detention,"* which corresponds to their representation in the largest photo, but not in the verbal stand-first. The word group *"the asylum seekers"* is *never* used throughout this long carefully structured story to identify this group of people as participants in a process. Thus, the editorial choice, not only to include this expression in the standout, but to make it prominent in the write-off, creates a significant ideological mismatch.

When the words *"asylum seeker/s"* appear as a noun group in the story, they always modify a more abstract noun, such as *"the asylum seeker problem,"* *"issue,"* or *"controversy."* Sometimes they are even further "embedded" as in *"the policy of detention of asylum seekers."* This highly systematic pattern, in respect to the use of the word group "asylum seekers" throughout the story, correctly reflects the fact that this is not a story about asylum seekers as such. It is a story about how Australia is dealing with asylum seekers—about the detention of, or the policy on asylum seekers.

TABLE 10.1
Grammatical Analysis of the Initial Clause of the Standout

GRAMMAR SYSTEM	*The asylum seekers*	*have polarized*	*Australia*
Transitivity	Participant 1	Process	Participant 2
	Actor/Agent	Material	Goal
	generic, human	transitive	abstract/symbolic
Mood	Subject		
Theme	Theme		

Perhaps a more complex word group, like "the asylum seeker issue" used in the story, was the initial choice in the stand-first, but space restrictions led to the dropping of a final word like "issue." If so, the consequence revealed by this analysis, of representing asylum seekers in a very different light than they are in the written story, was not noted or seen to be of concern. A mismatch is created, however, and is identified as ideological, in that covert evaluative meanings are carried by the words used to label social actors. (For the effects of different lexical labels given to this social group in the Australian press see Clyne, 2005).

A further striking grammatical contrast can be seen between the Point and the written story—this time in respect to processes that asylum seekers are involved in. In the clause *"The asylum seekers have polarised Australia,"* asylum seekers not only are labeled according to what they do (seek asylum), but also are represented as having done something. Significantly, they are thus represented in the clause as agentive actors, acting not just on an object or person, but on the whole country. This contrasts both with the written story and with largest photo. Throughout this lengthy written story, the same people who are most often referred to as "people in detention" or "boat people" are nowhere represented grammatically as having done something to anyone other than themselves. Similarly, the two people in the top photo are clearly not represented as active, free agents, but as passive and as having had something done to them—detention. The unique grammatical representation of asylum seekers in the verbal Point is not only contradictory to the top image and the story, but is given thematic status as the first and most prominent verbal proposition, not just in the stand-first but in the standout and on the page.

A final but crucial point of comparison between the standout and the story further amplifies the lexical and grammatical mismatch already identified. The people represented in the Point as *"The asylum seekers"* and in other ways in the story, are in fact *not* the key social actors in the story. The Australian government is the key actor in this feature story about the government response to asylum seekers. The Point (and the Lure, discussed later), however, is all about asylum seekers and not about the Australian government, which is not referred to explicitly in the standout. The only other social actor in the Point is the more symbolic "Australia," which also appears in the story as one among a number of social actors. The fact that the key player and focus of the written story is neither visually nor verbally represented in the standout is further evidence of the independent textual status of the standout, and contributes to the different stance it constructs on the issue.

This analysis so far has identified a significant ideological mismatch between the point of the story as given in the standout, and as elaborated in the feature story. Linguistic choices made in representing one key social actor in this issue have been revealed as constructing a different ideological stance toward the same people than is systematically constructed throughout the story. Their representation as actively impacting on Australia is ide-

ological because a stance is implicit here although offered as self-evident through lexical and grammatical choices. The same social group in the story is represented by the writers' choices as passive and violently acted on by the Australian state. Without using explicit attitudinal language, this pattern of contrasting lexical and grammatical choices creates an evaluative effect by ideologically orienting readers differently towards to the same people. The next section on appraisal examines explicit evaluative choices in the stand-out, revealing further contrasts between the Point and the written story.

APPRAISAL

A further significant mismatch between the standout and the written story is demonstrated here—an evaluative mismatch additional to, and interacting with the ideological mismatch just described. The analysis applies the three systems of evaluative meanings as mapped in appraisal, those of attitude, graduation, and engagement. The three kinds of attitude values mapped here are as follows:

1. Affect—embodied feelings to do with emotions like happiness as in "sad" or "thrilled," or security as in "afraid" or "safe."
2. Judgement—ethical assessments of behavior in terms of social sanction, including the propriety of people's actions as in "right" or "wrong," or social esteem, including people's capacity as in "strong" or "weak."
3. Appreciation—assessment of things in terms of aesthetic or social worth, as in "beautiful," "useful" or "important."

Importantly, all attitude values can be either explicit, referred to as inscribed, or implicit, referred to as evoked. Attitude values can be evoked in various, and more or less forceful ways by nonattitudinal lexical and grammatical choices. They may be close to explicit when provoked by common metaphors, or merely afforded and implicit, like those referred to here as ideological meanings. A significant distinction between verbal and visual meaning, is that most attitude values in the visual are necessarily evoked, as only a few affect values can be unambiguously visually inscribed.

The second appraisal system, graduation, maps values that make evaluative meaning by raising or lowering the force of attitudinal or nonattitudinal meanings, by discrete words such as the intensifiers in "*very* strong" or "*high* proportion," or by infusing intensification into "non-core" words, like "smash" as opposed to the more neutral "hit." The third system is engagement, which makes evaluative meanings through dialogically positioning an

utterance. If an external voice is attributed as in "someone says . . . ," or another possible position acknowledged as in "it seems . . . ," this is referred to as *heteroglossic*. The alternative option is the *monoglossic* or single-voiced utterance in the authorial voice, the so-called "factual" proposition.

APPRAISAL IN THE POINT

The appraisal analysis begins by demonstrating how strongly provoked attitude values in the Point's first clause confirm and amplify those evoked by the lexicogrammatical choices described earlier as ideological. The analysis shows that *"The asylum seekers"* are not only represented here as people actively doing something to Australia, but as doing something "bad" to Australia. And there is no "maybe" about this, nor is this attributed to a source. This negative evaluation is a bare assertion presented as a statement of fact in the editorial voice. Thus, the proposition, that *"The asylum seekers have polarised Australia"* is analyzed here as a monoglossic assertion, negatively evaluating asylum seekers in respect to their impact on Australia. The metaphor in the verb "polarize" particularly as aimed at a country is analyzed here as provoking (very close to inscribing) negative judgment in terms of social sanction: propriety. The target of judgment is *"The asylum seekers,"* the subject and actor of the process *"have polarized Australia."*

The force of presenting this first full evaluation in the Point and on the page, as a truth asserted in the editorial voice, also is increased by its interaction with other word choices. The two plural nouns here intensify the evaluative meaning in the clause through graduation in terms of high quantification. By suggesting that *all* asylum seekers do something bad to *all* Australians, the attitude provoked by *"polarized"* is given higher force, without the use of further explicit attitudinal language. Additionally, the absence of a modality expression such as "seem to," the dictionary meaning of "two extremes" carried by the non-core word "polarize," and the quasi-scientific context it invokes also all intensify the evaluation while reinforcing the status of the proposition as fact, not opinion. An appraisal analysis is presented in Table 10.2.

In the written story by contrast, asylum seeker behavior is never negatively judged by the authors in terms of its propriety, nor presented as doing something damaging to Australia. In contrast, where the journalists do consistently make explicit negative judgments of this type, the target is the Australian government, the key social actor omitted from the standout. In the written story, the Australian government is frequently and often explicitly criticized and judged either by the authors or by others, in regard to its policies, actions, and its statements on the immigration and detention of asylum seekers.

TABLE 10.2
Appraisal Analysis of the Initial Clause of the Standout

APPRAISAL SYSTEM	*The asylum seekers*	*have polarized*	*Australia*
Attitude	Target of judgment	**Negative judgment: social sanction**	
Graduation	High force (*all* asylum seekers)	High force (*non-core* word)	High force (*all* Australians)
Engagement	**Monogloss:** Implicit appraiser is news review editor		

Also very significantly, unlike the Point, none of the judgments made in the authorial voice in the story are bare assertions. Even the strongest explicit negative judgment made in the writers' voice, *"barbaric,"* is presented indirectly—not as a statement of fact but as a rhetorical question. Additionally, the target of this strong judgment within the rhetorical question is the pronoun "it." To retrieve the *it* in full, the reader has to remember or refer back to a previous sentence on another page in order to identify *"Government immigration and detention policy"* as the target of negative judgment.

What is of most concern, however, is that the Point's evaluation of asylum seekers accurately reflects an evaluation explicitly condemned and argued against throughout the story by the journalists. This mismatch is of much greater significance than others so far described. The editorial negative appraisal of asylum seekers thematized in the Point closely echoes the position of the prime minister as reported in the story, where he is quoted as suggesting that the behavior of boat people poses *"a threat"* to the country. This close match between the evaluative position taken by one quoted social actor and by the standout is even more problematic than the contradictory evaluation of asylum seekers by standout producers and story authors.

"LURING" READERS INTO THE FEATURE STORY: THE HEADLINE-IMAGES NUCLEUS

The initial and obligatory stage of the standout, the Lure, is the largest component of the standout and is realized by the headline and three large colour photos. Together, these comprise the most arresting element on the page, much more dominant than the Point, which was demonstrated to be at odds with the written story. Whether readers go on to the written story, read only the standout, or just glance at the page, they cannot miss the Lure. The

meanings of the Lure, however, necessarily interact with, and color the meanings in the Point and the full story, both introduced by the Lure. The analysis below refers to the Lure as read on its own, as it interacts with the Point and as it compares to the story.

Visual–Verbal Lexis and Grammar

In contrast to the Point, the dominant visual representation of people in the largest image is as "people in detention" and so, is closely consonant with their dominant verbal representation in the written story. This photo unambiguously represents people in a participant role diametrically opposed to the active one they are given in the Point. The two people passively standing and waiting in the top image have clearly been acted on and the crosswire across the entire foreground explains how and why. The lead image is therefore both "lexically and grammatically" at odds with the Point in terms of their representation of the same people.

The representation of people in the big picture is, however, both consonant with and closely grammatically linked to the headline to the extent that they can constitute one proposition. The depicted people supply the human participant implied in the more ambiguous headline—they are the people who *"wait in fright."* The first of the boldest, biggest words on the page, *"Wait"* clearly echoes the visually represented "waiting" stance of the two people. The crosswire extending across the largest photo, signifying a detention center to most Australians, explains why they *"wait"* and why they are *"in fright."* The verbal headline thus supports and elaborates the visual representation of people as "in detention." In addition to the overlapping layout of all images, the people depicted or implied in them may also be linked, even in a quick glance, as belonging to the same social group (middle eastern) by dress or attributes. So, I suggest that all three photos can be "read" at a glance as representing a generic social actor and as the participant missing from the headline. In this way, all the verbal–visual meanings in the Lure interact to create a single meaning unit, the most arresting verbal–visual proposition on the page represented by meanings read at a glance.

APPRAISAL IN THE LURE

The negative emotion of fear is the most explicit attitudinal meaning in the Lure, which deploys a common strategy used in introductions to media, literature, and other texts of representing or evoking some strong emotion. Often, this emotion is explicitly ascribed to some person or group in order to better achieve the immediate emotional engagement and interest of read-

ers. Reporting people's emotional state serves the rhetorical purpose of aligning readers in response to a person or group, either through shared positive or negative affect. Here, readers may share the negative affect inscribed in the headline and recognize the clearly depicted circumstances of detention as its trigger. Additionally, another attitude value is evoked by their depicted situation, that of negative judgment, not of the impropriety of their actions, but of their incapacity resulting from detention. Detainees can only stand and wait. The Lure thus evaluatively orients us to the depicted people by inscribing their circumstances in the headline as frightening, as well as depicting them as incapacitating and, importantly, as imposed on them.

The strong negative affect value inscribed in the word *"fright,"* made prominent as the last word of a short headline is the only explicit emotion in the standout. Although fear is one of the few emotions that can be unambiguously visually inscribed, it is verbally inscribed here, although also supported by visual items in the three photos, items that may evoke empathy in the reader with the "emoters." These include the open, crossed hands and palms facing the viewer—the only items in the top picture focusing on individual humanity and suggesting vulnerability. In the same warm, flesh color and reinforcing the same attributes in Image 2 of Fig. 10.3, are the young girl's hands and her serious face. Although much smaller, this photo offers a more personalized, female, and youthful realization of the same social actor. "Youth" is also reinforced by the childish handwriting in the letter of Image 3 and so may also provoke the positive judgment of "innocence" to add to readers' empathy with their "vulnerability."

Another attitude value is negative judgment in terms of social esteem: capacity is not inscribed but strongly visually provoked in the top image and supported by the words in the headline. These people are depicted as "incapacitated" by their passive "waiting" stance in combination with their "detention" as signified by the crosswire. Thus, both the shared affect and judgment values associated with people depicted are positioned in relation to their cause—enforced detention. All these visual items, which I suggest can be "read" simultaneously in an initial glance at the Lure, work to create bonding in the compliant reader with "people in detention," and perhaps also negative judgment of whomever is responsible.

Importantly, however, many kinds of visual graduation also are used here to amplify and intensify the attitude values just described. The values evoked by visual meanings are flagged here in multiple ways, giving them higher force or impact. First, each of the two most salient visual meanings in the top photo is intensified and not only by the large size of the image. The crossed hands are intensified by brightness of light and the vividness of the flesh color, as well as by the repetition in two sets of hands. The crosswire also is intensified, but by its quantification and extent, with the crosswire both foregrounded and spread across the entire photo. Second, even more powerfully flagging an evaluative reading of these two items is the visual

TABLE 10.3
A 'Grammatical' and 'Appraisal' Analysis of the Lure

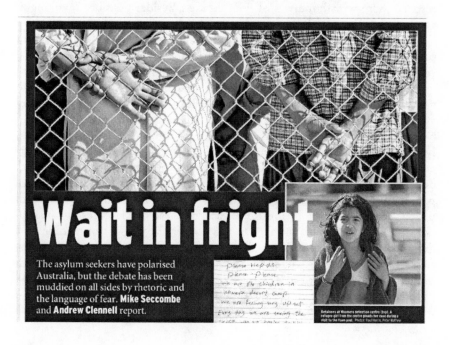

"GRAMMAR"	Visual Participant	Visual Process	Verbal Process	Visual Circumstance	Verbal Circumstance
Verbal lexis/ visual items	Mideast people: adults, girl, child	stand + wait	*wait*	in detention	*in fright*

APPRAISAL

Attitude (targeting asylum seekers)	Evoked and inscribed negative judgment: capacity
	Evoked and inscribed negative affect
Graduation	Attitude intensified by light, color, repetition of crossed hands; quantity, extent of crosswire + visual echoing of crossed hands/wire
Engagement	Monogloss: visual–verbal assertion by appraiser (standout producers)

echoing between these two cross formations. The two sets of crossed hands resonate here with hundreds of wire crosses. Besides possibly invoking a symbolic reading of "the cross," this visual echoing more obviously amplifies the link between incapacitated, vulnerable, frightened middle eastern people and the cause, detention. An appraisal analysis of the Lure is presented in Table 10.3 together with a verbal–visual "grammatical" analysis.

Through these interacting inscribed, evoked, and graduated verbal and visual attitudinal meanings, the Lure bonds readers with people in detention as members of a universal humane community and so guarantees alignment with the broad spectrum of readers targeted by the *SMH*. It also very closely reflects the feature story stance toward this social group, where a similar evaluative strategy is repeatedly deployed in respect to the plight of detainees. In the story, a range of negative emotional states are ascribed to people in detention and accompanied by descriptions of their mental and physical incapacity. As in the Lure, each of these descriptions is causally linked to their detention and though more specifically to government immigration and detention policies. These linguistic choices create similar attitude values to those provoked by the standout and are similarly intensified in the story by repetition. The same attitude values are associated with many different detainees in a long list of quotes by experts and presented as damning evidence for the writers' condemnation of Australian government policy as "*barbaric.*"

SHIFTING STANCE:
FROM THE LURE TO THE POINT

The analysis so far has demonstrated a very different evaluative stance in the arresting Lure from that in the opening of the more serious Point. Bonding and empathy for frightened, incapacitated people in detention is achieved by the first, condemnation of asylum seekers' impact on the country by the second. The initial Lure is, however, by far the largest and more prominent, if not the clearest verbal–visual proposition in the standout. As the Lure more closely reflects the feature story stance, perhaps it should not be of concern that the less prominent Point takes a contradictory stance to the written story. On the contrary, the analysis shows that this mismatch between the Lure and the Point is a concern, not only because the Point has higher status in terms of "serious" information, but because its stance does *not* contradict the Lure, and is in fact coherent with it.

The appraisal analysis shows how the Point succeeds in holding onto much of the same audience as the Lure with no discordant note. Most of the wide audience likely to be captured by the Lure can be shown as coherently realigned by the Point—from an initial, sympathetic position on detainees

to disalignment with asylum seekers. The same people are represented now not as people we (in Australia) have done something to, but people who want something from us and have done something negative to us. By this new representation, reader loyalty can quite easily be shifted from an affiliation based on common humanity, to an affiliation closer to home, that of patriotism. The new participant, "Australia," brought in by the Point invokes a community with which most *SMH* readers are likely to be more strongly aligned. Although readers may feel for people in detention, they also may have to condemn them if they harm their country. This smooth shift to disalignment with asylum seekers in the Point is of particular significance for the many readers who read only the standout.

The coherent evaluative shift in reader positioning from positive in the Lure and negative in the Point would, however, probably not be possible without other supporting verbal–visual meanings. After all, reader sympathy for detainees is achieved in the print news equivalent of widescreen technicolor in the Lure, and disalignment with asylum seekers is achieved in the smaller black-and-white words of the Point. There are, however, visual meanings in the Lure that interact with the verbal meanings in the more authoritative Point to facilitate this realignment by providing support for, and reinforcing its more negative appraisal of asylum seekers.

CONSOLIDATING STANCE:
FROM THE POINT BACK TO THE LURE

Although in some ways the lead image helps us bond with detainees, in other ways, all three images help make the Point's realignment of reader sympathies possible. First, detainees' "fright" is not visually depicted, which might have given it more indelible impact. Also, many visual choices here result in very low social involvement between viewers and depicted people. In this large but cropped image taken from a rear position, there is no eye contact, no faces, nor even heads, making this not only a generic but also an abstracted representation of detainees. This depersonalization of depicted social actors distances readers from them as individuals, and so facilitates disalignment with them in the shift from Lure to Point. Although reader bonding is potentially high with the direct frontal portrait of the young girl, it is greatly reduced both by its small size and by differences between the representation of the girl and the adults in the top picture. Unlike them, she is not frightened, there are no visual signs of her detention, and she is not passively waiting but addressing the viewer, talking and gesticulating. In this way, the force of evaluative work done in the lead image provoking reader sympathy with frightened detainees can be eroded in a closer examination of images in the Lure.

I argue here that when the second clause of the Point is read, the nega-
tive appraisal of asylum seekers in its opening clause is further consolidated
if and when readers re-view and read the two smaller images in relation to it.
In a spatially orbital text like the standout, particularly if only the standout
is read, a number of passes through its components is likely. Thus, if a verbal
meaning in any of the satellites resonates with an image, readers may revisit
the image, originally seen together with others at a glance in the Lure. This
is clearly the case when a caption for a specific image is read, but I suggest
this also applies when readers read the stand-first, reproduced in full here.

The asylum seekers have polarised Australia, but the debate has been
muddied on all sides by rhetoric and the language of fear.

Most significantly, the two smaller photos represent asylum seekers as
actively speaking out on their own behalf. This is at odds both with their
representation in the largest image and throughout the feature story. By
depicting them as actively addressing Australians in writing and face to face,
the smaller images can reinforce the Point's more negative representation of
these people. Even more importantly, they may implicate asylum seekers as
one of the *"sides"* that have *"muddied the debate,"* another provoked nega-
tive judgment in the second clause of the Point. This highly grammatically
abstract clause has no explicit human participants, thus encouraging readers
to infer them from close co-text. The closest clause has provided an actor,
"asylum seekers," responsible for a negatively judged act *"have polarised
Australia."* If re-viewed, the two small images provide 'asylum seekers
speaking out.' In the kind of scanning encouraged by the orbital standout,
the previously read clause and re-viewed smaller images can easily collocate
closely with *"sides," "debate," "muddied."* Together, all these interactions
may further support the representation of asylum seekers as negatively
impacting on Australia.

The representation of asylum seekers as having a voice is precisely the
opposite of that in the written story. Of the hundreds of attributed state-
ments in the story, only one sentence is attributed to an individual asylum
seeker. And he is far from pleading his case, or participating in a debate—he
says he wants to kill himself. The only other relevant references are to
detainees as having *no* voice, in one case caused by sewing their own lips in
protest or in another caused by mental illness resulting from long detention.
Ironically, the smaller images may be an example of dedicated editors, high-
ly sensitive to the significance and implications of the social issue explored
in the story. Thus, the girl may provide a face with which readers can
empathize more readily and the letter may be what is sometimes described
as a *value-added* visual component (News Review editor, personal commu-
nication, 2006). It provides a long quote by asylum seekers and so gives a

voice to this group, which is under-represented in most public discussion, including this feature story.

What this close analysis suggests is that the precise evaluative meanings and overall impact created by complex intermodal relations in the standout may not have been sufficiently considered or recognised in its production. Certain words or images like the letter may be included in the standout to provide what is perceived as an important perspective missing in the story. Others, like the stand-first, may be seen as valid abbreviation of a complex position developed by the story. Unfortunately, in this case the interaction of the meanings in the lead image and the stand-first and between the small images and the stand-first seems to create the opposite effect. As a definitive abstract of the feature story, the Point can disalign the many readers initially aligned with detainees by the Lure. As backing visuals for the captions, quote, and stand-first, the two small photos can help reinforce the standout's negative evaluative stance on asylum seekers, which dramatically diverges from the stance in the written story.

CONCLUSION

This chapter has established that one prominent standout of a top news review feature story on a critical social issue constructs a different ideological and evaluative stance in regard to that issue than does the story. The standout constructs a negative stance toward asylum seekers, whereas the story develops and argues a negative stance toward government statements and policies on asylum seekers. In an even greater contrast to the story, the standout stance corresponds to the Australian government's position on asylum seekers, a stance quoted and strongly criticized by the writers of the story.

It is unlikely that the newspaper was "trying to have it both ways" as the title of this chapter suggests, in terms of intentionally having two different evaluative positions on the same issue in the one news context. However, like many newspapers today, the *SMH* may be trying to have it both ways in terms of marketing the story. It introduces a long, serious, in-depth news analysis with a visually provocative and verbally abbreviated standout. This study does not suggest such texts should not be used in serious broadsheets. It does suggest that more careful consideration needs to be given to the evaluative effect of meanings made by the myriad verbal–visual interactions, which readers process and are positioned by at a glance. To consider these meanings, the standout must be seen, not just as initial promotion of the story, but also as a wide-reaching, independent text with its own evaluative stance.

The analysis presented has demonstrated that the standout stance is created by different kinds of interaction between, and by the multiplication of

meanings across two semiotic modalities—the verbal and visual. Thus, evidence has been presented of how certain ideological and evaluative meanings are made bimodally in a range of complex but identifiable ways in one standout. Even so, this does not exhaust the evaluative meanings in this standout, as other bimodal meanings not discussed here contribute to its evaluative stance, particularly those to do with intertextuality (see Economou, 2008). The case study reported here has thus taken a first step in extending Appraisal analysis to visual meaning and in exploring the way images and words interact to make evaluative meaning.

There is an urgent need to recognize the standout as a powerful and complex news media genre requiring more sophisticated understanding and systematic examination than it is currently receiving by news producers (Colon, 2004; Poynter, 2004). Such texts are currently being deployed more often, more prominently, and in more contexts. This reflects not only the rapid development of visual technologies, but also the tension between the ever-growing number of news texts on offer and ever-shrinking time available to read them. Standouts that successfully pull readers in and that can be read in a series of quick glances may increasingly become the news genre most often read by busy consumers. We need to better understand how they position us in regard to critical social issues of our time, and that requires more systematic investigation of how their verbal–visual meanings evaluatively position readers.

REFERENCES

Bell, A. (1991). *The language of news media*. Oxford: Blackwell.

Chouliaraki, L., & Fairclough, N. (1999). *Discourse in late modernity*. Edinburgh, UK: Edinburgh University Press.

Clyne, M. (2005). The use of exclusionary language to manipulate opinion. *The Journal of Language and Politics, 4*(2), 173-196.

Colon, A. (2005). Doing illustrations: A question of accuracy and fairness. *Poynteronline*—The Design Desk. Retrieved May 2009, from www.poynteronline.org.

Economou, D. (2008). Pulling readers in: News photos in Greek and Australian broadsheets. In E. Thompson & P.R.R.White (Eds.), *Communicating conflict: Multilingual case studies of the news media* (pp. 253-280). London: Continuum.

Economou, D. (2009). *Photos in the news: Appraisal analysis of visual semiosis and verbal-visual intersemiosis*. Unpublished thesis, Education Faculty, University of Sydney Press.

Fairclough, N. (1989). *Language and power*. London: Longman.

Fairclough, N. (1992). *Discourse and social change*. Cambridge, UK: Polity.

Fairclough, N. (1995). *Media discourse*. London, New York, Sydney, & Auckland: Edward Arnold.

Fairclough, N. (2003). *Analysing discourse: Text analysis for social research.* Cambridge, UK: Polity Press.

Fowler, R., Hodge, B., Kress, G., & Trew, T. (1979). *Language and control.* London, Boston, Henley: Routledge & Kegan Paul.

Fulton, H. (2005). *Narrative and media.* Cambridge, UK: University Press.

Halliday, M.A.K. (1978). *Language as a social semiotic.* London: Edward Arnold.

Halliday, M.A.K, & Matthiesson, C.M.M. (2004). *An introduction to functional grammar* (3rd ed.). London: Edward Arnold.

Hodge, R., & Kress, G. (1979). *Language and ideology.* London: Routledge & Kegan Paul.

Hodgson, F.W. (1998). *New subediting.* Oxford, UK: Butterworth-Heinemann.

Iedema, R., Feez, S., & White, P. (1994). *Media literacy (Literacy in industry research project-stage 2).* Sydney: Metropolitan East Region Disadvantaged Schools Programme.

Keeble, R. (2006). *The newspapers handbook.* London: Routledge & Kegan Paul.

Kress, G., & van Leuween, T. (2006). *Reading images: The grammar of visual design.* London & New York: Routledge. (Original work published 1996)

Macken-Horarik, M. (1996). Construing the invisible: Specialised literacy practices in junior secondary English. *Linguistics.* Sydney: University of Sydney Press.

Macken-Horarik, M. (2003a). The children overboard affair. *Australian Review of Applied Linguistics, 26*(2), 1-16.

Macken-Horarik, M. (2003b) Working the borders in racist discourse: The challenge of the children overboard affair in news media texts. *Social Semiotics, 13*(3), 283-303.

Martin, J.R. (2002a). Fair trade: Negotiating meaning in multimodal texts. In P. Coppock (Ed.), *The semiotics of writing: Transdisciplinary perspectives on the technology of writing* (pp. 311-338). Belgium: Brepols.

Martin, J.R. (2004b). Mourning: How we get aligned. *Discourse and Society* (Special issue on discourse around 9/11), *15*(2-3), 321-344.

Martin, J.R., & White, P.R.R. (2005). *The language of evaluation: Appraisal in English.* New York: Palgrave Macmillan.

McKay, J. (2006). *The magazines handbook.* London: Routledge & Kegan Paul.

Poynter. (2004). Visual credibility. *Poynteronline*—The Design Desk. Retrieved May 2009, from www.poynter.org.

Trew, T. (1979). Theory and ideology at work. In J. Fowler (Ed.), *Language and control* (pp. 94-116). London: Routledge & Kegan Paul.

van Dijk, T.A. (1991). *Racism and the press.* London: Routledge & Kegan Paul.

van Dijk, T.A. (1998). *News as discourse.* Hillsdale, NJ: Erlbaum.

van Leuween, T.J. (1996). The representation of social actors. In C.R. Caldas-Coulthard & M. Coulthard (Eds.), *Texts and practices: Readings in critical discourse analysis* (pp. 32-70). London: Routledge & Kegan Paul.

White, P.R.R. (1998). *Telling media tales: The news story as rhetoric.* Unpublished doctoral dissertation, Sydney University, Sydney, Australia.

White, P.R.R. (2000). Dialogue & intersubjectivity: Reinterpreting the semantics of modality and hedging. In M. Coulthard, J. Cotterill, & F. Rock (Eds.), *Working with dialogue* (pp. 67-80). Tubingen: Neimeyer.

White, P.R.R. (2003a). Beyond modality and hedging: A dialogic view of the language of intersubjective stance. *Text, 23*(2), 259-284.

White, P.R.R. (2003b). News as history. In J.R. Martin & R. Wodak (Eds.), *Re/read-ing the past* (pp. 61-89). The Hague: Benjamins.

White, P.R.R. (2004a). Appraisal: The language of attitudinal evaluation and inter-subjective stance. In J. Verschueren, J. Östman, J. Blommaert, & C. Bulcaen (Eds.), *The handbook of pragmatics* (pp. 1-27). Amsterdam: Benjamins.

White, P.R.R. (2004b). Appraisal web site. Retrieved May 2009, from www.gram-matics.com/appraisal.

Wodak, R. (1989). *Language, power and ideology: Studies in political discourse.* Amsterdam: John Benjamins.

Wodak, R., & Reisigl, M. (2001). Discourse & racism. In D. Schriffen, D. Tanner, & H.E. Hamilton (Eds.), *The handbook of discourse analysis.* Oxford, UK: Blackwell.

11

WHAT YOU SEE AND WHAT YOU GET

The Evolving Role of News Photographs in an Australian Broadsheet

Helen Caple

University of Wollongong

Newspapers are in a constant state of evolution. They respond to the societal and technological advances that occur around them, and change manifests itself on the news pages of the newspaper in the ways that news stories are presented. This is particularly true of the broadsheet newspapers in Australia where quite dramatic changes in the presentation of news stories have occurred in recent years. In particular, *The Sydney Morning Herald*, Australia's oldest broadsheet newspaper, has been presenting both hard and soft news stories in a new and innovative manner. Here, we see large photographs with a heading above and a short caption either below or to the side of the picture. There is no extended text with such stories. I term this unique news story genre the *image-nuclear news story*. Also, I use the term *heading* rather than *headline* to distinguish between the more traditional use of headlines in other news story genres and the heading in image-nuclear news stories. The story headed *"Caught in the throws of revolt"* in Fig. 11.1 is an example of one such story.

Along with a modern sans serif font used in these headings, image-nuclear news stories particularly exploit the extra white spaces[1] created around the story to separate them out from the other more traditionally formatted stories on the rest of the page. What also is interesting in these stories is the playful manipulation of common idiomatic expressions in the heading compared with the other often more straightforward headlines on

[1] White space was a feature that was particularly emphasised after the 2000 redesign of the newspaper.

Fig. 11.1. An image-nuclear news story on the world news page, *The Sydney Morning Herald* (March 9, 2005, p. 12).

the page. The heading also often enters into a playful relationship with the photograph, a relationship that has important implications in the interpersonal management of the text.

How and why such stories have emerged in newspapers such as *The Sydney Morning Herald* is the focus of this chapter. However, before we can reach any conclusions regarding such questions, it is necessary to trace the evolution of the use of press photographs in news relay and how this relates to the evolution of the traditional news story genre. Also, the nature of the relationship established between the newspaper as an institution and the reading public is also explored, before concluding that, in line with technological and social changes throughout the history of Australian newspapers, the functional structure of news stories has developed and adapted, and as a result, so too has the way that the newspaper relates with the readers.

Newsworthy events have been photographed since the daguerreotype[2] made its debut in 1839. Public scenes, ceremonies, royal visits, and even a fire in Hamburg in 1842 were photographed using this early technology (Gernsheim, 1988). However, to reproduce these images in newsprint

[2]The daguerreotype was one of the earliest photographic methods producing a positive image exposed directly onto a silver-coated plate.

involved the reinterpretation of the photograph by an engraver and it was not until the 1880s, when the half-tone process allowed for the more accurate reproduction of photographs, that newspapers truly began to embrace the photograph. In fact, many magazines and, in particular tabloid newspapers, built their reputations on the use of photography. Nevertheless, not all newspaper formats, particularly the broadsheets, took to the photographic representation of news as enthusiastically. But by the late 1930s, amid protests by prominent editors that photographs were nothing more than "a mechanical sideline to the serious business of fact narration—a social inferior" (*Time Magazine* editors, 1936, cited in Zelizer, 2005, p. 174), photographs began appearing quite regularly in Australia's quality broadsheet newspapers. From this point on, there was rarely a major news event that did not have at least one photograph accompanying it.

Over this same period, newspapers themselves evolved from institutions whose discursive practices were founded in politics and ideology to institutions with strong commercial interests. Thus, the discourses of journalism also have evolved and are now informed by market forces as well (Chalaby, 1998). This has implications for how newspapers position their readers with respect to the information being relayed to them and is a theme that is addressed in this chapter with respect to how solidarity or bonding (Martin, 2001, 2002, 2004a, 2004b; Stenglin, 2004) between the reader and the newspaper is achieved. By the same token, one cannot ignore the impact that technological changes have had on the dissemination of news. The Internet, for example, is rapidly gaining ground as a means of keeping up to date with the world's events and newspaper companies have responded to these changes by producing online versions of their newspapers. At the same time, traditional hard-copy newspapers also are modernizing their page design to reflect these digital advances. This is particularly evident in *The Sydney Morning Herald*, a broadsheet newspaper published by Fairfax Holdings in Sydney, New South Wales. Here, there is greater use of color, in particular the same blue that is used for the masthead and hyperlinks in the online version similarly is being used on information graphics and typography in the hard copy. Fonts are being modernized with more bold, condensed sans serif fonts being used on headlines, as evidenced in the image-nuclear news stories.

Changes also are evident in the amount of information contained within each news story. Knox (2007), writing on visual–verbal communication on online newspaper home pages, including *The Sydney Morning Herald*, described the "atomization of news texts with which readers interact over short time scales" (p. 19). The image-nuclear news stories described in this chapter follow a similar pattern. Given the amount of competition among media platforms for audience attention, it is not surprising that newspapers continue to evolve as they do.

HOW PRESS PHOTOGRAPHY CAME ABOUT

Since their inception, all newspapers have made use of illustration. Be it the satirical cartoons that offer commentary on the machinations of our governments and community leaders, the elaborate sketches that accompanied early advertisements, or the modern-day digitalized press photograph providing a snapshot of an event, each mode of illustration has held its own position of prominence in the evolution of news print. Barnhurst and Nerone (2001) summarized the evolution of the press photograph as a shift in tenor from personage to person. By this they inferred that photography shifted from the "posed icons of a ritual event to the active dramatic moments preferred by photojournalism" (p. 171), reinforcing the notion that press photographs offer a "shared public memory" (p. 171) of an event. In the following section, I outline the evolution of the press photograph focusing in particular on how it has been used in *The Sydney Morning Herald*.

Establishing the Field

One of the first illustrated weekly papers was established in 1842 in London, when the *Illustrated London News* began engraving the daguerreotype (Rosenblum, 2007). A year later, a similar version called *L'Illustration* was being published in Paris. However, the lengthy exposure times needed to capture an image and the fact that the daguerreotype produced a unique and unreproducible positive image severely limited both the types of subjects that could be photographed (to mostly portraiture and landscapes) and how they could be reproduced in news print. The invention of the collodion process in 1851, however, signaled the means to mass produce photographic images and although it still required a vast amount of equipment to develop the wet plates, photography began to travel (Welling, 1987). Photographers joined expeditions to the far reaches of the planet. But more importantly as far as news reporting is concerned, photography became an adjunct of war reporting. Roger Fenton took 360 photographs of the Crimean War between 1853 and 1856 and Matthew B. Brady similarly photographed the American Civil War (Gernsheim, 1988). As far as the reproduction of such images in newsprint was concerned, however, newspapers were still reliant on woodcut engravings. Thus, efforts were underway to improve this technology.

 In 1881, the half-tone process that allowed for the simultaneous and more accurate reproduction of photographs and text in books and newspapers was introduced and, by the turn of the century, it became possible for printing presses to run at full speed while reproducing half-tone photo-

graphs on the news pages (Gernsheim, 1955). Technological improvements in the size of cameras, (e.g., the Kodak camera in 1888), along with the introduction of roll film, allowing for multiple exposures of an event to be taken in quick succession, and flash powder saw the introduction of documentary photography. Photographers in New York, Glasgow, and London began photographing slum conditions in these cities and "straight" photography, introduced by P.H. Emerson in 1889, showed images in sharp focus and free of manipulation or reinterpretation (Welling, 1987). With this, the notion of truthful, objective photography emerged.

In long-established newspapers like *The Sydney Morning Herald*, however, photographs were still a rarity at this time. News photographs were more commonly sold as prints or postcards, or exhibited or published in albums and portfolios. Gernsheim (1955) recalled that the subjects of news photography at the turn of the century tended to be celebrities or "news events of lasting interest" (p. 344) like Queen Victoria's funeral or the coronation of Edward VII. Events such as accidents or criminal court cases were of "too fleeting an interest to be published" (p. 344) a week or more after they had occurred. Portraiture became the dominant means of establishing a rapport between the reading public and the luminaries of the day. Putting a face to the names that frequently appeared in the news helped the public not only to identify such figures, but also to humanize them, and then to empathize with them. As early as 1860, for example, Abraham Lincoln suggested that he was able to sway the public in the presidential election that saw him take office through the wide distribution of visiting cards, or *carte-de-visite* as they were called then, which were like small business cards that carried a portrait of the person (Welling, 1978). Similarly, the use of photographs in *The Sydney Morning Herald* during the early decades of the 20th century was usually restricted to the static portraiture of prominent figures in society (see Fig. 11.2).

The news photograph, however, came into being most prominently during World War I, some 30 to 40 years after the invention of the half-tone process. Becker (2004) surmised from this fact that it was not then the technology that established the conditions for the use of photographs in newspapers; rather it was a set of "cultural and political circumstances that established the patterns for a visual culture of journalism" (p. 152). Thus, what the technology affords, the social, in its own good time, will take advantage of.

By the beginning of the 20th century, the vocation of press photography was well under way. Photographers and journalists began using the medium to inform the public on crucial matters of public interest, such as the slum conditions in major cities, and through their exhibitions and publication in newspapers and magazines they were able to bring about important social change. A good example is that of William H. Jackson whose photographs of Yellowstone resulted in the US Congress setting aside the area as a national park (Welling, 1987).

Fig. 11.2. Portraits of prominent figures, *The Sydney Morning Herald* (April 9, 1917, p. 3).

Perfecting the Process

From 1925 onward there was a remarkable change in the way photographers operated because technological advances, especially those of size and portability, simply allowed photographers to disappear. They no longer took center stage in orchestrating the positioning of participants; rather they could merge with the crowd and take snapshots of people who were unaware of the camera's gaze, thus giving the notion of "candid" photography (Welling, 1987). The Leica 35mm roll-film camera was introduced in 1925 (Rosenblum, 2007). Wide-aperture lenses meant that exposure time was drastically reduced, allowing for more active, narrative-type images to emerge, indoor photography using available light became possible, and by 1935 Kodachrome had perfected the art of color photography. As far as magazines were concerned, however, it was not until 1953 that *Life* magazine first used color photography on its pages. And in newspapers, the uptake of color reproduction was even slower given the fact that the costs were too prohibitive. *The Sydney Morning Herald* ran its first color advertisement on April 20, 1966, and it wasn't until January 1998 that the first color front page was produced ("Milestones," 1975).

Between the 1930s and 1950s, magazines like *Picture Post* in London, *Paris Match* in Paris, and *Life* in the United States built their reputations on the use of photography, in particular photo essays that narrated a complete story to the readers. Tabloid newspapers like *The Daily Mirror* in the United Kingdom and *The Daily Graphic* in the United States also emerged at this time as newspapers that exclusively relied on photography in news relay (Gernsheim, 1955). The tabloid press fully embraced photography in newspapers, using large, sensational photographs that usually revolved around the themes of violence, sex, scandal, and accidents. Photography historian Robert Taft labeled the reproduction of such photographs in the tabloids as "trite, trivial, superficial, tawdry, salacious, morbid or silly" (Taft, 1938, cited in Becker, 1992, p. 133). Thus, the early press photograph earned its reputation as sensational journalism, making it increasingly difficult to view it as a credible medium for serious news reporting. For the picture magazines, however, it was quite a different story to the tabloids. During the interwar period for example, the glossy picture magazines established the genre of photo reportage, or photo essay, and documentary photography began to be respected as a form of popular art, thus elevating the status of magazine photojournalism to one that combined the formal structure of documentary photography with the notion of the photograph as possessing aesthetic value (Becker, 1992).

In *The Sydney Morning Herald*, however, quite a different pattern was emerging. From the 1930s to 1950s, it was common for the *Herald* to group all photographs together on one page forming a kind of "picture gallery" covering special events like the Melbourne Cup, as a kind of photo essay, or grouping three or four unrelated events together on the page. Given the costs involved in reproducing photographs on newsprint, this is quite understandable. Also, there clearly was little consideration of page design at this time as pictures and captions appear to be quite randomly arranged on the page with a series of headings across the top of the page relating to only some of the pictures on the page. An example page from November 2, 1939 is shown in Fig. 11.3. Three headings run across the top of this page: "*Army Service Corps Distributes Rations*," "*Presentation of Picture*," and "*Kindergarten*." It takes considerable effort on the part of the reader to determine which of the pictures on the page are related to these headings, and clearly some of them are not, for example the cricket picture.

In the 1970s, the lenses of both still and moving cameras were making audiences across the globe eyewitnesses to the atrocities of the Vietnam War. Some of the most memorable and terrifyingly authentic images to come out of that war were instrumental in swaying public opinion and fueling anti-war protests around the world (Sontag, 2003). With television providing such graphic images of newsworthy events, newspapers had to follow suit. Since then, news reports often have been accompanied by photographs to the extent that it is now rare for lead stories in the newspapers not to have

Fig. 11.3. Picture gallery, *The Sydney Morning Herald* (November 2, 1939, p. 12).

photographs with them. Such photographs stand in evidence of the events and issues happening around us, the historic instantaneous as Barthes (1977) said, underwriting the objectivity of the newspaper. Today, many photographs are very disturbing in nature, instances of the aftermath of disasters both natural and man-made, all too often depicting the mangled remains of our material world.

Thus, although the tabloid newspapers had fully embraced photography on its news pages during the first half of the 20th century, broadsheets like *The Sydney Morning Herald* did not seriously take up news photography until the 1970s and 1980s. Even then, however, the salient, dramatic news photographs accompanying major news events that we expect to see in today's newspapers were not common. Fig. 11.4 shows the front page of *The Sydney Morning Herald* from November 12, 1975, on the momentous occasion of the dismissal of the then prime minister of Australia, Gough Whitlam. As the news of his dismissal broke, the only photograph that appeared on the front page of *The Sydney Morning Herald* was a small portrait of his replacement, Malcolm Fraser.

Fig. 11.4. **The front page of** *The Sydney Morning Herald* **after the announcement of the dismissal of Prime Minister Gough Whitlam (November 12, 1975).**

The randomness with which newspapers like *The Sydney Morning Herald* included photographs with major news stories suggests that there was little consideration of the function of photographs in the telling of the news beyond the notion of "having been there" that is so often reported in the journalism studies literature (Barnhurst & Nerone, 2001; Zelizer, 2005). If they were not there, they did not get the picture. According to Zelizer, both journalists and the reading public see images as the eyewitness authority, authentic and trustworthy. Thus, it would appear that their denotative function, offering concrete, grounded depiction of events underlying the news, was valued over their connotative function (Zelizer, 2005). However, as pointed out by Barthes (1977) and Hall (1981), photographs also are powerful tools for their ability to appeal directly to the emotions. In Zelizer's words, they "facilitate an appeal to the emotions that transforms them into powerful and memorable vehicles" (p. 168).

Another explanation for the lack of consistency in the use of press pho-
tographs in *The Sydney Morning Herald* during the majority of the 20th
century is because of the technological limitations of printing processes.
Until the 1980s, most presses used letterpress technology. Letterpress used
an oil-based ink on off-white low-quality newsprint paper. The photo-
engraving dots that formed pictures often bled or smeared. This produced
final copy with blurred pictures that often were difficult to distinguish. It
wasn't until the introduction of offset printing during the 1980s that premi-
um quality photographic reproduction could be more or less guaranteed.
This also explains why most press photographers remained in obscurity
while their colleagues working for the glossy magazines, printed in color
with high-quality inks and paper, had achieved celebrity status.

The Digital Age

Newspaper production is now fully computerized and digital photography
is the norm. Today, photographers are weighed down with the latest in dig-
ital cameras, laptop computers, and satellite phones capable of beaming
images around the world in a matter of minutes. News agencies, like
Reuters, AP, and AFP, also provide banks of images captured by photogra-
phers in every corner of the world, and the choice available to newspapers is
now almost immeasurable. Also, today's newspapers are a designer's news-
paper (S. Clark,[3] personal communication, 2006). Stories are planned and
packaged around the notion of visual design, taking into consideration how
they are framed and how they relate to other stories and advertising spaces
on the page. News stories are usually packaged within defined rules with a
headline that stretches across both verbiage and image, signalling the posi-
tion of the photograph as content within that story (see Fig. 11.5).

This method of presenting news stories, as shown in Fig. 11.5, is now
the most common way of laying out news stories across newspapers. In *The
Sydney Morning Herald*, however, there is another way in which such sto-
ries and images are often being presented (see Fig. 11.6). It is the fact that
there now exists so much choice between ways of presenting news stories
that I see as being significant in the meaning potential of the news.

In the year 2000, *The Sydney Morning Herald* carried out a significant
redesign. The white spaces between stories were emphasized and news pho-
tographs began to take up more column inches than in the past. At the same
time, the *Herald* began making greater use of what are called picture stories
on its news pages. Picture stories most often are large aesthetically motivat-
ed images that may have little news value, but which can fill a space during

[3]Stephen Clark is a senior news designer with *The Sydney Morning Herald*.

Fig. 11.5. A typical news story from *The Sydney Morning Herald* (June 30, 2005, p. 9).

Fig. 11.6. An image-nuclear typical news story on the world news pages, *The Sydney Morning Herald* (November 20, 2004, p. 16).

slow news periods. Press photographers generally refer to these as filler pictures and will regularly contribute to a bank of such images while they are out and about on their rounds. However, such images in *The Sydney Morning Herald* quickly began to take on a unique style and formatting of their own. They also became much more central to the telling of newsworthy events, both locally and internationally and regarding both hard news and soft news events. This became a particularly marked difference in the representation of news, especially because the same event would be presented using the more traditional news story format (as seen in Fig. 11.5) in the *Australian*, another (national) broadsheet newspaper that circulates in Sydney, or in the *Age*, the sister newspaper to *The Sydney Morning Herald* in Melbourne, Victoria. Thus, I began to view this as a new, unique news story genre, and given the salience of the photograph in such stories, I termed this the *image-nuclear news story*. Under the heading "Going against the grain," Fig. 11.6 shows an example image-nuclear news story on a world news page in the *Herald*.

However, in order to answer questions such as "What is the meaning potential of such image-nuclear news stories?" and "How do they relate to the reading public?" I turned to the academic literature for guidance in analyzing such texts.

DESCRIBING VISUAL-VERBAL RELATIONS IN NEWS STORIES

In the journalism studies literature, press photographs often are viewed simply as adjuncts to the words they accompany. They are said to be authoritative; mirrors of the events they depict, merely reflecting the world as it is, which is often referred to as photographic verisimilitude (Zelizer, 2005). Thus, beyond their denotative capacity, little attention is given to their connotative force. They rarely are viewed as constructs—the result of actions taken by photographers, subeditors, and editors—that have gone through a long and complex meaning-making process. As far as their relationship with the words accompanying them, theorists such as Barthes (1977) described images as polysemous and in need of language to come to the rescue in tying down the meaning of the image.

In the field of systemic functional linguistics, however, there has been a great deal of attention paid to the meaning potential of images both in themselves and in relation to the words that may accompany them. A rich and complex theory of images has been developed by O'Toole (1994) and Kress and van Leeuwen (1996, 2006), giving rise to the notion of multimodality, where meaning is communicated through the synchronization of two or more modes (Walsh, 2006). In so doing, however, what may have formerly

been viewed as context has been turned into text, so that we now have co-articulating modalities of communication. Thus, any multimodal analysis needs to take into consideration how the different modalities interact, which is an area that has been investigated by Martin (1994, 2001) and Stenglin (2004). In the remainder of this chapter, the co-deployment of press photographs and their headings, in particular in image-nuclear news stories, is examined with regard to their meaning potential and how they afford a certain kind of solidarity or bonding with different kinds of *Herald* readers. First, however, we need to clarify this notion of bonding.

HOW NEWSPAPERS BOND WITH THEIR READERS

Bonding is a notion developed by Martin (2001, 2002, 2004a, 2004b) in regard to the co-deployment of image and verbiage in multimodal texts. Martin (2001) suggested that one of the roles of images in multimodal texts is to co-articulate attitude, that is, affect, judgment, and appreciation. This notion of attitude comes from the work of Martin and White (2005) in establishing the appraisal system for the construal of evaluative meaning within the systemic functional linguistics framework. Using appraisal, Stenglin (2004) was able to demonstrate, in her analysis of museum space, how people are aligned around empathy or collective emotions through shared affect, how shared judgment negotiates character and principles, and how people can be aligned around tastes and preferences through shared appreciation. Thus, feelings are said to play a central role in negotiating communal alignment and it is around these shared attitudes that we bond (Stenglin, 2004).

Newspapers are said to be institutions that reflect the dominant ideology of society back on itself. Through their careful selection of stories to be relayed to the public and the diverse angles from which they will be approached, newspapers create a readership that may share certain values with one group or another or may appreciate some aspects of the product with another group. For example in *The Sydney Morning Herald*, readers may align themselves with the editorializing of Miranda Devine on the one hand or with that of Adele Horin on the other. (Devine is considered a right-wing, conservative columnist, and is well known for her controversial viewpoints, whereas Horin is a left-leaning columnist.) Other readers may enjoy the challenge of the cryptic crossword or the latest Sudoku puzzle. In the same way, certain readers will enjoy peeling back the layers of meaning built up in the image-nuclear news stories, whereas others will enjoy the more in-depth coverage of issues and events in the more traditional news stories. By sharing such experiences with their readers, the newspaper is able to create a sense of togetherness, inclusiveness, and affiliation, and it is around these shared feelings that we bond.

This sense of building interpersonal relations with the reader has been particularly evident in the 20th century. With the emergence of the distinct hard news story genre at the end of the 19th century, newspapers began to load up the beginning of the story with informational and interpersonal meanings central to the understanding of the story (White, 1997). One of the reasons for doing this is because of changes in the social purpose of the newspapers. In 1886, there were 48 daily newspapers in Australia and by 1900, there were 200 country newspapers (Iedema, Feez, & White, 1994). By 1923, however, with the invention of radio, the number of city daily newspapers had virtually halved to 26 (Iedema et al.). Competition not only among newspapers but also between media platforms was now intense. Newspapers became profit driven and had to find a way of attracting readers not only to their particular publication but also to choose from the many news stories on each page. Radio could give us the news as it happened. Newspapers, it seems, had to become more specialized; indeed, more entertaining.

Linguist Peter White (1997) stressed that the hard news story typically has two phases: "an opening nucleus containing the text's core informational and interpersonal meanings; a subsequent development stage which acts not to introduce new meanings but to qualify, elaborate, explain and appraise the meanings already presented in the opening 'nucleus'" (p. 111). This meant that the news story now centered on a crisis point established in the headline and lead (the nucleus), which then became the platform from which we leap into the remainder of the story. As Barnhurst and Nerone (2001) pointed out, headlines no longer functioned as titles or labels directing readers to the stories on the page, rather they became a "pointed summary of the news" (p. 198), carrying "deeply embedded codes of news values and cultural values . . . ranging from the unusual and the timely to the powerful and the moral" (p. 198). Thus, for the most part, the nucleus works to direct the reader toward the news values underpinning the inclusion of that story in the news, which also reflects the ideological positioning of the newspaper toward the events being covered. It is, then, the nucleus that attracts the reader into the story, and readers are now hooked into the story through the amplification of the ideational content. Of course, it is around this time that photographs started appearing in The Sydney Morning Herald. However, because they were mostly placed together on a separate page (as in Fig. 11.3), they had little to do with the verbal news stories printed on other pages.

Toward the end of the 20th century and into the 21st, there were further developments in how newspapers build relations with their audience. Through the use of the nuclear structure and the inclusion of salient narrative press photographs, the news story now seems to be engaging the reader on a much more interpersonally charged level. The social purpose of the hard news story, it seems, now includes attracting the reader to what the newspaper feels are the most salient news stories of the day and reflecting the major ideological themes of the newspaper back to the society it repre-

sents. Furthermore, with the nucleus acting as a story in microcosm, readers are now presented with a choice in their reading patterns. One such choice is to simply read the nucleus and/or any photograph and caption that may have been used to get at the gist of the story and then move onto the next story, or they may choose to engage more deeply with one particular story. The degree to which readers will engage with the story beyond the nucleus not only depends on how well the story engages the attention of the reader, but also on how much time, or interest in the event, readers have, or on their purpose for reading the newspaper.

Thus, during the 20th century the interpersonal volume was ramped up to such a degree that it now dominates and has become the underlying approach to the content of many stories. By this I mean that through the increasing use of evaluative language and salient images, the newspaper is able to align readers with the institutional practices involved and our attitudes toward them. This is particularly true of image-nuclear news stories where it is through the interpersonal that the reader is oriented to the ideational content, giving one the notion of evaluative stance in image-nuclear news stories. Gauntlett (2000), in his writing about the Internet and the media, described a phenomenon that Goldhaber called the "attention economy" (p. 9). Goldhaber suggested that given the vast quantity of information widely available on the Internet and the fact that most individuals have so little time to look at all of this information, it is vital that information grabs and retains the attention of the audience. He further stated that "money flows to attention, and much less well does attention flow to money" (Goldhaber, 1997, cited in Gauntlett, 2000, p. 10). This means that the content has to be engaging enough to keep the reader interested so that advertisers will then be willing to invest in the product. This is one strategy that *The Sydney Morning Herald* may employ in keeping their readers interested in the paper version of their newspaper rather than seeing them switch to other media platforms. The image-nuclear news story may then play a vital role in helping to keep the attention of the audience.

IMAGE-NUCLEAR NEWS STORIES: A NEW NEWS STORY GENRE

Image-nuclear news stories have a similar functional structure to verbiage nuclear news stories in that the heading and image work together to form a nucleus, from which the evaluative stance of the newspaper toward that particular story can be read. The caption then goes on to locate the image participants and their actions within a particular context, and may also expand on the news event that justifies its inclusion in the newspaper. Fig. 11.7 shows the structure of an image-nuclear news story. The term *image-nuclear*

Fig. 11.7. The structure of an image-nuclear news story.

comes from the fact that the photograph is salient in these stories, even though it is essentially a co-modalizing nucleus.

Compared with the other major daily newspapers that serve the Sydney metropolitan area, *The Sydney Morning Herald* has been particularly prolific in its use of image-nuclear news stories in recent years. Most weekday editions use at least one, usually on the world news pages. However, during 2004 there were up to five of these stories used in any single edition of the paper. Since 2004, I have reviewed of 1,000 of these stories and 95% of them engage in wordplay between the heading and the image.

A New Kind of Solidarity

It is this degree of wordplay in image-nuclear news stories that has led me to the conclusion that *The Sydney Morning Herald* is trying to bond with its readers in new and exciting ways that are much more challenging for the reader. By this I mean that given the degree to which headings rely on wordplay or the evocation of intertexts ranging from the highly literary to the most common idiomatic expressions (for examples of such headings, see Table 11.1), readers must now draw on a vast range of general, cultural, and linguistic knowledge in order to be able to peel back the layers of meaning built up in these texts. Extra skills are needed by the reader to see that the play is between the image and the text on one level and then intertextually with remembered knowledge on another. Equally, readers must be able to determine which of these layers of meanings correlates to that required to decode the story. Thus, readers are now expected to select from and display their cultural capital (Bourdieu, 1998), and are invited to engage with the

TABLE 11.1
Headings and Their Intertextual References

HEADINGS	DISCOURSES ALLUDED TO	INTERTEXTUAL REFERENCES
"The duke of hazard"	Television discourses	Allusion to popular 1980s American TV series *The Dukes of Hazzard*
"Gold ahead, make my day"	Cinematic discourses	Allusion to a famous quotation from a movie: Clint Eastwood as Dirty Harry in *Sudden Impact* 1983: Original quote reads: "*Go ahead punk, make my day*"
"Dry hard with a vengeance"		Allusion to movie title: *Die Hard With a Vengeance* (1995), starring Bruce Willis
"Fighting them on the beaches"	Politico-historical discourses	Manipulation of the Churchill speech to Parliament on June 4, 1940: Original quotation: "*. . . we shall defend our Island, whatever the cost may be, we shall fight on the beaches, we shall fight on the landing grounds, we shall fight in the fields and in the streets, we shall fight in the hills . . .* "
"Not waving, but worshipping"	Literary discourses	Manipulation of the Stevie Smith poem "*Not waving, but drowning*" (1957), or reference to 1980s Melbourne band, "Not Drowning Waving"
"Just another night in paradise"	Musical discourses	Manipulation of the 1989 musical hit "*Another Day in Paradise*" for Phil Collins
"One-horse town is under starter's orders"	Sporting discourses	Reference to the discourse of horse racing. "*Under starter's orders*" is used at the beginning of a horse race when all of the horses are locked into the barriers before the race begins
"Give us this day our little bread roll"	Religious discourses	Manipulation of the Lord's Prayer, "*Give us this day our daily bread*"
"Cooking with gas"	Advertising discourses	An old advertising slogan for gas oven (circa 1940). Original ref: "*Now you're cooking with gas*"
"Shot cross the bow captures collision"	Military discourses	Based on the military practice of aiming a *shot across the bow* (a small explosion in front of a ship) to force it to stop
"Give the lady a big hand"	Folk discourses	Common idiomatic expression *give* "*somebody a big hand*," meaning to congratulate.

text on whichever level they are comfortable with, ranging from the purely aesthetic or affectual response to a salient photograph, to being able to unpack the multiple layers of meaning built up between the different parts of the story.

Coming back to Goldhaber's notion of the "attention economy," it seems that modern-day, computer-literate readers need to be able to access quite a range of reading abilities to deal with the volume of information at their disposal. They need to be able to skim and scan information quickly, flitting from one source of information to the next, never actually engaging deeply with any of them. Given the lack of depth in image-nuclear news stories, this also may be a way that *The Sydney Morning Herald* is catering to these reading habits, grabbing the attention of the reader only fleetingly. Thus, the reader can flit from one story to the next, never engaging on a deeper level.

A careful analysis of one of these new news stories may help to clarify how image-nuclear news stories bond with the reader through the interpersonal evaluative stance established in the nucleus, and how little depth is offered in such stories. Fig. 11.8 shows an image-nuclear news story taken from page 15 of *The Sydney Morning Herald* on the weekend of October 16-17, 2004. The heading above the image reads *"Trouble on Oiled Water"*; the image depicts an aerial view of a stretch of coastline that has been affected by an oil spill in the state of Washington. The story is used quite large on the page, extending beyond the fold line and is positioned between two other international news stories. The caption below the image reads *"An oil spill, dispersed by tides and winds, creates a multi-coloured sheen on the water lapping the beaches of Vashon Island, Washington State. Department of Ecology officials and spill contractors were trying to use booms to protect sensitive marine habitats."*

Given the unusual angle from which the photograph has been taken and the fact that the image is in color, readers may initially be drawn to the patterns produced by the coastline, the beach, the ripples, and the colors of the oil on the water and as a result may initially engage with the image as an aesthetic work of art that is to be appreciated. If we then turn to the heading, which can be viewed as a manipulation of the common idiomatic expression "to pour oil on troubled waters," or maybe even as a reference to the Simon and Garfunkle song "Bridge Over Troubled Waters," we can begin to appreciate the extent to which intertextual references are played with in the heading, and the amount of work required of the reader who wishes to play along and engage with this wordplay. However, the reader also has to realize that in taking up the idiomatic expression, the more common use of the idiom, meaning "to do or say something in order to make people stop arguing and become calmer" (Cambridge Dictionaries Online, 2006), is not called for in this instance. Rather a more literal reading of the words in the heading is required. However, that may not become apparent until the caption is also

Fig. 11.8. "Trouble on oiled water," *The Sydney Morning Herald* (October 16-17, 2004, p. 15).

engaged with. Thus, by combining this clever, witty wordplay with the aesthetic image, we can say that the image and heading together produce an effect that engages the reader on an interpersonal level, and which at first blush elides the devastating effects that an ecological disaster of this nature may threaten the surrounding environment with.

Furthermore, the caption makes no reference to the causes of this disaster, nor does it make direct reference to any timeframe surrounding these events. However, if we go by the traditional news value of timeliness (Hall, 1981), then we may surmise that these events are happening now and are continuing. The use of the present and continuous tenses in the caption also reinforces this notion of currency. This brings us back to the notion of engaging the reader on a very temporary basis, a reader that is skilled in flitting from one story to the next, never actually engaging deeply with any one story over a longer period. Editors from *The Sydney Morning Herald* suggest that one reason why this format may be used with essentially hard news stories is that the story may have been more comprehensively dealt with in a previous edition. With this particular news story, however, this was the

first and only reference the newspaper made to this event. Ideologically then, we could also infer from the treatment of news stories using this particular format, that the *Herald* is setting up a particular worldview for some of its readers, one that initially establishes a somewhat playful orientation to an event in the headings and images, before alluding to the more serious news values behind the story in the captions.

Of course, any in-depth analysis of such news stories also will have to take into consideration the affordances (Kress, 2003) of the photographs themselves, and how they fit in with the layout of the whole page.

CONCLUSION

In the 1990s, Kress (1996) suggested that "the prominence of the verbal ha[d] gone, or rather, it ha[d] been fundamentally transformed into 'display' rather than 'information' in the traditional sense" (p. 25). To exemplify this point he described the reader of the *Sun* newspaper (a U.K. tabloid) as follows: "This is a reader . . . who does not have the time, the skill, the concentration or willingness to read in a focused fashion. This is a reader who just wants to get her or his perceptions immediately, directly. Information must be presented in a pleasurable fashion" (pp. 25-26). Although this is rather an extreme description that would certainly not be appropriate for the readers of *The Sydney Morning Herald*, it serves as an indication of the ways in which moves toward a more visual representation of information have been viewed. Some may see the inclusion of the image-nuclear news story among the repertoire of the *Herald's* news story formats as a tabloidization of the news. However, I do not see it that way. Rather, I see such stories as encouraging a readership that can pride itself in the knowledge that this newspaper caters to their extensive understanding of the world and to their wit. In turn, this means that *The Sydney Morning Herald* can establish a very powerful readership profile that can be easily packaged and sold to advertisers. This also may be viewed as an attempt by the newspaper to set itself apart from other news providers, maintaining readership loyalties through this special relationship with its readers, and thus prolonging the longevity of the newspaper amid the ever growing and sometimes fierce competition from other media platforms.

REFERENCES

Barnhurst, K., & Nerone, J. (2001). *The form of news: A history*. New York: Guilford.
Barthes, R. (1977). *Image, music, text*. London: Fontana.

Becker, K.E. (1992). Photojournalism and the tabloid press. In P. Dahlgren & C. Sparks (Eds.), *Journalism and popular culture* (pp. 130-153). London: Sage.

Becker, K.E. (2004). Where is visual culture in contemporary theories of media and communication? *Nordicom Review, 25*(1-2), 149-157.

Bourdieu, P. (1998). *On television and journalism.* London: Pluto Press.

Cambridge Dictionaries Online. (2006). Retrieved July 4, 2007, from http://dictionary.cambridge.org/define.asp?key=61986&dict=CALD.

Chalaby, J.K. (1998). *The invention of journalism.* Basingstoke, UK: Macmillan Press.

Gauntlett, D. (Ed.). (2000). *Webstudies: Rewiring media studies for the digital age.* London: Arnold.

Gernsheim, H. (1955). *The history of photography.* London: Oxford University Press.

Gernsheim, H. (1988). *The rise of photography 1850-1880.* London: Thames & Hudson.

Hall, S. (1981). The determinations of news photographs. In S. Cohen & J. Young (Eds.), *The manufacture of news. Deviance, social problems and the mass media* (pp. 226-243). London: Sage.

Iedema, R., Feez, S., & White, P. (1994). *Stage two: Media literacy. A report for the Write it Right Literacy in Industry Research Project by the Disadvantaged Schools Program, N.S.W.* Department of School Education, Sydney.

Knox, J. (2007). Visual–verbal communication on online newspaper home pages. *Visual Communication, 6*(1), 19-53.

Kress, G. (1996). Representational resources and the production of subjectivity. In C. Caldas-Coulthard & M. Coulthard (Eds.), *Texts and practices: Readings in critical analysis* (pp. 15-31). London: Routledge.

Kress, G. (2003). *Literacy in the new media age.* London: Routledge.

Kress, G., & van Leeuwen, T. (1996). *Reading images: The grammar of visual design.* London: Routledge.

Kress, G., & van Leeuwen, T. (2007). *Reading images: The grammar of visual design* (2nd ed.). London: Routledge.

Martin, J.R. (1994). Macro-genres: The ecology of the page. *Network, 21*, 29–52.

Martin, J.R. (2001). Fair trade: Negotiating meaning in multimodal texts. In P. Coppock (Ed.), *The semiotics of writing: Transdisciplinary perspectives on the technology of writing* (pp. 311-338). Brepols.

Martin, J.R. (2002). Blessed are the peacemakers: Reconciliation and evaluation. In C. Candlin (Ed.), *Research and practice in professional discourse* (pp. 187–227). Hong Kong: Hong Kong University Press.

Martin, J.R. (2004a). Mourning: How we get aligned. *Discourse and Society* (Special issue on discourse around 9/11), *15*(2-3), 321-344.

Martin, J.R. (2004b). Sense and sensibility: Texturing evaluation. In J. Foley (Ed.), *Language, education and discourse: Functional approaches* (pp. 270-304). London: Continuum.

Martin, J.R., & White, P.R.R. (2005). *The language of evaluation: Appraisal in English.* New York: Palgrave Macmillan.

Milestones from hot metal to electronic pagination—A Fairfax chronology. (1975). Fairfax Library. Sydney NSW.

O'Toole, M. (1994). *The language of displayed art.* London: Leicester University Press.

Rosenblum, N. (2007). History of photography. Retrieved March 15, 2007, from Encyclopædia Britannica Online: http://www.britannica.com/eb/article-252873.

Sontag, S. (2003). *Regarding the pain of others*. London: Hamish Hamilton.

Stenglin, M.K. (2004). *Packaging curiosities: Towards a grammar of three-dimensional space*. Unpublished doctoral thesis, Department of Linguistics, University of Sydney, Sydney.

Walsh, M. (2006). The textual shift: Examining the reading process with print, visual and multimodal texts. *Australian Journal of Language and Literacy, 29*(1), 24-37.

Welling, W. (1987). *Photography in America: The formative years, 1839-1900*. Albuquerque: University of New Mexico Press.

White, P.R.R. (1997). Death, disruption and the moral order: The narrative impulse in mass "hard news" reporting. In F. Christie & J.R. Martin (Eds.), *Genres and institutions: Social processes in the workplace and school* (pp. 101-133). London: Cassell.

Zelizer, B. (2005). Journalism through the camera's eye. In S. Allan (Ed.), *Journalism: Critical studies* (pp. 167-176). Maidenhead, UK: Open University Press.

ABOUT THE CONTRIBUTORS

Marcel J. Broersma is professor in Journalism Studies and Media at the University of Groningen, the Netherlands. His research focuses on the effects of form and style changes in journalism and the transformation of the public sphere. He has published books on the history of a Dutch newspaper (the *Leeuwarder Courant*, 1752-2002) and readership decline, and he recently edited a volume on *Form and Style in Journalism. European Newspapers and the Representation of News, 1880-2005* (Peeters, Leuven, 2007). He is editor of the *Dutch Journal for Media History* (TMG) and a member of the Dutch Press Council.

Donald Matheson teaches in media and communication at the University of Canterbury, New Zealand. He is the author of *Media Discourses* (Open University Press, 2005) and co-author with Stuart Allan of *Digital War Reporting* (Polity, 2009). He co-edits *Ethical Space*, a journal focused on communication ethics, and writes on journalism, discourse and digital media. In a previous life he was a journalist.

Svenik Høyer is Professor Emeritus at the University of Oslo. His research includes the study of media and elections, historical studies of the development of the Norwegian press, the study of the journalistic profession, and media institutions in Norway. Lately he has been engaged in comparative studies of journalism. He has published books and journal articles in Norwegian and English and his most recent study is *Reminiscence of Intellectual Battles bygone in Communication Research* (Gothenburg, Nordicom, 2007).

Verica Rupar teaches in international journalism at Cardiff University, United Kingdom. Her research interests are in comparative journalism stud-

ies. She writes on journalism and meaning making and has published articles in academic journals in the field including *Journalism Studies, Journalism: Theory, Practice and Criticism* and *Journalism Practice*. She worked as a journalist for 20 years.

Grant Hannis heads the Journalism School at Massey University in Wellington, New Zealand. His main research interests are journalism history, consumer journalism, and the democratic role of journalism. He worked for 14 years as a journalist, initially as a political and financial journalist, then as the senior finance writer and latterly as manager of the writing staff. He continues to publish freelance articles in a variety of major New Zealand publications.

Ebbe Grunwald is Associate Professor in the Department of Political Science and Public Management (research unit) and the Centre of Journalism (education unit) at the University of Southern Denmark, Odense. His research interests are in the language and genres of journalism in the print media. His most recent books are *Artiklen* [The Article] (2004) and *Sprogbilledet* [Images of Language] (2006). He has published academic articles and book chapters on the narrative of written news, journalistic genres, metaphors and other image-evoking mechanisms in the language of journalism.

David Rowe is a Professor in the Centre for Cultural Research, University of Western Sydney, Australia, of which he was Director (2006-9). His main research interests are in the areas of media and popular culture, including sport, journalism, and urban leisure. He has published over 60 book chapters and over 70 articles in journals including *Media, Culture & Society, Social Semiotics, Continuum, Social Text* and *Journalism*. His books include *Popular Cultures: Rock Music, Sport and the Politics of Pleasure* (London: Sage, 1995) and *Sport, Culture and the Media: The Unruly Trinity* (second edition, Maidenhead, UK: Open University Press, 2004).

Libby Lester is deputy head of school and coordinator of the Journalism, Media and Communications Program at the University of Tasmania, Australia. Before joining the university, she worked as a journalist for a number of Australian newspapers and magazines, including the *Melbourne Age* and *Good Weekend*. Her recent research has appeared in *Media, Culture & Society, Journalism Studies* and *Media International Australia*. She is working on a book for Polity Press on media and environmental conflict.

Anonna Pearse works as a research assistant at Newcastle University. Her research interests are journalism and media studies, and cultural and dark tourism.

Dorothy Economou has recently completed a doctorate at Sydney University where she has taught linguistics, media studies and academic skills since 1997. Using systemic functional linguistics (SFL), multimodal and critical discourse analysis, her PhD investigates how verbal-visual feature story introductions ideologically orient broadsheet readers to critical social issues. This thesis brings together her journalism experience in newspapers and television over the years with her academic research interests in SFL and discourse analysis. The thesis develops the functional description of visual meaning in naturalistic photographs, identifying different kinds of evaluative meaning in news photos and explores how these interact with verbal meaning in headlines, subheadlines and captions to orient and position newspaper readers.

Helen Caple is a lecturer in English Language and Linguistics at the University of Wollongong, Australia. Her PhD with the Department of Linguistics at the University of Sydney analyzed the semiotic landscape between press photographs and the verbiage accompanying them. Her research interests include visual storytelling and the representation of sportswomen in the media. She also lectures in media discourse, journalism studies and is a former press photographer.

AUTHOR INDEX

Albert, P., 28, *33*
Alger, D., 90, 91, *101*
Allan, S., 76, 78, *87*, 134, *137*
Arbouw, E., 19, *33*
Archibald, E., 79, *88*
Austin, J.L., 18, *33*
Australian Associated Press, 95, *101*

Bagdikian, B., 90, *101*
Baker, R., 90, 91, *101*
Barnard, M., 150, *156*, 164, *172*
Barnhurst, K.G., 21, 22, *33*, 59, 62, *68*, 76, 79, *87*, 134, *137*, 202, 207, 212, *218*
Barthes, R., 38, 40, *52*, 164, *172*, 206, 210, *218*
Becker, K.E., 203, 205, *219*
Bell, A., 37, 44, 45, 46, 48, 51, *52*, 177, *196*
Bennett, L.A., 134, *137*
Bennett, W.L., 19, *33*
Benson, R., 39, 30, *33*, 75, *88*, 142, *156*
Bernstein, C., 90-91, *101*
Bevilacqua, S., 151, *156*
Bird, S.E., 39, 41, *52*
Blainey, G., 159, *172*
Blumer, H., 5, 6, *11*
Bonner, F., 144, 146, *157*
Boorstin, D., 141, *156*
Borjesson, K., 91, *101*
Bosk, C., 76, *88*, 148, *157*

Bourdieu, P., 4, 5, 6, *11*, 18, 19, 30, 31, *33*, 74, 75, 76, 81, 86, 87, *88*, 131, *137*, 214, *219*
Breed, W., 5, *11*
Broersma, M., 17, 20, 22, 26, 28, 31, 32, *33*
Bruner, J.S., 38, *52*
Butler, J., 18, *33*

Calhoun, C., 31(n1), *33*
Cambridge Dictionaries Online, 216, *219*
Campbell, W.J., 26, *34*
Carlson, M., 18, *34*
CBS 60 Minutes 2, 15, *34*
Chalaby, J.K., 21, 24-25, 28, 31, *34*, 65, 65(n8), 66, *68*, 210, *219*
Chandler, D., 40, *52*
Child, J., 92, *101*
Chouliaraki, L., 179, *196*
Clarke, B., 90, *101*
Clarke, J., 8-9, *11*, 40, *53*
Clyne, M., 185, *196*
Cobia, D., 92, *101*
Cohen, A.A., 66, 67, *69*
Colon, A., 196, *196*
Conboy, M., 61, *68*, 144, *156*
Costa, G., 166, *172*
Cottle, S., 142-143, 148, *156*
Couldry, N., 160, *172*
Critcher, C., 8-9, *11*, 40, *53*

SUBJECT INDEX

CPSIA information can be obtained at www.ICGtesting.com
Printed in the USA
LVOW112238120412

277400LV00001B/73/P